CROCHET
step by step

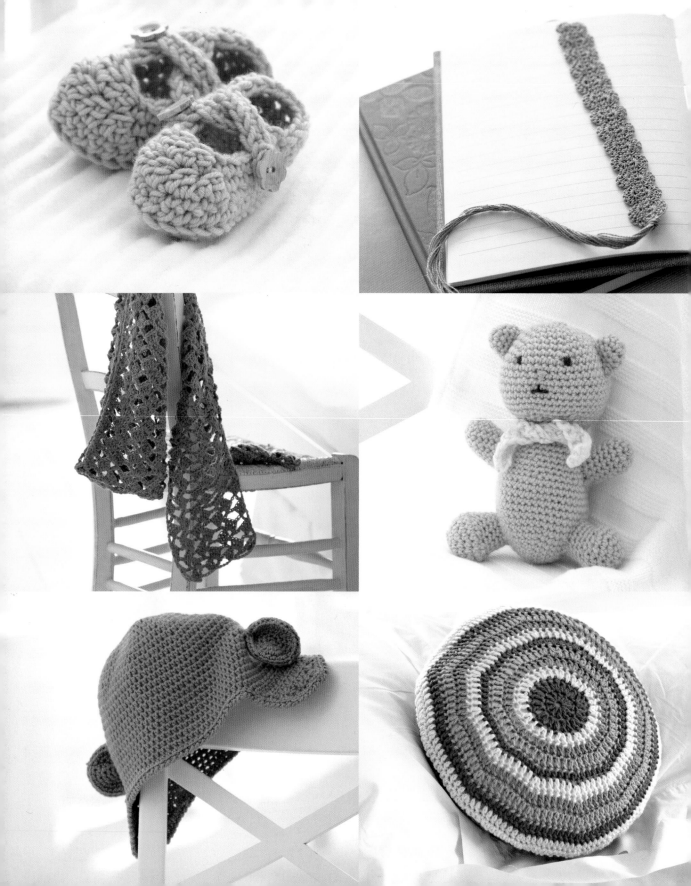

CROCHET
step by step

Sally Harding

LONDON, NEW YORK, MUNICH,
MELBOURNE, DELHI

DK INDIA

Senior Editor Nidhilekha Mathur
Assistant Editor Aditi Batra
Senior Art Editor Balwant Singh
Art Editor Anjan Dey
Assistant Art Editors Aastha Tiwari, Pooja Verma
Managing Editor Glenda Fernandes
Managing Art Editor Navidita Thapa
CTS Manager Sunil Sharma
DTP Designers Anurag Trivedi, Mohammad Usman

DK UK

Senior Designer Glenda Fisher
Project Editor Laura Palosuo
Technical Consultant Catherine Hirst
Design Assistant Charlotte Johnson
Managing Editor Penny Smith
Managing Art Editor Marianne Markham
Senior Jacket Creative Nicola Powling
Producer, Pre-Production George Nimmo
Senior Producer Seyhan Esen
Creative Technical Support Sonia Charbonnier
New Photography Ruth Jenkinson
Crochet Projects and Patterns Catherine Hirst,
Claire Montgomerie, and Erin McCarthy
Art Direction for Photography Glenda Fisher
Art Director Jane Bull
Publisher Mary Ling

First published in Great Britain in 2013
by Dorling Kindersley Limited,
80 Strand, London WC2R ORL.

Penguin Group (UK)
4 6 8 10 9 7 5 3
006 – 187878 – Jan/2013

A CIP catalogue record for this book
is available from the British Library.
ISBN 978-1-4093-6418-4

Printed and bound by South China Printing Co. Ltd, China

Discover more at www.dk.com

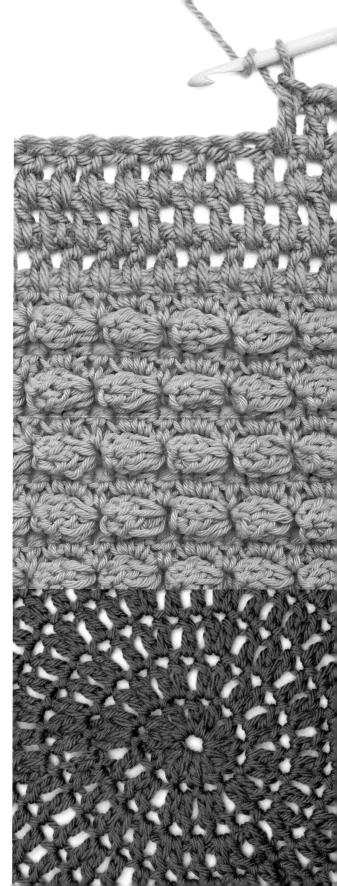

CONTENTS

Introduction 6

Tools and materials 8

Techniques 28
 Basic stitches 30
 Stitch techniques 58
 Openwork 77
 Colourwork 89
 Following a crochet pattern 102
 Embellishments for crochet 124
 Circular crochet 136
 Unusual yarns 156

Finishing off 164

Projects 176

Glossary 218

Index 220

Acknowledgments 224

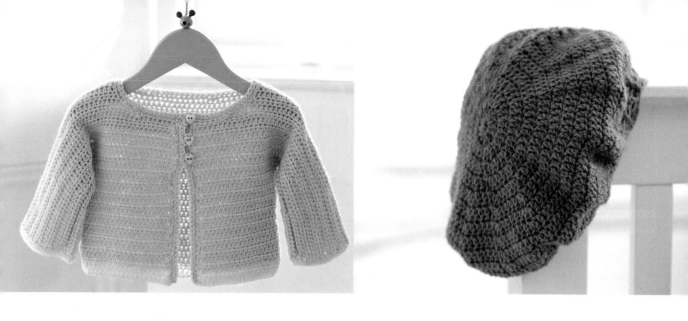

Introduction

This book is suitable for readers with no previous experience of crochet, for crocheters hoping to improve their technique, and will serve as an excellent reference for anyone with more advanced skills. *Crochet step by step* guides you through basic techniques and stitches, covering the relevant abbreviations and symbols on the way. A section of beautiful projects to make will inspire you to put newly honed skills to the test, while a final chapter covers useful finishing techniques such as attaching hooks and eyes and buttons.

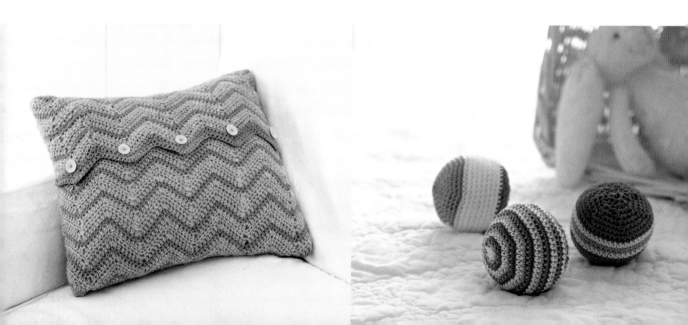

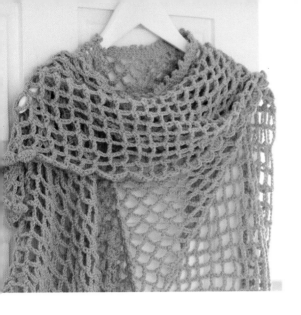

If you're new to crochet, start by familiarizing yourself with the tools and materials. The pages that follow ease you into the essential skills you will need. For example, in the Techniques section, you learn how to hold the yarn and hook, how to make a slip knot and how to create a foundation chain. You will then be taken through the most common crochet stitches as well as the ins and outs of reading crochet patterns. Once you've mastered these basics, you are free to move through the sections, refining your skills, and practising the techniques that you enjoy the most. Finally, you can turn your hand to one of the complete projects in the back. Start with "Easy" and work your way up to "Moderate" – there are plenty to choose from!

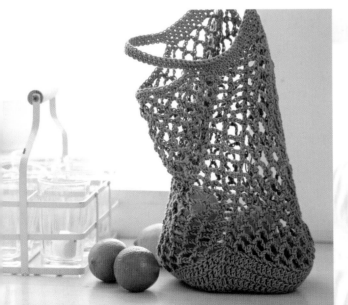

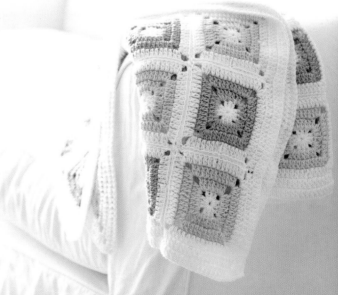

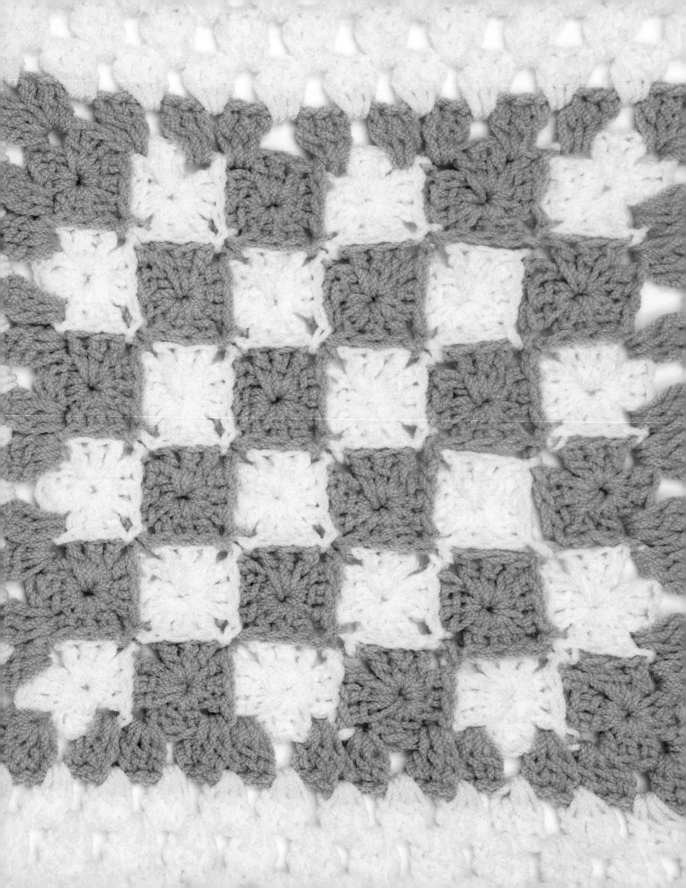

Tools and materials

 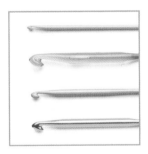

Yarns

A yarn is the long, stranded, spun fibre that we crochet with. There are many types of yarns, allowing crocheters to enjoy a variety of sensory experiences as they express themselves through the medium. Yarns can be made of many different fibres (see pp.10–13) and have a range of textures (see pp.14–15). Their possibilities are exciting: you can, in theory, crochet with anything – from a skein of supple sock yarn to the plastic bag that you brought it home in. Choose from a colour palette that ranges from subtle, muted tones to eye-popping brights.

Fibres

Yarns, like fabrics, are made from fibres. A fibre may be the hair from an animal, man-made (synthetics), or derived from a plant. The fibres are processed and spun to make a yarn. A yarn may be made from a single type of fibre, such as wool, or mixed with other fibres to enhance its attributes (for example to affect its durability or softness). Different blends are also created for aesthetic reasons, such as mixing soft, luxurious cashmere with a rougher wool. As a result, all yarns have different properties, so it is important to choose an appropriate blend for your project.

Cotton

Cotton crochet threads ↑
Traditionally, crochet was worked in cotton threads that were suitable for lace. Today, cotton threads are still used for lace edgings and filet crochet (see pp.127–135 and pp.78–83).

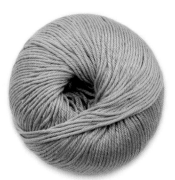

← Fine-weight cotton yarns
This thicker yarn is a good weight for garments and accessories and will show the texture of stitch patterns clearly.

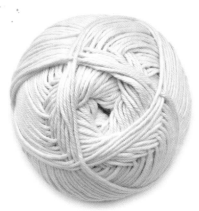

← Matt cotton
Cotton is the fluffy mass that grows around the seeds of the cotton plant. It is spun into a breathable, summery fibre. Most cotton yarns are easy to wash, and when cared for correctly, can be incredibly robust and last for decades. It is therefore a good fibre for homewares, crocheted pouches, and shoulder bags. Pure, untreated cotton is ideal for hand-dyeing.

← Mercerized cotton
Cotton fibre can be mercerized, a treatment during which it undergoes mechanical and chemical processing to compress it and transform it into an ultra-strong yarn with a reflective sheen. It is a fine choice of fibre for a project that needs to be strong and hold its shape, such as a clutch bag (see pp.206–207), a long summer cardigan, or a throw.

Wool

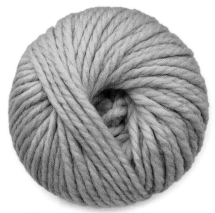

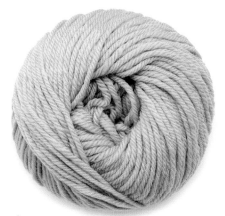

Merino wool ↑

This is wool from the merino sheep, which is said to provide one of the softest wools of any sheep breed. The bouncy, smooth-surfaced fibre is just as warm as a more wiry, coarse wool. Merino is a fantastic choice for wearing against the skin, and is often treated to make it suitable for machine-washing. Good for soft scarves, arm warmers, and children's garments.

Wool ↑

The hair, or fleece, of a variety of breeds of sheep, such as the Shetland Moorit or Bluefaced Leicester, is made into pure wool yarns, or blended with other fibres. It is very warm and hard-wearing, and great for winter wear such as jackets, cardigans, hats, and gloves. Some wool is rough, but softens with wear and washing. Wool sold as "organic" contains a high proportion of lanolin, making a strong, waterproof yarn.

Luxury

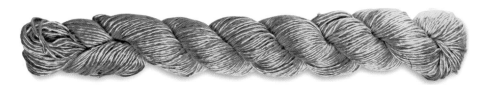

Silk ↑

The silkworm, a caterpillar that eats mulberry leaves, spins a cocoon in order to develop into a moth. Made from the fibres of the cocoon, silk is shiny and sleek, very delicate, and owing to its extraordinary source, very expensive. The luxurious texture of silk yarn makes it ideal for wedding and christening gifts, and indulgent fitted garments.

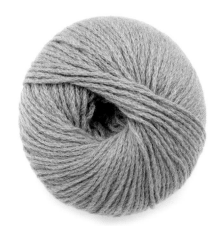

← Cashmere

This fibre is spun from the hair of a goat, and makes an ultra-luxurious, velvety-soft yarn. It is light but incredibly strong, and weighs very little by the metre; it often goes further than a pure wool or cotton. It is expensive to produce and is often blended with other fibres in a yarn to add softness. Cashmere should be enjoyed close to the skin in scarves, snoods, or jumpers. Treat it with great care; may be dry-clean only.

Other natural fibres

← Hemp
The hemp plant is particularly versatile, and the use of its fibres for knitting yarn is one of its less common applications. Hemp has an earthy roughness that will soften with age and wear. It is usually produced in an environmentally friendly way, and the strong fibre is good for crocheting openwork shopping bags and homewares such as placemats and coasters.

← Ramie
A plant from the nettle family yields the fibre called ramie. The bark of the plant is dried out into workable fibres, which are then spun into yarns. Like other plant fibres, this yarn does not insulate; it is desirable for its strength and airy quality. It is frequently blended with other fibres to produce a yarn that is breathable and wears well.

Synthetic fibres

Nylon →
Polyamide, or nylon, is an incredibly strong and lightweight fibre. Its elasticity makes it perfect for use in crocheted fabrics, and it is often used to reinforce yarn blends for items that may be subjected to heavy wear such as sock and darning yarns. Like other man-made fibres, nylon improves the washability of the fibres it is blended with by preventing shrinkage and felting.

Microfibre ↑
With a quality of velvety softness, microfibre is increasingly common in multi-fibre yarns, as it is efficient at holding other fibres together as one yarn. Synthetic fibres such as this may not appeal to you, but they are often included in a yarn to reduce density, add texture, or to prevent excess spun fibre from migrating and pilling on the surface of a piece of crochet.

← Acrylic
Acrylic fibres are produced from ethylene, which is derived from oil, and they are very cheap to manufacture. Acrylic yarn feels slightly rougher than other synthetics, and often comes in very bright and luminous shades which are hard to create with natural fibres. Robust and resistant to moths, acrylic yarn is ideal for toys, novelty items, and budget projects. The yarn tends to accumulate static electricity.

Yarn blends

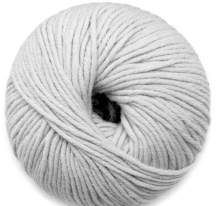

Natural and synthetic mixes →
Man-made fibres are often blended with natural fibres to bring structure, strength, and washability; also to alter their appearance, such as to add a sheen. They help bind other yarns, such as mohair and wool, together and prevent shedding; they also prevent animal fibres shrinking. The strength of such blends makes them perfect for socks or gloves.

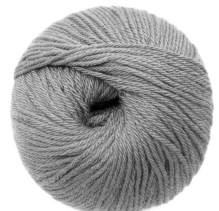

Wool and cotton mixes ↑
The strength and softness of cotton adds smoothness, breathability, and washability to wool's very warm (and sometimes scratchy) qualities. The blend is great for those with sensitive skin and for babies. Cotton and wool absorb dye differently, which may lead to a stranded colour appearance in such blends. Wool sheds fewer hairs when mixed with a stabilizing plant fibre.

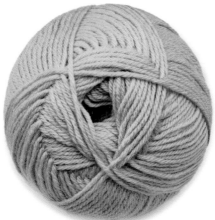

← Synthetic-only mixes
Manufacturers can mix man-made, easily manipulated fibres to create a variety of textures such as furry eyelash yarns, soft and smooth babywear yarns, and rough aran substitutes. Although they do not hold much warmth in comparison to animal fibres, most synthetic-only blends can be washed at a high temperature and tumble-dried.

Multicoloured yarns

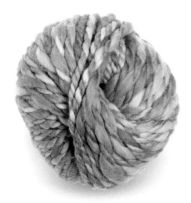

Variegated wool yarn ↑
Two strands of different colours are twisted around each other in this super-bulky-weight yarn. Each strand changes from dark to light and back again along its length.

Variegated cotton yarn ↑
Thin strands of different colours are twisted around a core yarn to create this fairly smooth multicoloured yarn.

Novelty yarns and textural effects

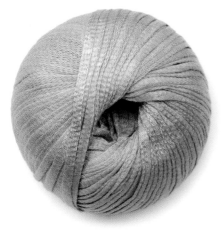

← Tape yarn
The main characteristic of tape yarn is its flat shape. It may also be tubular, and is flattened when wound into a ball.

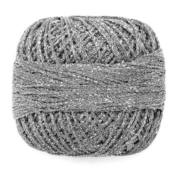

Metallics ↑
Although not a fibre, metallics are part of the library of yarns/fibres that is available to crocheters. Lurex and other metallic yarns make highly effective trims and decorations. They may be uncomfortable to wear if used on their own, but if blended with other yarns, they create very interesting mixes and are fun to experiment with.

← Bouclé yarn
The curly appearance of bouclé yarn results from whirls of fibre attached to a solid core yarn. When crocheted, these loops of fibre stand out and create a carpet-like looped fabric. (Bouclé is also the name of a type of fabric manufactured using a similarly spun yarn.) Bouclé yarns are completely unique and often specify a deceptively larger tension guideline as a result of their overall thickness. Bouclé is a lovely choice for very simply shaped garments.

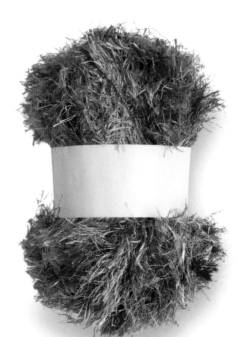

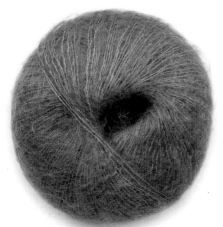

← Mohair
This fibre is the hair of a furry breed of goat, and it produces a unique natural "halo" when crocheted. Working with it can be challenging, as its fuzzy appearance makes it difficult to see the structure of the crochet and any mistakes made. Mohair makes particularly interesting oversized jumpers or accessories. It is not advisable to use mohair for babywear as it may shed hair when newly made, which could be dangerous if inhaled.

Novelty yarn ↑
Unique novelty yarns change with fashion trends. This shaggy yarn creates a crocheted fabric that looks like fur.

Unusual yarns

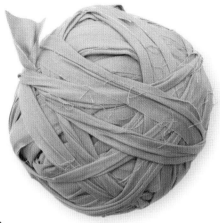

Fabric ↑

Traditionally, fabric from old clothes and other textiles was often made into doormats and rugs by tying strips together. Think about using fabric strips to crochet with, too. The hook size will depend on how thick the strips are.

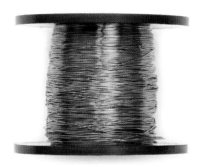

Wire ↑

This unusual medium is often used for crocheting jewellery: buy beading wire, which is available in a range of colours, and crochet it into chokers, necklaces, and bracelets. Try stranding beads on the wire before you work and place them in the crochet as you go along (see pp.124–125). For a really unusual project, strand the wire with another yarn to crochet a malleable fabric that holds its shape, and make three-dimensional sculptures.

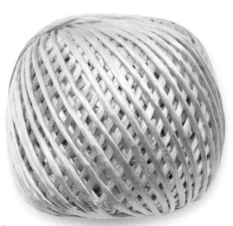

String ↑

Ideal for crocheting practical household items such as bowls and boxes, string is available in a range of colours and weights. Experiment with relatively small hooks, such as 5mm (UK6/US8), to create a very stiff fabric capable of holding its shape. Coat finished household items with diluted PVA glue to waterproof them and make future cleaning easy: just wipe with a damp cloth.

Plastic bags ↑

Recycle plastic bags by cutting them into strips and joining these together with tight knots to form yarn. Create interesting textures by mixing coloured and clear bags; the knots will add further texture. Crochet with a large hook, depending on the width of the strips you have cut – 10mm (US15) upwards is recommended; also choose the size according to whether you want a very tight or a floppy plastic fabric. Use this technique to make bags, mats, and waterproof items such as toiletry bags or garden seat covers.

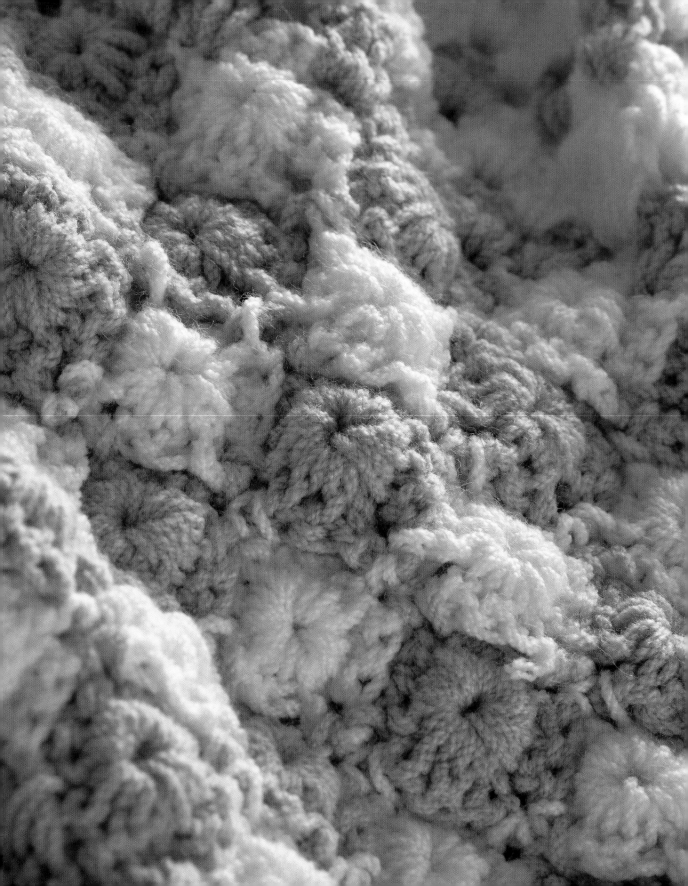

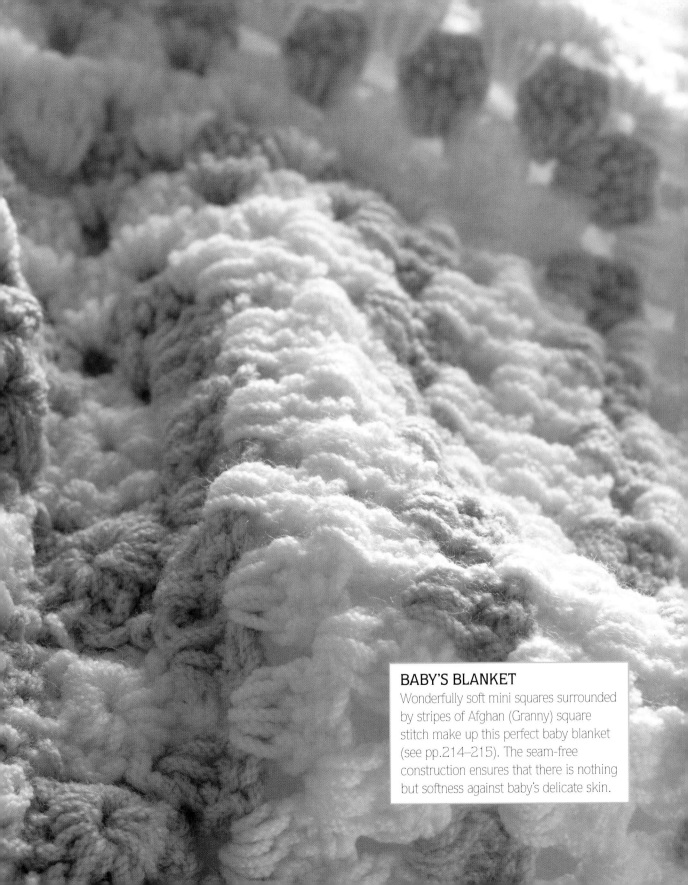

BABY'S BLANKET

Wonderfully soft mini squares surrounded by stripes of Afghan (Granny) square stitch make up this perfect baby blanket (see pp.214–215). The seam-free construction ensures that there is nothing but softness against baby's delicate skin.

Buying yarn

Yarns are packaged for sale in specific quantities or "put-ups". The most common ones for crochet are balls, hanks, and skeins, which usually come in quantities of 25g, 50g, or 100g.

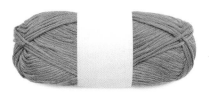

Hank ↑
A twisted ring of yarn, which needs to be wound into a ball before it can be used. You can do this by hand, or by using a ball-winder. This gives you the opportunity to check that there are no knots or faults in the yarn as you wind it. Some yarns available as hanks consist of soft, delicate fibres, and these are unsuitable for use in certain industrial ball-winding machines.

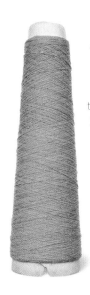

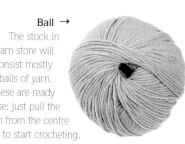

Ball →
The stock in a yarn store will consist mostly of balls of yarn. These are ready to use: just pull the yarn from the centre to start crocheting.

← Skein
The oblong-shaped skein of yarn is ready to use without any special preparation. Keep the label in place as you work to ensure that the skein doesn't totally unravel.

← Cone
This is often too heavy to carry around in a project bag and the yarn is best wound into balls before you start crocheting.

Yarn weights

The yarn "weight" refers to its thickness. Some yarns are spun by manufacturers to fall into what are considered as "standard" yarn weights, such as US sport or worsted and UK double-knitting and aran. These standard weights have long histories and will probably be around for some time to come. However, even within these "standard" weights there is slight variation in thickness, and textured novelty yarns are not easy to categorize by thickness alone.

STANDARD YARN-WEIGHT SYSTEM

Yarn weight symbol & category names	0 Lace	1 Super fine	2 Fine	3 Light	4 Medium	5 Bulky	6 Super bulky
Crochet tension ranges in dc to 10cm (4in)	32–42*** trebles	21–32 sts	16–20 sts	12–17 sts	11–14 sts	8–11 sts	5–9 sts
Recommended hook in metric size range	1.6–2.25mm	2.25–3.5mm	3.5–4.5mm	4.5–5.5mm	5.5–6.5mm	6.5–9mm	9mm and larger
Recommended hook in US size range	6 steel, 7 steel, 8 steel, B-1	B-1 to E-4	E-4 to 7	7 to I-9	I-9 to K-10½	K-10½ to M-13	M-13 and larger

GUIDELINES ONLY
The above reflect the most commonly used tensions and hook sizes for specific yarn categories. The categories of yarn, tension ranges, and recommended hook sizes have been devised by the Craft Yarn Council of America (YarnStandards.com).

*** Ultra-fine lace-weight yarns are difficult to put into tension ranges; always follow the tension given in your pattern for these yarns.

DEFINING YARN WEIGHT

Visual yarn thickness is only one indicator of a yarn-weight category. A yarn can look thicker than another yarn purely because of its loft, the air between the fibres, and the springiness of the strands. By pulling a strand between your two hands you can see how much loft it has by how much the thickness diminishes when the yarn is stretched. The ply of a yarn is also not an indication of yarn thickness. Plies are the strands spun together around each other to form the yarn. A yarn with four plies can be very thick or very thin depending on the thickness of each individual ply.

Yarn labels

Everything you need to know about a yarn is on its label. It will include symbols that tell you how to crochet with it and how to clean it. Here is just a selection of the most common symbols. Always keep the labels: they are vital for identifying the yarn if you run short and need more. New yarn needs to have the same dye lot number as the original purchase in order to avoid a slight difference in colour in the finished item.

← Ballband

A yarn label is also known as a ballband. It features information on the yarn's weight and thickness, as well as washing guidelines. Yarns range from the very fine and light to the thick, dense, and heavy.

Symbols

Yarn manufacturers may use a system of symbols to give details of a yarn. These include descriptions of suitable hooks and the required tension.

Yarn weight and thickness

Recommended crochet hook size

4mm (UK 8/ US G-6)

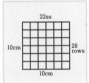

Tension over a 10cm (4in) test square

SHADE/ COLOUR
520

Shade/colour number

DYE LOT NUMBER
313

Dye lot number

50g
NETT AT STANDARD CONDITION IN ACCORDANCE WITH BS984

Weight of ball or skein

100%
WOOL

Fibre content

Machine-wash cold

Machine-wash cold, gentle cycle

Hand-wash cold

Hand-wash warm

Do not bleach

Dry-cleanable in any solvent

Dry-cleanable in certain solvents

Do not dry-clean

Do not tumble-dry

Do not iron

Iron on a low heat

Iron on a medium heat

Choosing yarn colours

When embarking on a new crochet project, the choice of colour is a very important decision. Even a simple design gains impact from good colour choices. The colour wheel is a useful tool, which will introduce you to colour theory.

The colour wheel: The three primary colours, red, yellow, and blue form the basis of a colour wheel. When two primary colours are combined, they create "secondaries". Red and yellow make orange, yellow and blue make green, and blue and red make purple. Intermediate colours called tertiaries occur when a secondary is mixed with the nearest primary.

Hue, shade, tone, and tint: Each segment shows the hue, shade, tone, and tint of a colour. A hue is the pure, bright colour; a shade is the colour mixed with black; a tone is the colour mixed with grey; and a tint is the colour mixed with white (pastels). The use of colour can affect the appearance of a project dramatically.

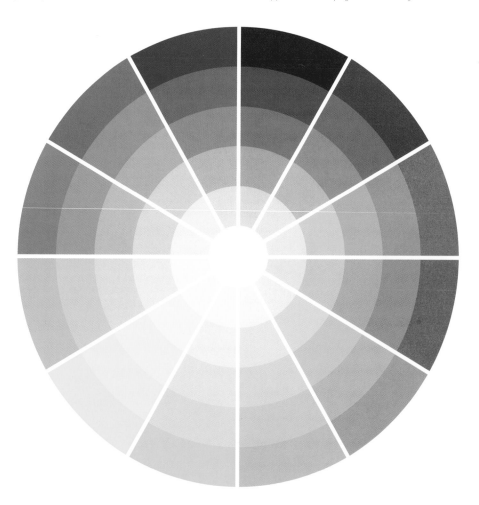

Complementary colours: Colours that lie opposite one another on the wheel, such as red and green, or yellow and violet, are called complementaries. They provide contrasts that accent design elements and make both colours stand out. Don't forget black and white, the ultimate opposites.

Monochromatic designs: These use different versions of the same colour. So a project based on greens will not stray into the red section of the colour wheel, but might have shades and tints of yellow and blue mixed in, which can then become "harmonious" combinations of colours that are next to each other on the colour wheel. These "adjacent" colours can also be combined to great effect, as long as there are differences in value between them.

Colour temperature: Colour has a visual "temperature", with some colours being perceived as "warm" and others as "cool". Many people tend to think of blue and its adjacent colours as being cool, while the reds and yellows are warm, but in fact there are warmer and cooler versions of all the primaries; think, for example, of a warm, azure blue and a cold, icy blue. Colour temperature is an important element in whether a colour recedes or advances that is, in whether it stands out from or blends in with the background and surrounding colours.

Warm shades →
The warm end of the colour spectrum consists mainly of red and yellow tones; browns, oranges, and purple are part of this group. Use these colours to bring richness and depth. A blend of warm shades can be a very flattering mixture to use, depending on your colouring: hold yarn against your face to see what suits you.

← Cool shades
Blue, green, and violet are at the cool end of the spectrum, and these can look very good used together. Cool colours are generally darker in tone than warm ones. If used with warm shades, their impact is lessened: if you need to balance a warm mixture in a project, you will need a higher proportion of cool than warm colours to do it.

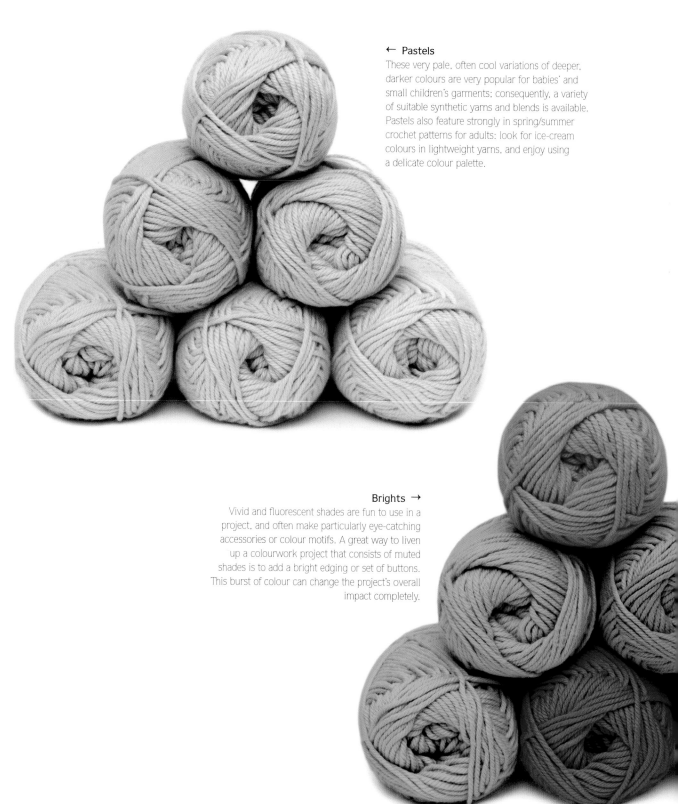

← Pastels

These very pale, often cool variations of deeper, darker colours are very popular for babies' and small children's garments; consequently, a variety of suitable synthetic yarns and blends is available. Pastels also feature strongly in spring/summer crochet patterns for adults: look for ice-cream colours in lightweight yarns, and enjoy using a delicate colour palette.

Brights →

Vivid and fluorescent shades are fun to use in a project, and often make particularly eye-catching accessories or colour motifs. A great way to liven up a colourwork project that consists of muted shades is to add a bright edging or set of buttons. This burst of colour can change the project's overall impact completely.

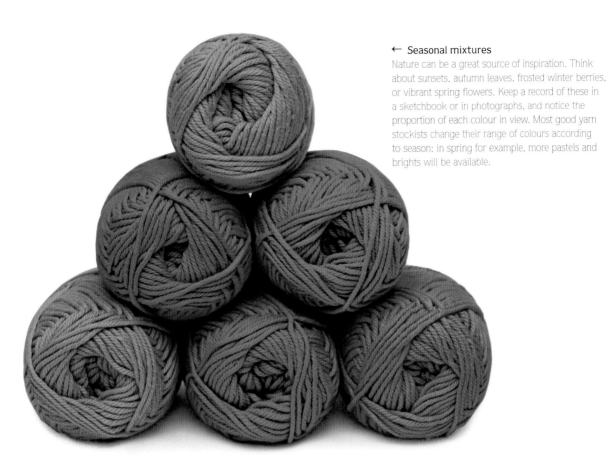

← Seasonal mixtures

Nature can be a great source of inspiration. Think about sunsets, autumn leaves, frosted winter berries, or vibrant spring flowers. Keep a record of these in a sketchbook or in photographs, and notice the proportion of each colour in view. Most good yarn stockists change their range of colours according to season: in spring for example, more pastels and brights will be available.

BLACK AND WHITE

Black and white are not included on the colour wheel as they are not classified as colours. Black is an absence of all colour and white is a combination of all colours in the spectrum. Bear in mind that when using black, not only is your work more difficult to see, but also that texture work will not be seen to best effect in the final garment. White, however, guarantees that every stitch and detail will be clear; the drawback is that white shows smudges of dirt more quickly and therefore needs washing more frequently.

Hooks and other equipment

Crochet is probably one of the most economical needlework crafts as it requires very little equipment. Aside from yarn, you will need a crochet hook of appropriate size to the project and a blunt needle for darning in ends. In addition, you will need some essential pieces that you are likely to already have in your sewing kit.

Crochet hooks

If you are a beginner, start learning to crochet with a good-quality standard metal crochet hook. Once you know how to work the basic stitches with a lightweight wool yarn and a 4mm or 4.5mm (US size 6 or 7) hook, branch out and try some other types of hooks in order to find the one that suits you best.

STANDARD METAL HOOK

Parts of a crochet hook →
The hook lip grabs the yarn to form the loops and the shank determines the size of the loop. The crochet handle gives weight to the tool and provides a good grip.

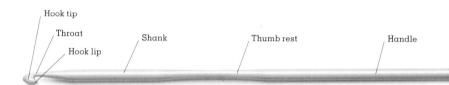

Hook tip
Throat
Shank
Thumb rest
Handle
Hook lip

ALTERNATIVE HOOK HANDLES

Comfort handle →
Hook handles come in different shapes. If you find the standard crochet hook uncomfortable to hold because it is too narrow, investigate hooks with alternative handles. This is a high-quality Japanese hook designed and refined especially for comfort and good grip.

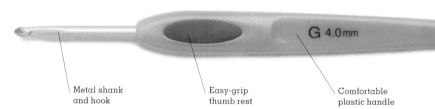

G 4.0 mm

Metal shank and hook
Easy-grip thumb rest
Comfortable plastic handle

HOOK TYPES

Point protector

← Lace hook
Because lace crochet hooks are so fine, ranging from 0.6mm (US size 14 steel) to 1.75mm (US size 5 steel), they are always manufactured in metal. Keep them with their metal point protectors in place to avoid accidents.

← Metal hooks
Some ranges of aluminium hooks are available in bright colours – a different colour for each size, which is handy for picking up the right size at a glance.

Wooden hooks ↑
Hardwood and bamboo hooks are very attractive and lighter in weight than metal hooks. They also provide a good grip to prevent your fingers from slipping when crocheting.

Plastic hooks ↑
Plastic hooks are not as precisely made as metal and wooden hooks, but they come in great colours, so are enjoyable to work with.

Jumbo hooks ↑
The largest crochet hook sizes – from a 10mm (US size N-15) to a 20mm (US size S) are made in plastic. They are used for making thick crochet fabric very quickly.

HOOK SIZES
Crochet hooks are manufactured in the various sizes (diameters) listed in the hook conversion chart on the right. The millimetre sizes are the diameters of the hook shank, which determines the size of the crochet stitches.

Although the middle range of hook sizes – from 2mm (US size B-1) to 9mm (US size M-13) – are the most commonly used, the finer and thicker hooks are also very popular for lace crochet and jumbo crochet. See p.18 for which hook size to use with the different yarn weights.

CONVERSION CHART

This chart gives the conversions between the various hook-size systems. Where there are no exact conversions possible, use the nearest equivalent.

EU METRIC	US SIZES	OLD UK
0.6mm	14 steel	
0.75mm	12 steel	
1mm	11 steel	
1.25mm	7 steel	
1.5mm	6 steel	
1.75mm	5 steel	
2mm		14
2.25mm	B-1	
2.5mm		12
2.75mm	C-2	
3mm		10
3.25mm	D-3	
3.5mm	E-4	9
3.75mm	F-5	
4mm	G-6	8
4.5mm	7	7
5mm	H-8	6
5.5mm	I-9	5
6mm	J-10	4
6.5mm	K-101/2	3
7mm		2
8mm	L-11	
9mm	M-13	
10mm	N-15	
12mm	P	
15mm	Q (16mm)	
20mm	S (19mm)	

Other equipment

In addition to a crochet hook, you will need a blunt-ended yarn needle for darning in yarn ends. Other essentials include scissors, pins, and a tape measure. Handy extras such as stitch markers and row counters will help keep track of stitches.

THE ESSENTIALS

Pins →
Use pins with glass heads or large heads (such as knitting pins), for seams and blocking (see p.117).

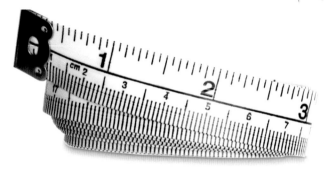

← Tape measure
Keep a tape measure on hand for checking your tension and measuring your crochet.

← Blunt-ended yarn needles
Use these for sewing seams and darning in yarn ends (make sure the eye of the needle is big enough for your chosen yarn).

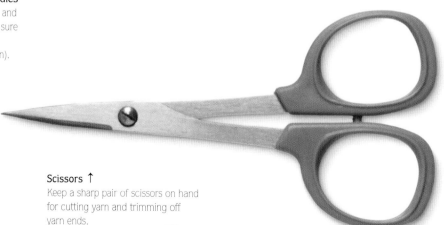

Scissors ↑
Keep a sharp pair of scissors on hand for cutting yarn and trimming off yarn ends.

HANDY EXTRAS

← Yarn bobbins
Useful for holding short
lengths of yarn for jacquard
crochet (see p.92).

Row counter ↑
These are useful for keeping track of where you
are in your crochet. String on a length of cotton
yarn and hang it around your neck – change it
each time you complete a row.

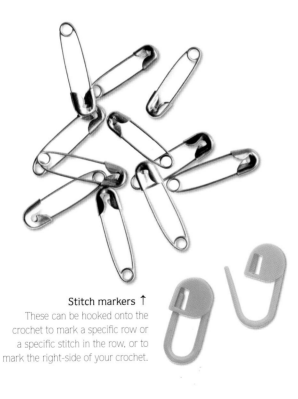

Stitch markers ↑
These can be hooked onto the
crochet to mark a specific row or
a specific stitch in the row, or to
mark the right-side of your crochet.

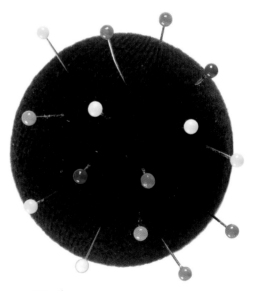

Pincushion ↑
A useful item to have by
your side when working.

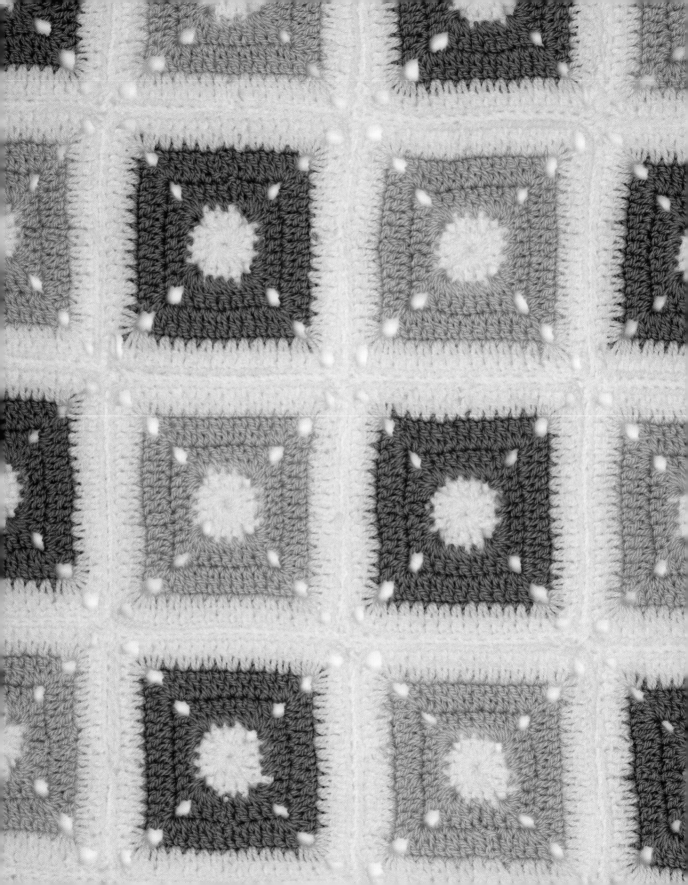

Techniques

Basic stitches

Learning to crochet can take a bit of time because there are several basic stitches to master. But there is no need to learn all the stitches at once. With only chain stitches and double crochet at your disposal, you can make attractive striped blankets and cushion covers in luscious yarns.

Getting started

Before making your first loop, the slip knot (see p.32), get to know your hook and how to hold it. First, review the detailed explanation of the parts of the hook on p.24. Then try out the various hook- and yarn-holding techniques below and opposite when learning how to make chain stitches. If you ever learned crochet as a child, you will automatically hold the hook the way you originally learned to, and you should stick to this whether it is the pencil or knife position.

HOLDING THE HOOK

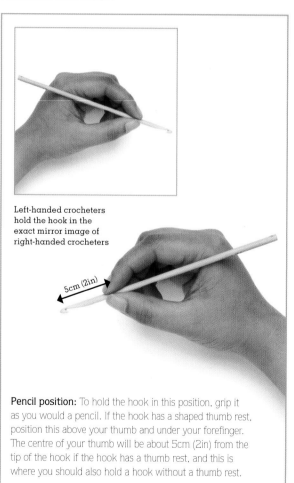

Left-handed crocheters hold the hook in the exact mirror image of right-handed crocheters

5cm (2in)

Pencil position: To hold the hook in this position, grip it as you would a pencil. If the hook has a shaped thumb rest, position this above your thumb and under your forefinger. The centre of your thumb will be about 5cm (2in) from the tip of the hook if the hook has a thumb rest, and this is where you should also hold a hook without a thumb rest.

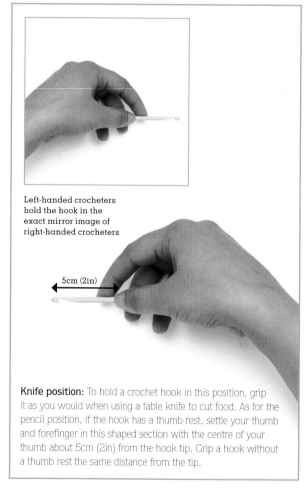

Left-handed crocheters hold the hook in the exact mirror image of right-handed crocheters

5cm (2in)

Knife position: To hold a crochet hook in this position, grip it as you would when using a table knife to cut food. As for the pencil position, if the hook has a thumb rest, settle your thumb and forefinger in this shaped section with the centre of your thumb about 5cm (2in) from the hook tip. Grip a hook without a thumb rest the same distance from the tip.

HOLDING THE YARN

In order to control the flow of the yarn to your hook, you need to lace it around the fingers of your free hand (called your yarn hand). Both of the techniques shown here are only suggestions, so feel free to develop your own.

Method one: Start by winding the yarn around your little finger, then pass it under your two middle fingers and over your forefinger. With this method the forefinger is used to position the yarn.

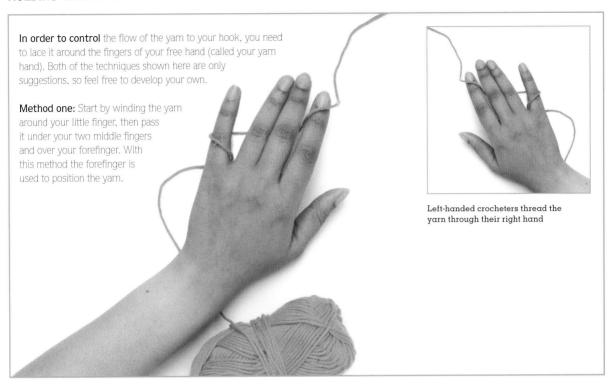

Left-handed crocheters thread the yarn through their right hand

Method two: Wrap the yarn around your little finger, then pass it behind the next finger and over the top of the middle finger and forefinger. This method allows you to position the yarn with either the forefinger or middle finger, whichever is more comfortable and gives you more control (see Tensioning your yarn on p.33).

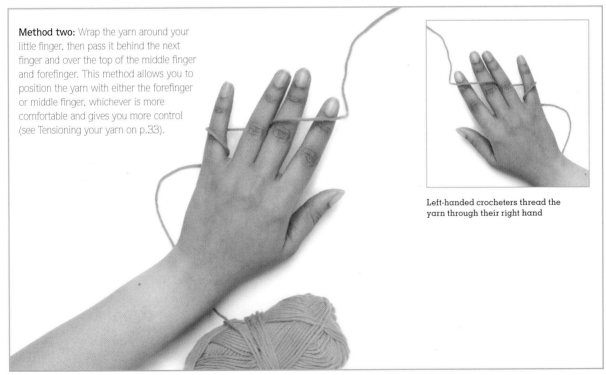

Left-handed crocheters thread the yarn through their right hand

MAKING A SLIP KNOT

1 To make the first loop (called the slip knot) on your needle, begin by crossing the yarn coming from the ball over the yarn end (called the yarn tail) to form a circle of yarn.

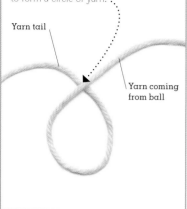

Yarn tail

Yarn coming from ball

2 Insert the tip of the hook through the circle of yarn.

3 Then use the hook to grab the ball end of the yarn and pull the yarn through the circle.

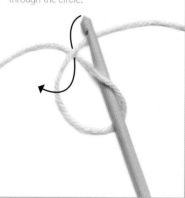

4 This forms a loop on the hook and a loose, open knot below the loop.

5 Pull both ends of the yarn firmly to tighten the knot and the loop around the shank of the hook.

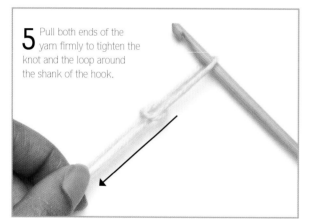

6 Make sure the completed slip knot is tight enough on the hook so that it won't fall off but not so tight that you can barely slide it along the hook's shank.

Make sure loop is secure but slides easily

Ball end of yarn

7 The yarn tail on the slip knot should be at least 10cm (4in) long so it can be threaded onto a blunt-ended yarn needle and darned in later. However, a crochet pattern may instruct you to leave an extra-long yarn tail (called a long loose end) to use for seams or other purposes.

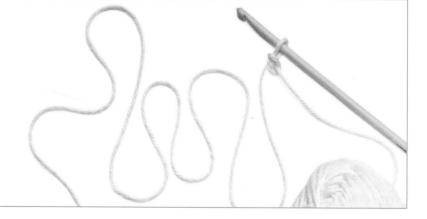

TENSIONING YOUR YARN

1 With your slip knot on your hook, try out some yarn-holding techniques. Wrap the yarn around your little finger and then lace it through your other fingers as desired, but so that it ends up over the tip of your forefinger (or your forefinger and middle finger).

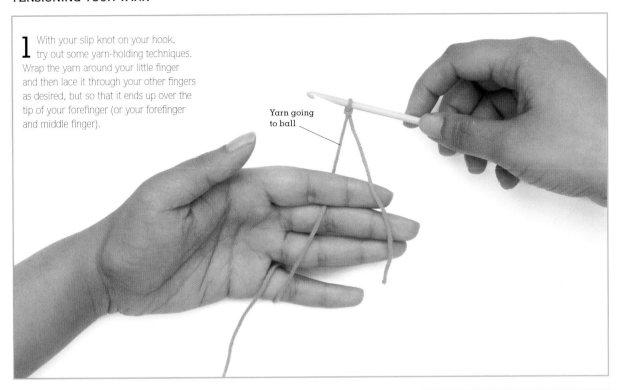

Yarn going to ball

2 As you crochet, grip the yarn tightly with your little finger and ring finger and release it gently as you form the loops. Use either your forefinger or your middle finger to position the yarn, and hold the base of the crochet close to the hook to keep it in place as the hook is drawn through the loops.

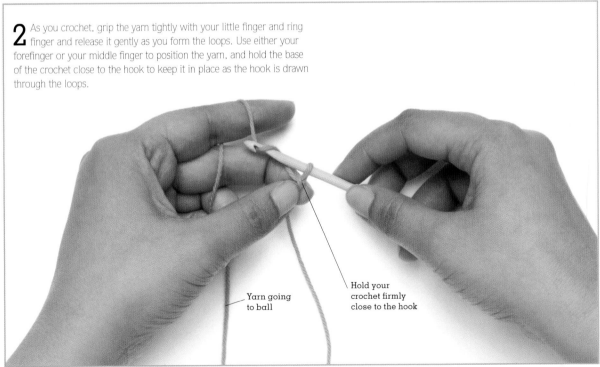

Yarn going to ball

Hold your crochet firmly close to the hook

Chain stitches (Abbreviation = *ch*)

Chain stitches are the first crochet stitches you need to learn because they form the base for all other stitches – called a foundation chain – and for turning chains (see p.55). They are used in combination with other basic stitches to create a vast array of crochet stitch patterns, both densely textured stitches and lacy ones. Practise chain stitches until you are comfortable holding a hook and releasing and tensioning yarn.

MAKING A FOUNDATION CHAIN

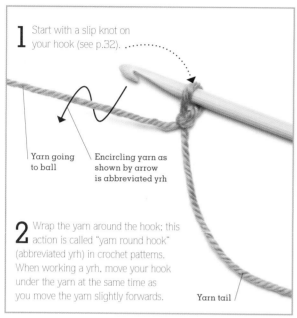

1 Start with a slip knot on your hook (see p.32).

Yarn going to ball

Encircling yarn as shown by arrow is abbreviated yrh

2 Wrap the yarn around the hook; this action is called "yarn round hook" (abbreviated yrh) in crochet patterns. When working a yrh, move your hook under the yarn at the same time as you move the yarn slightly forwards.

Yarn tail

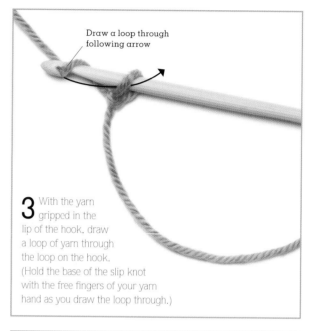

Draw a loop through following arrow

3 With the yarn gripped in the lip of the hook, draw a loop of yarn through the loop on the hook. (Hold the base of the slip knot with the free fingers of your yarn hand as you draw the loop through.)

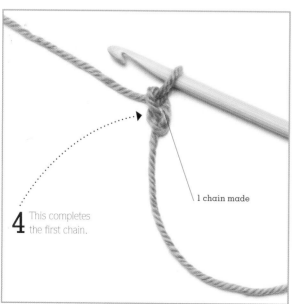

4 This completes the first chain.

1 chain made

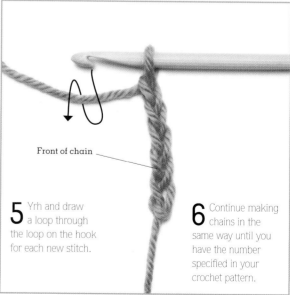

Front of chain

5 Yrh and draw a loop through the loop on the hook for each new stitch.

6 Continue making chains in the same way until you have the number specified in your crochet pattern.

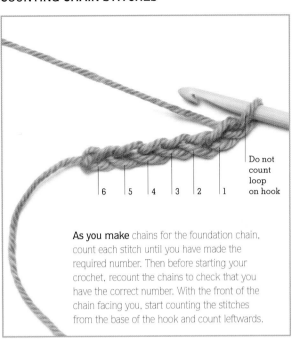

COUNTING CHAIN STITCHES

Do not count loop on hook

6 5 4 3 2 1

As you make chains for the foundation chain, count each stitch until you have made the required number. Then before starting your crochet, recount the chains to check that you have the correct number. With the front of the chain facing you, start counting the stitches from the base of the hook and count leftwards.

Back of chain

7 The back of the foundation chain has little bumps along it as seen here.

SIMPLE CHAIN STITCH NECKLACE

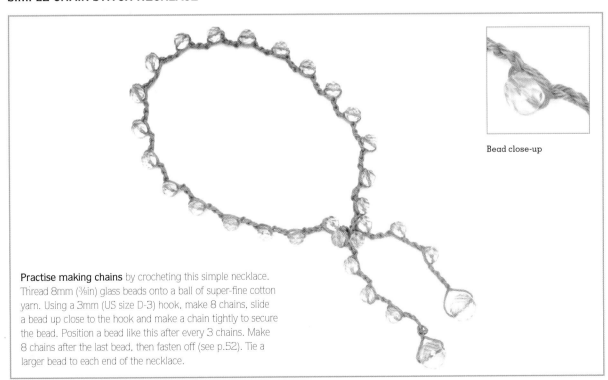

Bead close-up

Practise making chains by crocheting this simple necklace. Thread 8mm (⅜in) glass beads onto a ball of super-fine cotton yarn. Using a 3mm (US size D-3) hook, make 8 chains, slide a bead up close to the hook and make a chain tightly to secure the bead. Position a bead like this after every 3 chains. Make 8 chains after the last bead, then fasten off (see p.52). Tie a larger bead to each end of the necklace.

Double crochet (Abbreviation = *dc*)

Double crochet is the easiest crochet stitch to learn and one crocheters use frequently, either on its own or in combination with other stitches. Take your time learning and practising the stitch because once you become proficient, the taller stitches will be much easier to master. Double crochet forms a dense fabric that is suitable for many types of garments and accessories. It is also the stitch used for toys and containers because it can be worked tightly to form a stiff, firm textile.

When double crochet is worked back and forth in rows, it looks identical on both sides. Worked in the round it looks different on the right and wrong sides, which you can see on p.137.

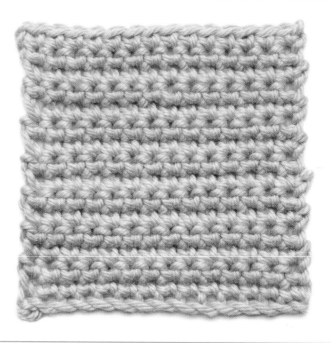

1 Make a foundation chain of the required length (see p.34).

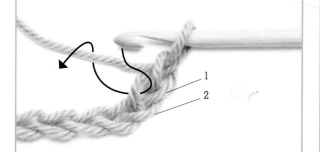

2 Insert the hook through the second stitch from the hook and wrap the yarn around the hook (yrh) following the large arrow. (You can insert the hook under one or two strands of the chain, but working under just one loop as shown here is easiest.)

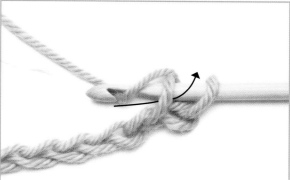

3 Holding the base of the chain firmly with your left hand and tensioning the yarn (see p.33), draw a loop back through the chain as shown by the large arrow.

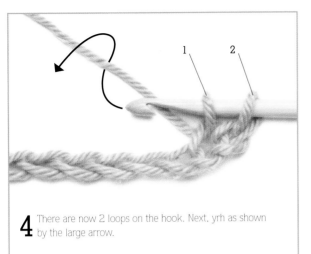

4 There are now 2 loops on the hook. Next, yrh as shown by the large arrow.

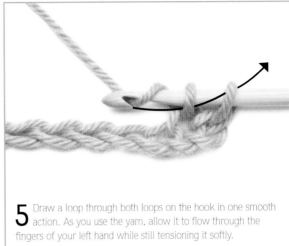

5 Draw a loop through both loops on the hook in one smooth action. As you use the yarn, allow it to flow through the fingers of your left hand while still tensioning it softly.

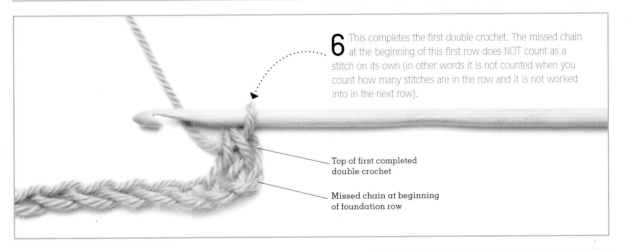

6 This completes the first double crochet. The missed chain at the beginning of this first row does NOT count as a stitch on its own (in other words it is not counted when you count how many stitches are in the row and it is not worked into in the next row).

Top of first completed double crochet

Missed chain at beginning of foundation row

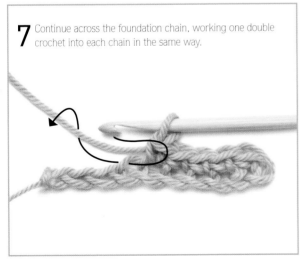

7 Continue across the foundation chain, working one double crochet into each chain in the same way.

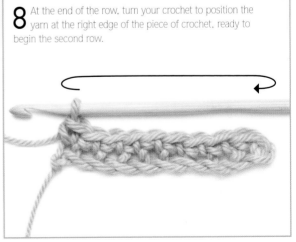

8 At the end of the row, turn your crochet to position the yarn at the right edge of the piece of crochet, ready to begin the second row.

9 To begin the second row, make one chain stitch. This chain is called the turning chain, and it brings the work up to the height of the double crochet stitches that will follow.

1-chain turning chain does NOT count as first stitch of row

10 Work the first double crochet into the top of the first stitch in the row below. Be sure to insert the hook under both legs of the "V" of the stitch. Work a double crochet into the top of each of the remaining double crochets in the row below.

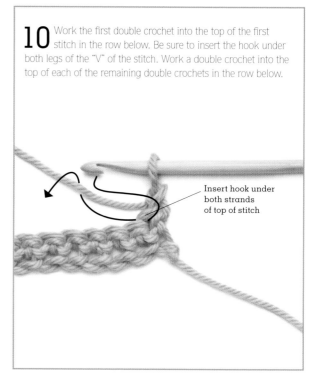

Insert hook under both strands of top of stitch

11 At the end of the row, work the last stitch into the top of the last double crochet of the row below. Work following rows as for the second row.

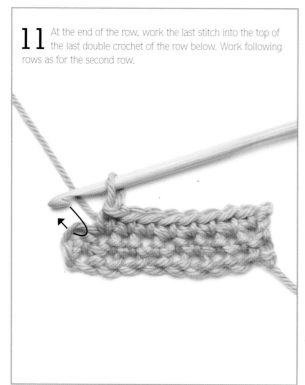

12 When you have completed your crochet, cut the yarn leaving a long loose end – at least 10cm (4in) long.

13 Remove the hook from the remaining loop, pass the yarn end through the loop, and pull tight to close it. Fastening off like this is done the same way for all crochet stitches.

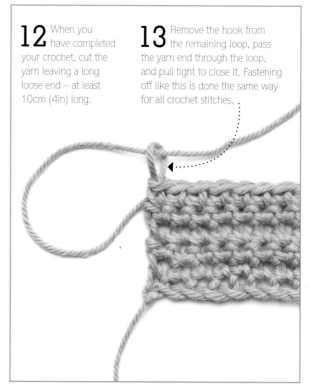

Half treble crochet (Abbreviation = *htr*)

After double crochet, half treble crochet comes next in order of stitch heights (see p.55). It is firm like double crochet and fairly dense, but produces a slightly softer texture, which makes it ideal for warm baby garments. It's not advisable to move on to learning how to work half trebles until you can make double crochet stitches with confidence.

Half treble crochet worked in rows, as here, looks the same on both sides, making it a totally reversible fabric, just like all basic stitches worked in rows.

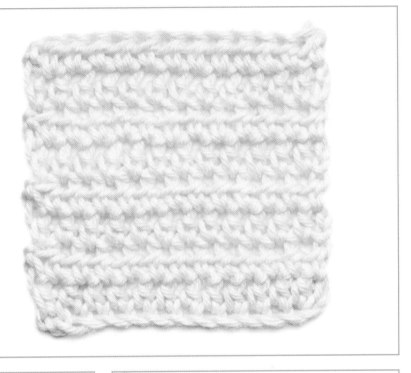

1 Make a foundation chain of the required length (see p.34). To begin the first stitch, wrap the yarn around the hook (yrh).

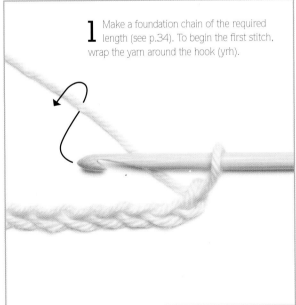

2 Insert the hook through the third chain from the hook, yrh again (as shown by the large arrow), and draw a loop back through the chain.

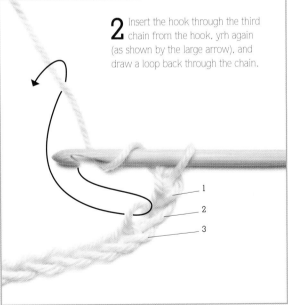

3 There are now 3 loops on the hook.

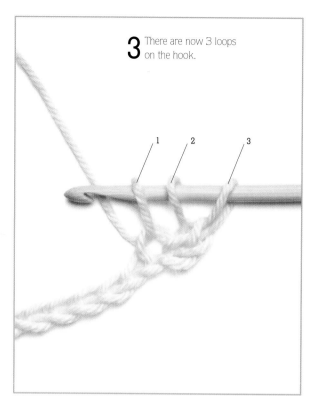

1 2 3

4 Yrh and draw a loop through all 3 loops on the hook as shown by the large arrow. (This motion becomes more fluid with practice.)

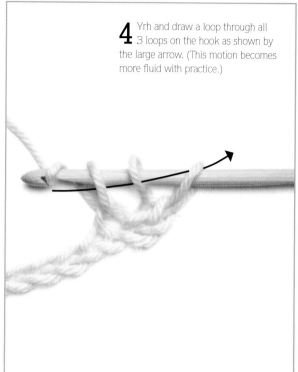

5 This completes the first half treble.

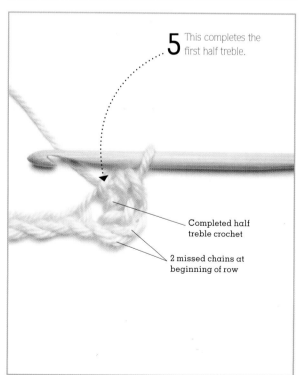

Completed half treble crochet

2 missed chains at beginning of row

6 Work one half treble crochet into each chain in the same way. Remember to start each half treble by wrapping the yarn around the hook before inserting it through the chain.

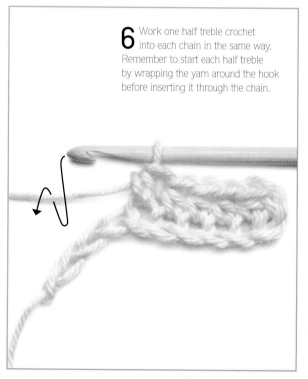

7 After working a half treble crochet into the last chain, turn the work to position the yarn at the right edge of the piece of crochet ready to begin the second row.

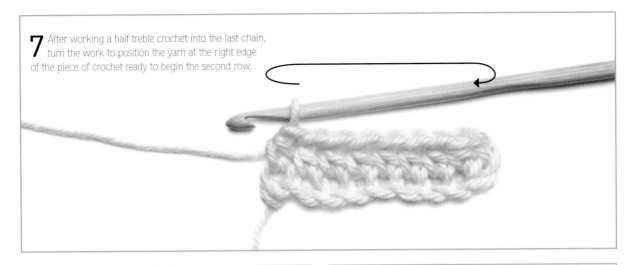

8 Begin the second row by making 2 chains. This turning chain brings the work up to the height of the half trebles that follow.

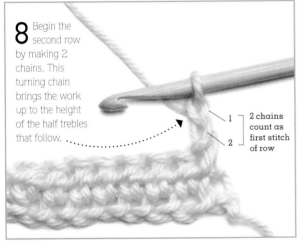

1
2
2 chains count as first stitch of row

9 Yrh and work the first half treble into the top of the second stitch in the row below.

Insert hook under both strands of top of stitch

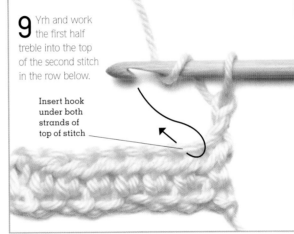

10 Work a half treble into each of the remaining half treble crochets in the row below. Work the following rows as for the second row.

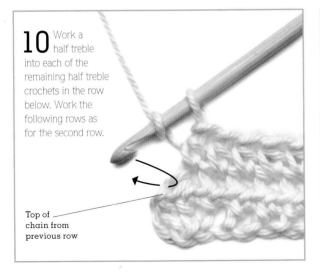

Top of chain from previous row

11 When the crochet is complete, cut the yarn. Remove the hook from the remaining loop, pass the yarn end through the loop, and pull tight to close the loop and fasten off securely.

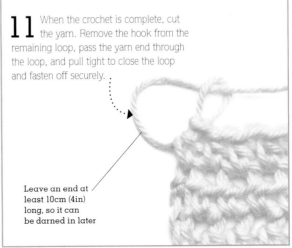

Leave an end at least 10cm (4in) long, so it can be darned in later

Treble crochet (Abbreviation = *tr*)

Treble crochet produces a more open and softer crochet fabric than the denser double and half treble crochet. Because treble crochet is a tall stitch, the fabric grows quickly as you proceed, which makes it the most popular of all crochet stitches.

As you work treble crochet in rows, you will see that it looks identical on the front and the back.

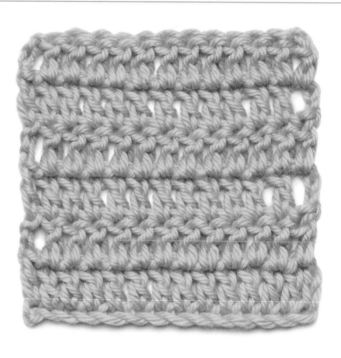

1 Make as many chains as required (see p.34). To begin the first stitch, wrap the yarn around the hook (yrh).

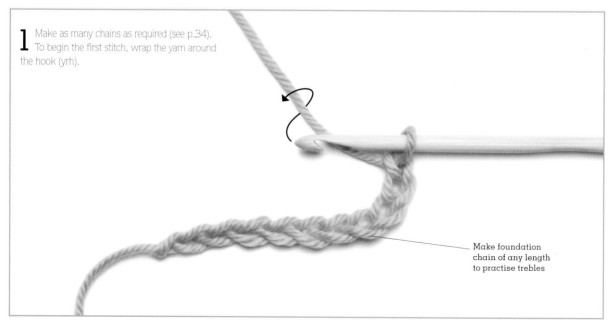

Make foundation chain of any length to practise trebles

2 Insert the hook through the fourth chain from the hook, yrh again (as shown by the large arrow), and draw a loop back through the chain.

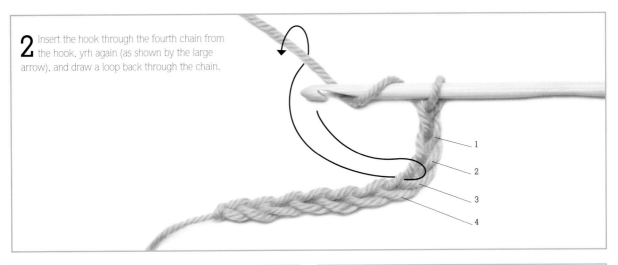

1
2
3
4

3 There are now 3 loops on the hook.

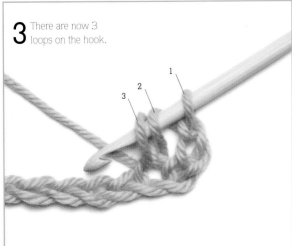

1
2
3

4 Yrh and draw a loop through the first 2 loops on the hook.

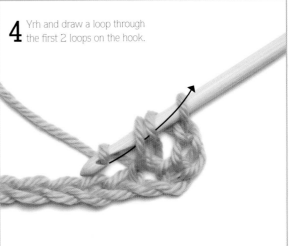

5 There are now 2 loops left on the hook. Yrh and draw a loop through the remaining 2 loops.

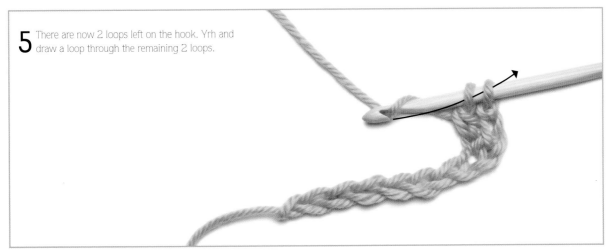

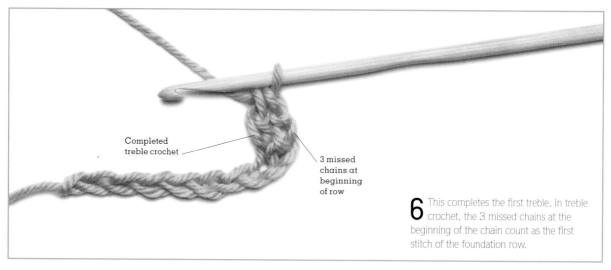

Completed treble crochet

3 missed chains at beginning of row

6 This completes the first treble. In treble crochet, the 3 missed chains at the beginning of the chain count as the first stitch of the foundation row.

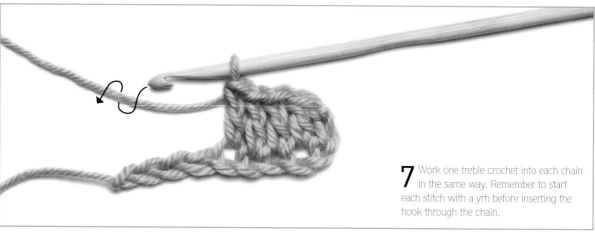

7 Work one treble crochet into each chain in the same way. Remember to start each stitch with a yrh before inserting the hook through the chain.

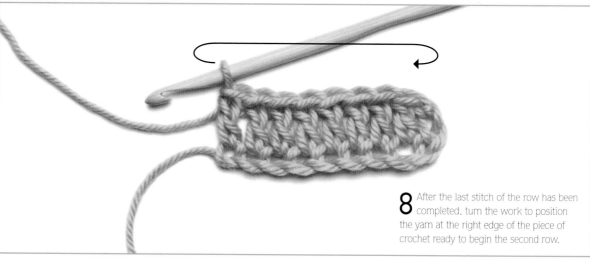

8 After the last stitch of the row has been completed, turn the work to position the yarn at the right edge of the piece of crochet ready to begin the second row.

9 To begin the second row of treble crochet, make 3 chain stitches. This brings the work up to the height of these tall stitches.

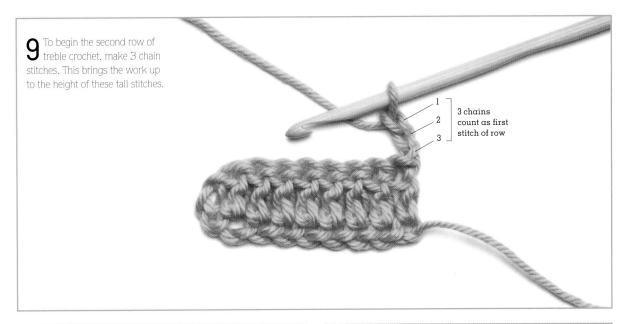

1
2
3
} 3 chains count as first stitch of row

10 Yrh, then, missing the first treble in the row below, work the first treble into the top of the second stitch.

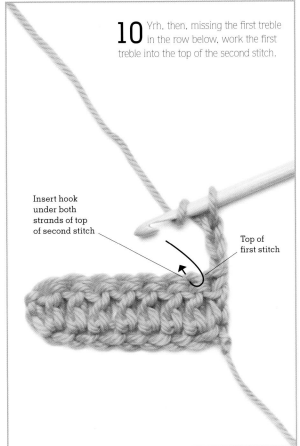

Insert hook under both strands of top of second stitch

Top of first stitch

11 Work a treble into each stitch, working the last stitch into the top of the 3 chains. Work the following rows in the same way.

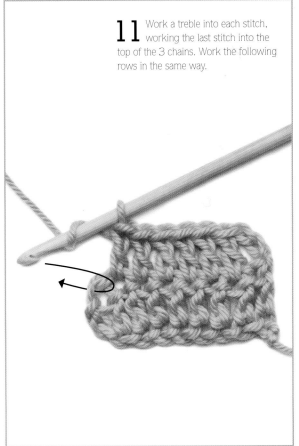

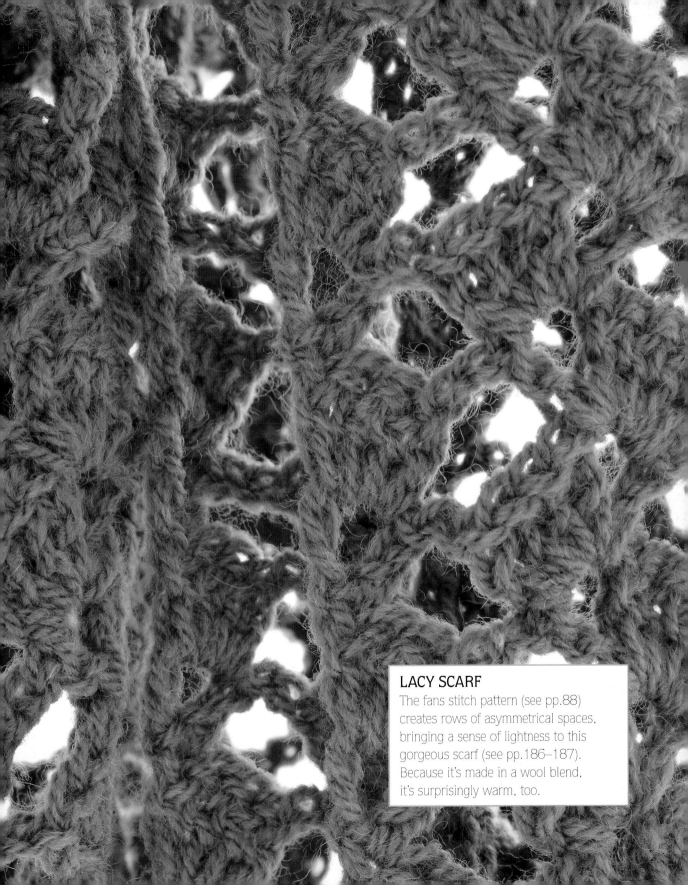

LACY SCARF

The fans stitch pattern (see pp.88) creates rows of asymmetrical spaces, bringing a sense of lightness to this gorgeous scarf (see pp.186–187). Because it's made in a wool blend, it's surprisingly warm, too.

Double treble crochet (Abbreviation = *dtr*)

Worked in a very similar way to treble crochet, double treble crochet stitches are approximately one chain length taller because the stitch is begun with two wraps instead of only one (see p.55). Double trebles are often used in lace crochet (see pp.84–88) and in crochet medallions (see pp.145–149).

Identical on the front and the back, double treble crochet worked in rows is even softer than treble crochet. It also grows more quickly because the stitches are taller but not that much slower to work.

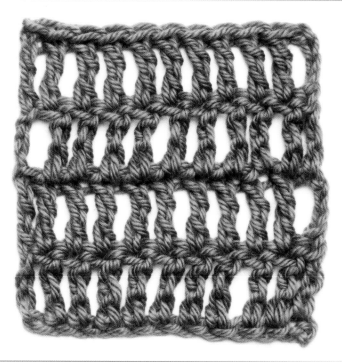

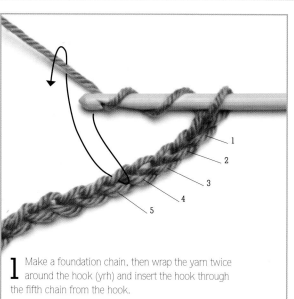

1 Make a foundation chain, then wrap the yarn twice around the hook (yrh) and insert the hook through the fifth chain from the hook.

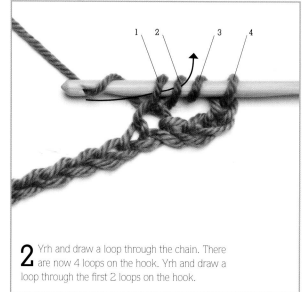

2 Yrh and draw a loop through the chain. There are now 4 loops on the hook. Yrh and draw a loop through the first 2 loops on the hook.

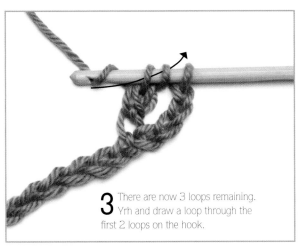

3 There are now 3 loops remaining. Yrh and draw a loop through the first 2 loops on the hook.

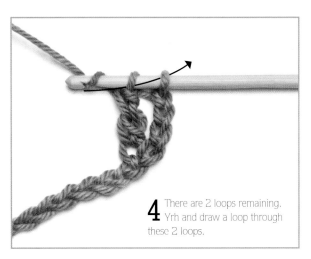

4 There are 2 loops remaining. Yrh and draw a loop through these 2 loops.

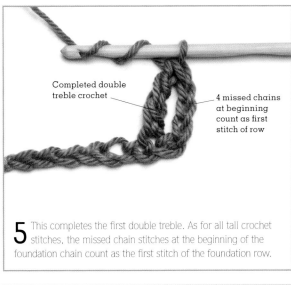

Completed double treble crochet

4 missed chains at beginning count as first stitch of row

5 This completes the first double treble. As for all tall crochet stitches, the missed chain stitches at the beginning of the foundation chain count as the first stitch of the foundation row.

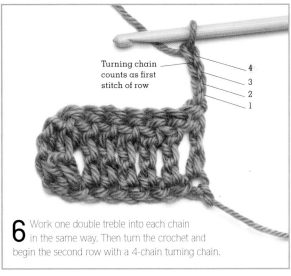

Turning chain counts as first stitch of row

4
3
2
1

6 Work one double treble into each chain in the same way. Then turn the crochet and begin the second row with a 4-chain turning chain.

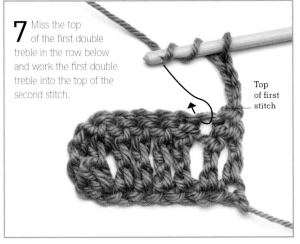

7 Miss the top of the first double treble in the row below and work the first double treble into the top of the second stitch.

Top of first stitch

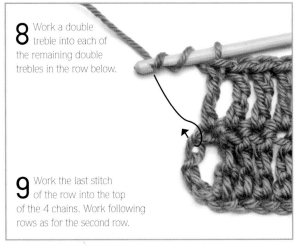

8 Work a double treble into each of the remaining double trebles in the row below.

9 Work the last stitch of the row into the top of the 4 chains. Work following rows as for the second row.

Triple treble crochet (Abbreviation = *trtr*)

Stitches taller than double trebles are all worked in the same way as double trebles, except that more wraps are wound around the hook before the stitch is begun and they require taller turning chains. Once you can work triple trebles easily, you will be able to work quadruple and quintuple trebles without much effort.

Triple treble crochet worked in rows looks the same on both sides of the fabric. Notice how airy the crochet texture becomes as the basic stitches get taller.

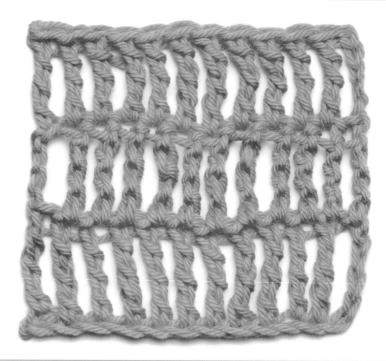

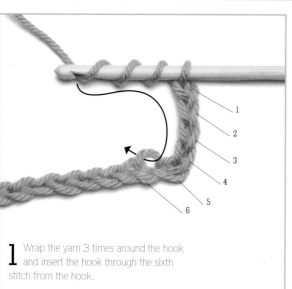

1 Wrap the yarn 3 times around the hook and insert the hook through the sixth stitch from the hook.

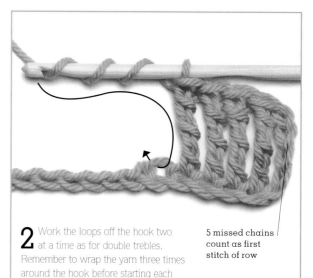

2 Work the loops off the hook two at a time as for double trebles. Remember to wrap the yarn three times around the hook before starting each stitch. Start following rows with 5 chains.

5 missed chains count as first stitch of row

Slip stitch (Abbreviation = ss)

Slip stitches are the shortest of all the crochet stitches. Although they can be worked in rows, the resulting fabric is so dense that it is only really suitable for bag handles. However, slip stitches appear very frequently in crochet instructions – to join on new yarn (see p.54), to work invisibly along the top of a row to move to a new position (see p.111), and to join rounds in circular crochet.

WORKING SLIP STITCH AS A FABRIC

1 Make a foundation chain of the required length. To begin the first stitch, insert the hook through the second chain from the hook, passing the hook under only one strand of the chain. Then wrap the yarn around the hook (yrh).

2 Holding the base of the chain firmly with the fingers of your left hand and tensioning the yarn (see p.33), draw a loop back through the chain and through the loop on the hook as shown by the large arrow.

3 Continue across the foundation chain, working a slip stitch into each chain in the same way. Always work slip stitches fairly loosely for whatever purpose you are using them.

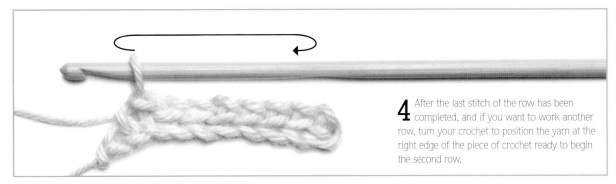

4 After the last stitch of the row has been completed, and if you want to work another row, turn your crochet to position the yarn at the right edge of the piece of crochet ready to begin the second row.

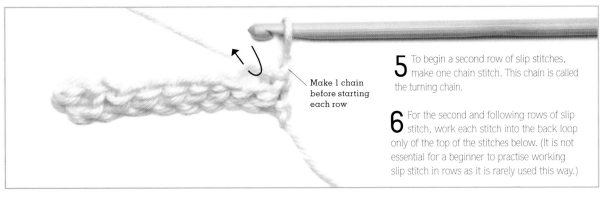

Make 1 chain before starting each row

5 To begin a second row of slip stitches, make one chain stitch. This chain is called the turning chain.

6 For the second and following rows of slip stitch, work each stitch into the back loop only of the top of the stitches below. (It is not essential for a beginner to practise working slip stitch in rows as it is rarely used this way.)

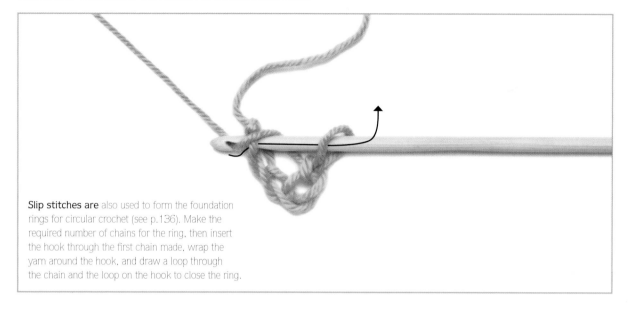

Slip stitches are also used to form the foundation rings for circular crochet (see p.136). Make the required number of chains for the ring, then insert the hook through the first chain made, wrap the yarn around the hook, and draw a loop through the chain and the loop on the hook to close the ring.

Fastening off chains and slip stitches

Stopping your crochet when it is complete is called fastening off. As there is only one loop on your hook, the process is extremely simple. Here is a visual aid for how to fasten off a length of chains or a row of slip stitches. The principle is the same for all stitches.

FASTENING OFF A LENGTH OF CHAINS

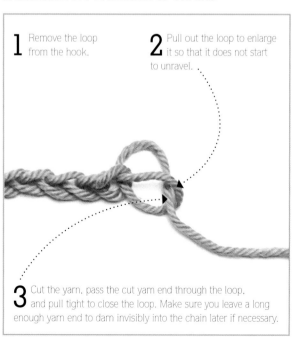

1 Remove the loop from the hook.

2 Pull out the loop to enlarge it so that it does not start to unravel.

3 Cut the yarn, pass the cut yarn end through the loop, and pull tight to close the loop. Make sure you leave a long enough yarn end to darn invisibly into the chain later if necessary.

FASTENING OFF SLIP STITCHES

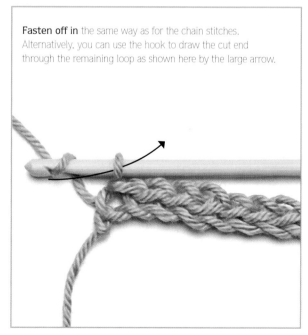

Fasten off in the same way as for the chain stitches. Alternatively, you can use the hook to draw the cut end through the remaining loop as shown here by the large arrow.

Beginner's tips

It is important to learn how to count stitches so you can make sure you retain the same number as your crochet grows. Two other essential techniques are how to join on a new ball of yarn and how to darn in yarn ends (see p.54) when your piece of crochet is complete.

COUNTING CROCHET STITCHES

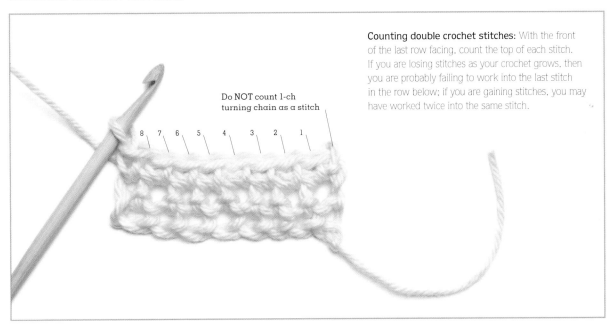

Do NOT count 1-ch turning chain as a stitch

8 7 6 5 4 3 2 1

Counting double crochet stitches: With the front of the last row facing, count the top of each stitch. If you are losing stitches as your crochet grows, then you are probably failing to work into the last stitch in the row below; if you are gaining stitches, you may have worked twice into the same stitch.

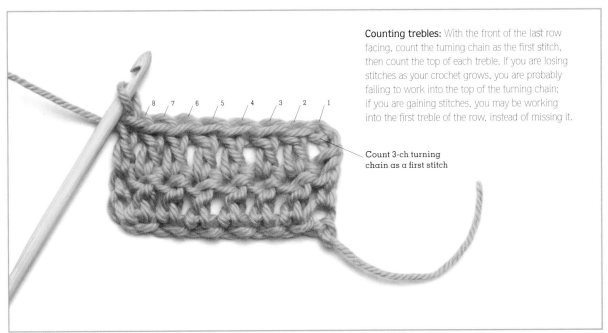

8 7 6 5 4 3 2 1

Counting trebles: With the front of the last row facing, count the turning chain as the first stitch, then count the top of each treble. If you are losing stitches as your crochet grows, you are probably failing to work into the top of the turning chain; if you are gaining stitches, you may be working into the first treble of the row, instead of missing it.

Count 3-ch turning chain as a first stitch

JOINING ON NEW YARN

Method one: Always join on a new yarn at the beginning of a row if possible. Simply drop the old yarn and pull the new yarn through the loop on the hook, then begin the row in the usual way. Darn in the yarn ends later.

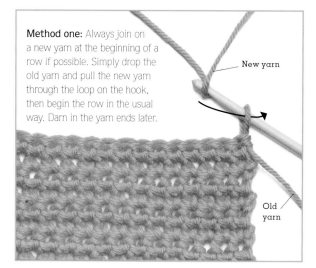

New yarn

Old yarn

Method two: This method is suitable for both stripes and plain crochet fabrics. First, fasten off the old yarn. Then place a slip knot on the hook, insert the hook through the first stitch of the row and draw a loop through the top of the stitch and the loop on the hook.

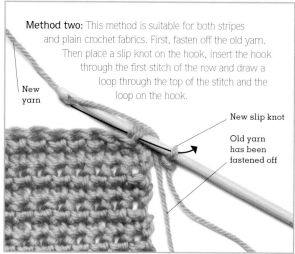

New yarn

New slip knot

Old yarn has been fastened off

DARNING IN YARN

Darning in along top row: Using a blunt-ended yarn needle, darn the yarn end through the centre of the base of 6–8 stitches in the last row. Clip off the remaining end close to the fabric.

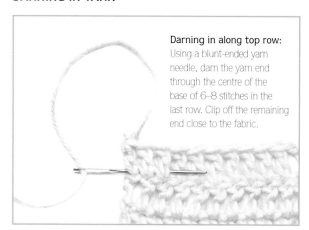

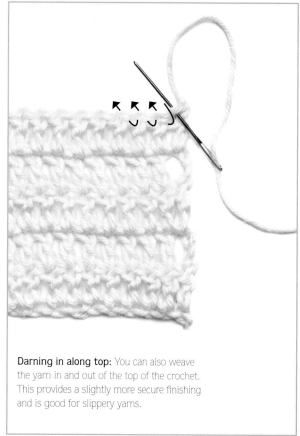

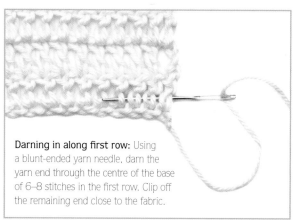

Darning in along first row: Using a blunt-ended yarn needle, darn the yarn end through the centre of the base of 6–8 stitches in the first row. Clip off the remaining end close to the fabric.

Darning in along top: You can also weave the yarn in and out of the top of the crochet. This provides a slightly more secure finishing and is good for slippery yarns.

Basic stitches in symbols and abbreviations

Crochet row instructions can be written out with abbreviations or using symbols for the stitches. There is a more detailed explanation for reading stitch pattern instructions on pp.66–67, but directions for the basic stitches are given in this section in both symbols and abbreviations. This provides an introduction to crochet instructions and a quick reference for how to work crochet fabrics with basic stitches. Please note that left-handed crocheters will need to work the diagram backwards.

STITCH HEIGHTS

The diagram on the right shows all the basic stitches in symbols and illustrates approximately how tall the stitches are when standing side by side. A double crochet is roughly one chain tall, a half treble crochet two chains tall, a treble crochet three chains tall, and so on. These heights determine the number of turning chains you need to work at the beginning of each row for each of the basic stitches. Also provided here is a reference for which chain to work into when working the first stitch into the foundation chain.

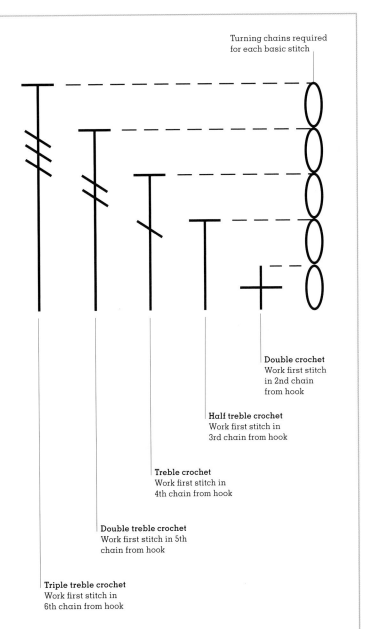

Turning chains required for each basic stitch

Double crochet
Work first stitch in 2nd chain from hook

Half treble crochet
Work first stitch in 3rd chain from hook

Treble crochet
Work first stitch in 4th chain from hook

Double treble crochet
Work first stitch in 5th chain from hook

Triple treble crochet
Work first stitch in 6th chain from hook

DOUBLE CROCHET INSTRUCTIONS

Crochet symbol instructions, especially for the basic stitches, are super-easy to understand. Roughly imitating the size and shape of the stitch, the symbols are read from the bottom of the diagram upwards. To get used to very simple crochet instructions, try working double crochet following the written directions and the symbol diagram at the same time (see p.68 for abbreviations list), then try this with the other basic stitches as well.

DOUBLE CROCHET IN ABBREVIATIONS
Make any number of ch.
Row 1 1 dc in 2nd ch from hook, 1 dc in each of rem ch to end, turn.
Row 2 1 ch (does NOT count as a st), 1 dc in each dc to end, turn.
Rep row 2 to form dc fabric.

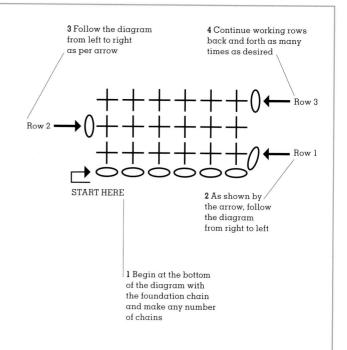

3 Follow the diagram from left to right as per arrow

4 Continue working rows back and forth as many times as desired

Row 3

Row 2 →

Row 1

START HERE

2 As shown by the arrow, follow the diagram from right to left

1 Begin at the bottom of the diagram with the foundation chain and make any number of chains

HALF TREBLE CROCHET INSTRUCTIONS

The symbol for half treble is a vertical line with a horizontal bar at the top, and it is about twice as tall as the double crochet symbol, just like the stitch is in reality. Read the written instructions for this basic stitch (below) and look at the chart at the same time. The direction of each arrow indicates whether to read the chart from left to right or right to left.

HALF TREBLE CROCHET IN ABBREVIATIONS
Make any number of ch.
Row 1 1 htr in 3rd ch from hook, 1 htr in each of rem ch to end, turn.
Row 2 2 ch (counts as first st), miss first htr in row below, *1 htr in next htr; rep from * to end, then work 1 htr in top of 2-ch at end, turn.
Rep row 2 to form htr fabric.

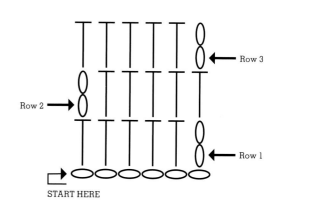

Row 3

Row 2 →

Row 1

START HERE

TREBLE CROCHET INSTRUCTIONS

The treble symbol has a short diagonal line across its "waist". The diagram shows clearly how the 3 chain turning chain counts as the first stitch of each row.

TREBLE CROCHET IN ABBREVIATIONS

Make any number of ch.
Row 1 1 tr in 4th ch from hook, 1 tr in each of rem ch to end, turn.
Row 2 3 ch (counts as first tr), miss first tr in row below, *1 tr in next tr; rep from * to end, then work 1 tr in top of 3-ch at end, turn.
Rep row 2 to form tr fabric.

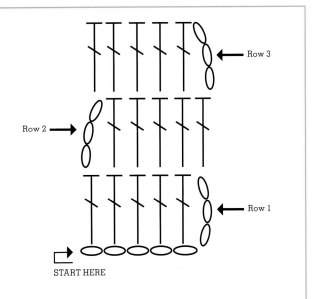

DOUBLE TREBLE CROCHET INSTRUCTIONS

Two short diagonal lines cross the "waist" of the double treble symbol, echoing the two diagonal yarn strands on the stitch itself.

DOUBLE TREBLE CROCHET IN ABBREVIATIONS

Make any number of ch.
Row 1 1 dtr in 5th ch from hook, 1 dtr in each of rem ch to end, turn.
Row 2 4 ch (counts as first dtr), miss first dtr in row below, *1 dtr in next dtr; rep from * to end, then work 1 dtr in top of 4-ch at end, turn.
Rep row 2 to form dtr fabric.

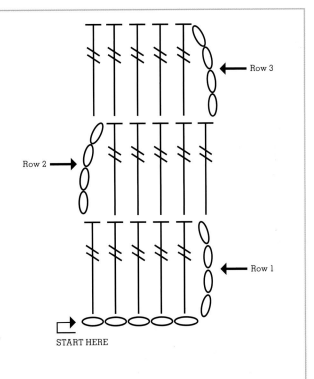

Stitch techniques

The basic crochet stitches can be combined in various ways to create endless textures and sculptured effects. Not all the vast range of crochet stitch techniques can be included, but the most commonly used are explained here in detail. When attempting the stitch patterns on pp.70–76, refer back to these step-by-step instructions to see more clearly how to achieve the textures.

Simple textures

The simplest and most subtle crochet textures are created by working into various parts of the stitches or between the stitches in the row below. Before trying out any of these techniques, learn about the parts of the stitches so you can identify them easily.

PARTS OF STITCHES

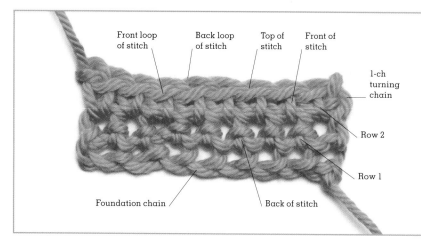

Front loop of stitch — Back loop of stitch — Top of stitch — Front of stitch — 1-ch turning chain — Row 2 — Row 1 — Back of stitch — Foundation chain

Double crochet stitches: Work two rows of double crochet (see pp.36–38) and fasten off. Look closely at your sample and make sure you can identify all the parts of the stitch labelled on the left. If your crochet pattern tells you to work into the stitch below, always insert the hook under BOTH loops (the front loop and the back loop) at the top of the stitch as explained on p.38 for double crochet, unless it tells you to do otherwise.

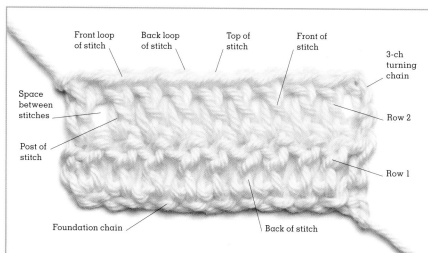

Front loop of stitch — Back loop of stitch — Top of stitch — Front of stitch — 3-ch turning chain — Row 2 — Row 1 — Space between stitches — Post of stitch — Foundation chain — Back of stitch

Treble crochet stitches: Work two rows of treble crochet (see pp.42–45) and fasten off. Again, make sure you can identify all the parts of the stitch labelled on the left. As for double crochet and all other crochet stitches, if your crochet pattern tells you to work into the stitch below, always insert the hook under both loops at the top of the stitch, unless it tells you to do otherwise.

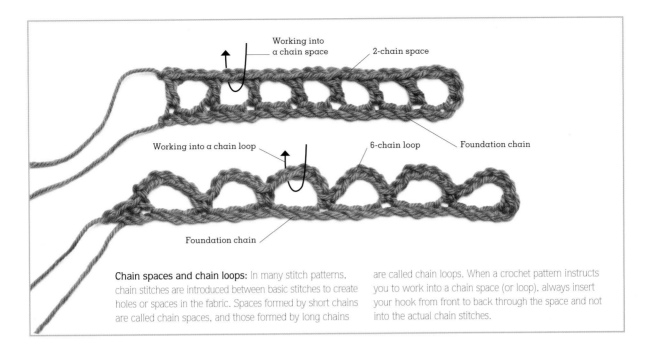

Working into a chain space

2-chain space

Working into a chain loop

6-chain loop

Foundation chain

Foundation chain

Chain spaces and chain loops: In many stitch patterns, chain stitches are introduced between basic stitches to create holes or spaces in the fabric. Spaces formed by short chains are called chain spaces, and those formed by long chains are called chain loops. When a crochet pattern instructs you to work into a chain space (or loop), always insert your hook from front to back through the space and not into the actual chain stitches.

WORKING INTO THE BACK LOOP OF A DOUBLE CROCHET

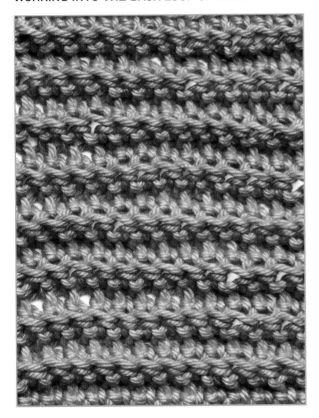

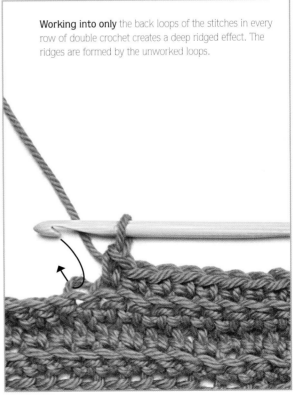

Working into only the back loops of the stitches in every row of double crochet creates a deep ridged effect. The ridges are formed by the unworked loops.

WORKING INTO THE FRONT LOOP OF A DOUBLE CROCHET

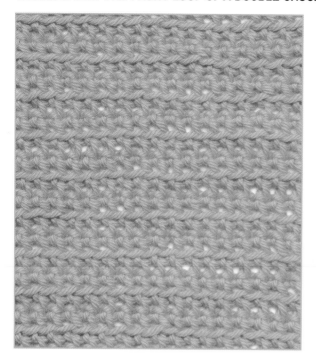

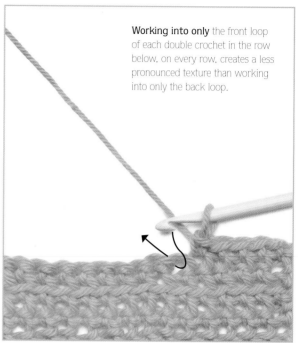

Working into only the front loop of each double crochet in the row below, on every row, creates a less pronounced texture than working into only the back loop.

WORKING INTO THE BACK LOOP OF A TREBLE CROCHET

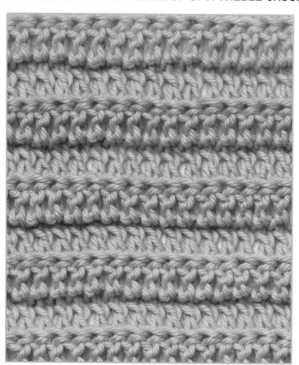

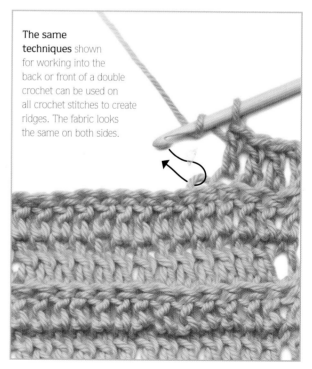

The same techniques shown for working into the back or front of a double crochet can be used on all crochet stitches to create ridges. The fabric looks the same on both sides.

WORKING INTO SPACES BETWEEN STITCHES

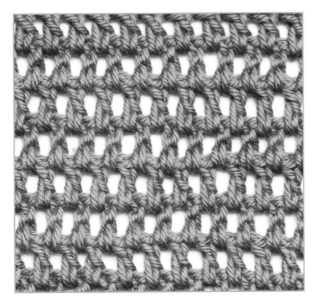

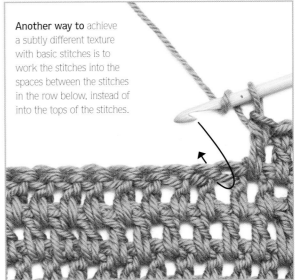

Another way to achieve a subtly different texture with basic stitches is to work the stitches into the spaces between the stitches in the row below, instead of into the tops of the stitches.

WORKING INTO A CHAIN SPACE

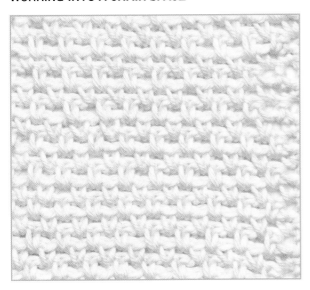

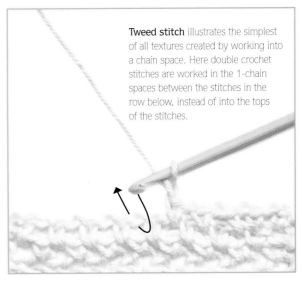

Tweed stitch illustrates the simplest of all textures created by working into a chain space. Here double crochet stitches are worked in the 1-chain spaces between the stitches in the row below, instead of into the tops of the stitches.

Tweed stitch pattern

Because it is such a popular stitch and a perfect alternative for basic double crochet, the pattern for it is given here. (See pp.68–69 for abbreviations.) Start with an even number of chains.

Row 1 1 dc in 2nd ch from hook, *1 ch, miss next ch, 1 dc in next ch; rep from * to end, turn.
Row 2 1 ch (does NOT count as a stitch), 1 dc in first dc, 1 dc in next 1-ch sp, *1 ch, 1 dc in next 1-ch sp; rep from * to last dc, 1 dc in last dc, turn.
Row 3 1 ch (does NOT count as a stitch), 1 dc in first dc, *1 ch, 1 dc in next 1-ch sp; rep from * to last 2 dc, 1 ch, miss next dc, 1 dc in last dc, turn.
Rep rows 2 and 3 to form patt.

Sculptural textures

These easy raised and grouped crochet stitch techniques produce attractive sculptural textures. Although they can be used to create fairly dense stitch patterns (see pp.70–76), they are also found in lace stitches (see pp.84–88).

FRONT POST TREBLE

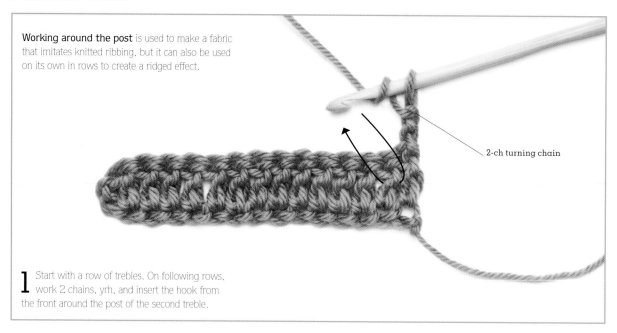

Working around the post is used to make a fabric that imitates knitted ribbing, but it can also be used on its own in rows to create a ridged effect.

2-ch turning chain

1 Start with a row of trebles. On following rows, work 2 chains, yrh, and insert the hook from the front around the post of the second treble.

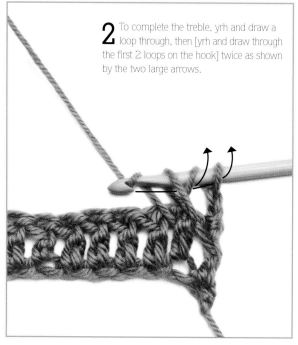

2 To complete the treble, yrh and draw a loop through, then [yrh and draw through the first 2 loops on the hook] twice as shown by the two large arrows.

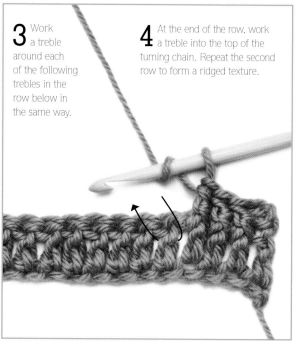

3 Work a treble around each of the following trebles in the row below in the same way.

4 At the end of the row, work a treble into the top of the turning chain. Repeat the second row to form a ridged texture.

BACK POST TREBLE

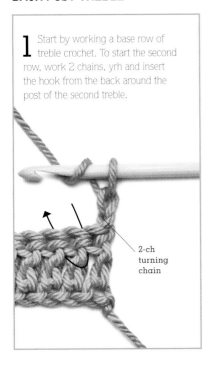

1 Start by working a base row of treble crochet. To start the second row, work 2 chains, yrh and insert the hook from the back around the post of the second treble.

2-ch turning chain

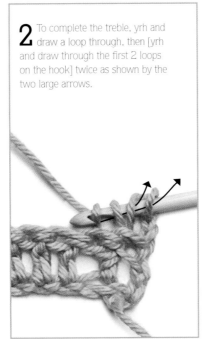

2 To complete the treble, yrh and draw a loop through, then [yrh and draw through the first 2 loops on the hook] twice as shown by the two large arrows.

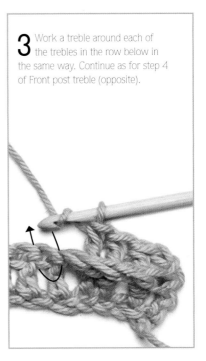

3 Work a treble around each of the trebles in the row below in the same way. Continue as for step 4 of Front post treble (opposite).

SHELLS

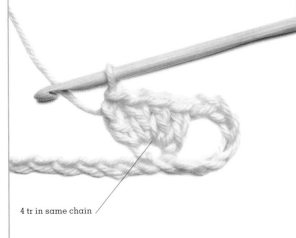

4-tr shell: Shells are the most frequently used of all crochet stitch techniques. Usually made with trebles, they are formed by working several stitches into the same stitch or space. Here 4 trebles have been worked into the same chain to form a 4-tr shell.

4 tr in same chain

5-tr shell: Here 5 trebles have been worked into the same chain to form a 5-tr shell. Any number of trebles can be used to form a shell, but the most commonly used crochet shells have 2, 3, 4, 5, or 6 stitches. Shells can also be made with half trebles and taller basic stitches.

5 tr in same chain

BOBBLES

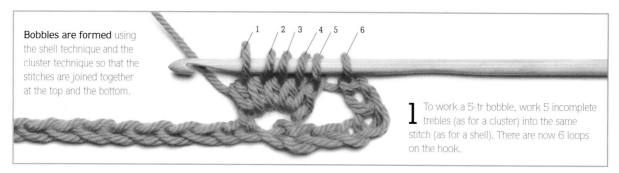

Bobbles are formed using the shell technique and the cluster technique so that the stitches are joined together at the top and the bottom.

1 To work a 5-tr bobble, work 5 incomplete trebles (as for a cluster) into the same stitch (as for a shell). There are now 6 loops on the hook.

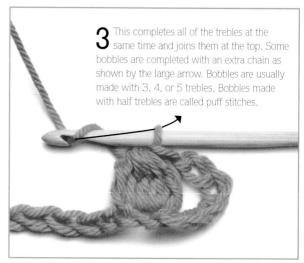

2 Wrap the yarn around the hook and draw a loop through all 6 loops on the hook.

3 This completes all of the trebles at the same time and joins them at the top. Some bobbles are completed with an extra chain as shown by the large arrow. Bobbles are usually made with 3, 4, or 5 trebles. Bobbles made with half trebles are called puff stitches.

CLUSTERS

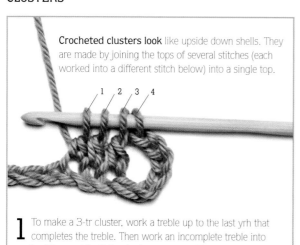

Crocheted clusters look like upside down shells. They are made by joining the tops of several stitches (each worked into a different stitch below) into a single top.

1 To make a 3-tr cluster, work a treble up to the last yrh that completes the treble. Then work an incomplete treble into each of the next 2 stitches in the same way. There are now 4 loops on the hook.

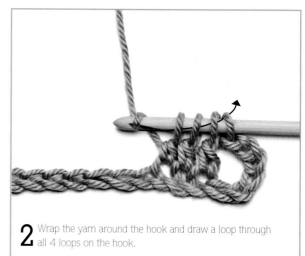

2 Wrap the yarn around the hook and draw a loop through all 4 loops on the hook.

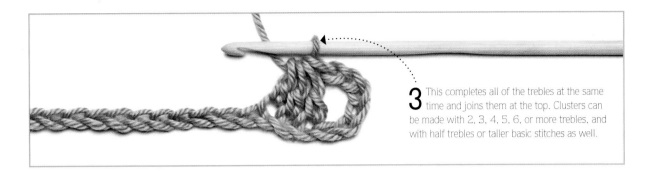

3 This completes all of the trebles at the same time and joins them at the top. Clusters can be made with 2, 3, 4, 5, 6, or more trebles, and with half trebles or taller basic stitches as well.

POPCORNS

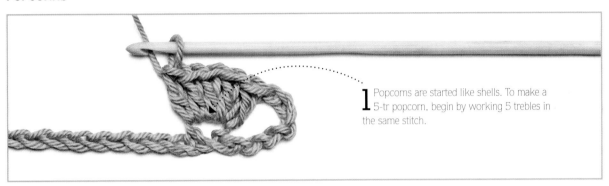

1 Popcorns are started like shells. To make a 5-tr popcorn, begin by working 5 trebles in the same stitch.

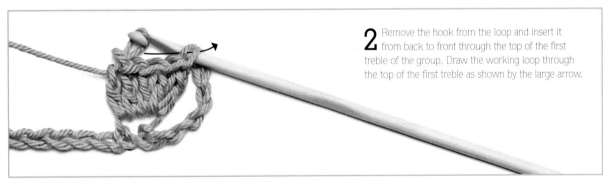

2 Remove the hook from the loop and insert it from back to front through the top of the first treble of the group. Draw the working loop through the top of the first treble as shown by the large arrow.

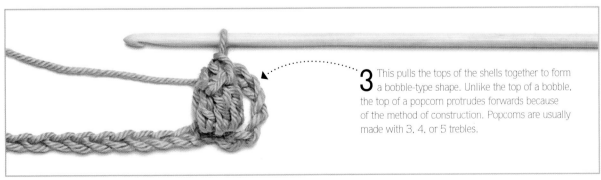

3 This pulls the tops of the shells together to form a bobble-type shape. Unlike the top of a bobble, the top of a popcorn protrudes forwards because of the method of construction. Popcorns are usually made with 3, 4, or 5 trebles.

Following simple stitch patterns

Working a project from a crochet pattern for the first time can seem difficult for a beginner, especially if an experienced crocheter is not at hand as a guide. The best way to prepare for a crochet pattern is to first practise crocheting rectangles of various stitch patterns using simple stitch techniques. This is a good introduction to following abbreviated written row instructions and symbol diagrams.

UNDERSTANDING WRITTEN INSTRUCTIONS

As long as you know how to work all the basic stitches and can work them from the simple patterns on pp.55–57 and have reviewed pp.58–65 where special stitch techniques are explained, there is nothing stopping you from trying to work the simple textures stitch patterns on pp.70–73 and p.76. Simply consult the list on pp.68–69 for the meanings of the various abbreviations and follow the written row instructions one step at a time.

Begin by making the required number of chains for the foundation chain, using your chosen yarn and one of the hook sizes recommended for this yarn weight

on pp.18–19. Crochet a swatch that repeats the pattern only a few times to test it out. (If you decide to make a blanket or cushion cover with the stitch later, you can adjust the hook size before starting it to obtain the exact flexibility of fabric you desire.)

Work each row of the stitch pattern slowly and mark the right side of the fabric (if there is one) as soon as you start, by tying a contrasting coloured thread to it. Another good tip is to tick off the rows as you complete them or put a sticky note under them so you don't lose your place in the pattern. If you do get lost in all the stitches, pull out all the rows and start from the foundation chain again.

UNDERSTANDING STITCH SYMBOL DIAGRAMS

Crochet stitch patterns can also be given in symbols (see p.69). These diagrams are usually even easier to follow than directions with abbreviations because they create a visual reference of approximately how the finished stitch will look. Each basic stitch on the chart is represented by a symbol that resembles it in some way. The position of the base of each stitch symbol indicates which stitch or chain space it is worked into in the row below. If the symbols are joined at the base, this means that they are worked into the same stitch in the row below.

The beginning of the foundation chain will be marked as your starting point on the diagram. Read each row on the diagram either from right to left or left to right following the direction of the arrow. Although you can consult the written instructions for

how many chains to make for a foundation chain and how to repeat the stitch repeat across a row (or a row repeat up the fabric), it is easy to work these out yourself from the diagram once you become proficient in reading diagrams. But to begin with, work from the written instructions and use the diagram as a visual aid. Once you have completed the first few rows of the pattern, you can dispense with the written instructions altogether and continue with the diagram as your sole guide. If the stitch is an easy one, you will very quickly be able to work it without looking at any instructions at all.

This symbol diagram for the open shell stitch (see p.85) is a good introduction to working from a symbol diagram. Start at the bottom of the diagram and follow it row by row with the aid of the numbered tips.

SAMPLE STITCH PATTERN

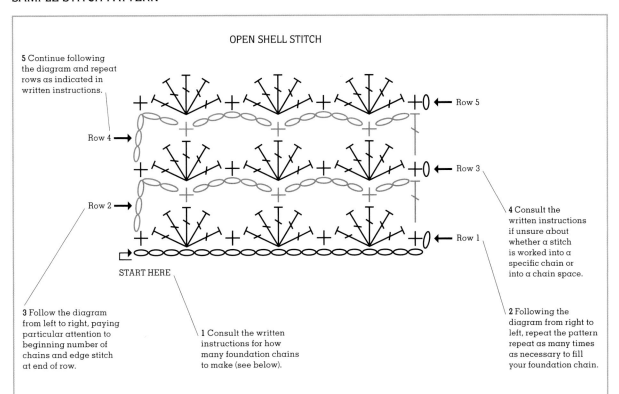

OPEN SHELL STITCH

5 Continue following the diagram and repeat rows as indicated in written instructions.

Row 5

Row 4 →

Row 3

Row 2 →

4 Consult the written instructions if unsure about whether a stitch is worked into a specific chain or into a chain space.

Row 1

START HERE

3 Follow the diagram from left to right, paying particular attention to beginning number of chains and edge stitch at end of row.

1 Consult the written instructions for how many foundation chains to make (see below).

2 Following the diagram from right to left, repeat the pattern repeat as many times as necessary to fill your foundation chain.

CROCHET INSTRUCTIONS

Make a multiple of 6 ch, plus 2 extra.

Row 1 (RS) 1 dc in 2nd ch from hook, *miss next 2 ch, 5 tr in next ch, miss next 2 ch, 1 dc in next ch; rep from * to end, turn.

Row 2 5 ch (counts as first tr and a 2-ch sp), 1 dc in centre tr of first shell, *5 ch, 1 dc in centre tr of next shell; rep from *, ending with 2 ch, 1 tr in last dc, turn.

Row 3 1 ch (does NOT count as a st), 1 dc in first tr, *5 tr in next dc, 1 dc in next 5-ch loop; rep from * working last dc of last rep in 3rd ch from last dc, turn.

Rep rows 2 and 3 to form patt.

CROCHET TERMINOLOGY

The following terms are commonly used in crochet patterns. Many crochet terms are the same in the UK and the US, but where they differ, the US equivalent is given in parentheses. Turn to the pages indicated for how to work the various increases, decreases, or stitch techniques listed.

bobble: Several stitches worked into the same stitch in the row below and joined together at the top (see p.64).

cluster: Several stitches worked into different stitches in the row below, but joined together at the top (see p.64).

dc2tog (work 2 dc together): See pp.108–109. (US sc2tog)

dc3tog (work 3 dc together): [Insert hook in next st, yrh and draw a loop through] 3 times, yrh and draw through all 4 loops on hook – 2 sts decreased. (US sc3tog)

facing: Facing toward you as you're working.

fasten off: Cut the yarn and draw the yarn tail through the remaining loop on the hook (see p.52).

foundation chain: The base of chain stitches that the first row of crochet is worked onto.

foundation row: The first row of a piece of crochet (the row worked onto the foundation chain) is sometimes called the foundation row.

htr2tog (work 2 htr together): [Yrh and insert hook in next st, yrh and draw a loop through] twice, yrh and draw through all 5 loops on hook – 1 st decreased. (US hdc2tog)

htr3tog (work 3 htr together): [Yrh and insert hook in next st, yrh and draw a loop through] 3 times, yrh and draw through all 7 loops on hook – 2 sts decreased. (US hdc3tog)

miss a stitch: Do not work into the stitch, but go on to the next stitch. (US "skip" a stitch)

shell: Several stitches worked into the same stitch in the previous row or into the same chain space (see p.63).

pineapple: A bobble made with half trebles; also called a puff stitch.

popcorn: A type of bobble (see p.65).

puff stitch: See pineapple.

tr2tog (work 2 tr together): See pp.109–111. (US dc2tog)

tr3tog (work 3 tr together): [Yrh and insert hook in next st, yrh and draw a loop through, yrh and draw through first 2 loops on hook] 3 times, yrh and draw through all 4 loops on hook – 2 sts decreased. (US dc3tog)

turning chain: The chain/s worked at the beginning of the row (or round) to bring the hook up to the correct height for working the following stitches in the row (see p.55).

CROCHET ABBREVIATIONS

These are the abbreviations most commonly used in crochet patterns. The abbreviations for the basic stitches are listed first and the other abbreviations found in crochet patterns follow. Any special abbreviations in a crochet pattern will always be explained in the pattern.

Abbreviations for basic stitches

Note: The names for the basic crochet stitches differ in the UK and the US. This book uses UK crochet terminology, so if you have learned to crochet in the US, be sure to take note of the difference in terminology.

ch	chain	dtr	double treble (US treble crochet – tr)
ss	slip stitch		
dc	double crochet (US single crochet – sc)	trtr	triple treble (US double treble crochet – dtr)
htr	half treble (US half double crochet – hdc)	qtr	quadruple treble (US triple treble crochet – trtr)
tr	treble (US double crochet – dc)	quintr	quintuple treble (US quadruple treble – quadtr)

Other abbreviations

alt	alternate	dc3tog	see Crochet Terminology
beg	begin(ning)	dec	decreas(e)(ing)
cm	centimetre(s)	foll	follow(s)(ing)
cont	continu(e)(ing)	g	gram(s)
dc2tog	see Crochet Terminology	htr2tog	see Crochet Terminology

htr3tog	see Crochet Terminology	TFL	through front loop
in	inch(es)	tog	together
inc	increase(e)(ing)	tr2tog	see Crochet Terminology
m	metre(s)	tr3tog	see Crochet Terminology
mm	millimetre(s)	WS	wrong side
oz	ounce(s)	yd	yard(s)
patt(s)	pattern(s)	yrh	yarn round hook (US
rem	remain(s)(ing)		yarn over hook – yo)
rep	repeat(s)(ing)	*	Repeat instructions after asterisk or between
RS	right side		asterisks as many times as instructed.
sp	space(s)	[]	Repeat instructions inside square brackets
st(s)	stitch(es)		as many times as instructed.
TBL	through back loop		

CROCHET STITCH SYMBOLS

These are the symbols used in this book, but crochet symbols are not universal so always consult the key with your crochet instructions for those used in your pattern.

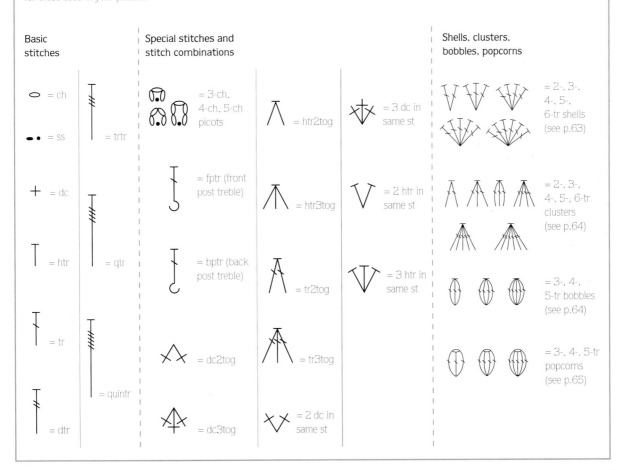

Basic stitches

Special stitches and stitch combinations

Shells, clusters, bobbles, popcorns

= ch
= ss
= dc
= htr
= tr
= dtr
= trtr
= qtr
= quintr
= 3-ch, 4-ch, 5-ch picots
= fptr (front post treble)
= bptr (back post treble)
= dc2tog
= dc3tog
= htr2tog
= htr3tog
= tr2tog
= tr3tog
= 2 dc in same st
= 3 dc in same st
= 2 htr in same st
= 3 htr in same st
= 2-, 3-, 4-, 5-, 6-tr shells (see p.63)
= 2-, 3-, 4-, 5-, 6-tr clusters (see p.64)
= 3-, 4-, 5-tr bobbles (see p.64)
= 3-, 4-, 5-tr popcorns (see p.65)

Simple textures stitch patterns

Selected for how easy they are to work, these stitch patterns cover an array of crochet textures, including those made using the techniques explained on pp.58–65. Although crochet is often identified with lacy openwork fabrics, there are also lots of solid textures like these to choose from. Quick to work and easy to memorize after the first few rows, the following stitches would make lovely cushion covers, baby blankets, or throws. They all look good on both sides of the fabrics and two of them are completely reversible (see Special Notes below).

SPECIAL NOTES

• Both written and symbol instructions are given for all the simple textures stitch patterns. To get started, beginners should follow the written instructions for the first few rows, referring to the symbols for clarification. See pp.68–69 for a list of crochet abbreviations and basic stitch symbols. The written instructions explain how many chains to start with and which rows to repeat to form the pattern. So if working from the diagram, be sure to read the written instructions first for guidance. If a special symbol is used in a diagram, this symbol is explained in the accompanying key. A complete explanation of how to read a crochet symbol diagram is included on pp.66–67.

• Where there is no right side or wrong side marked in the instructions of a stitch, it looks exactly the same on both sides

of the fabric. The crochet rib stitch (below) and the close shells stitch (opposite) are examples of this – they are completely reversible.

• Make a test swatch of your chosen stitch pattern before starting to make a cushion cover, baby blanket, or throw from any of these textured stitches. Try out various yarns to see which suits your purpose. Tightly spun yarns are the best for showing off the sculptural aspects of textured stitches. Keep in mind that dense crochet textures need not be stiff and unyielding. If your sample swatch is not soft and pliable enough, try working another swatch with a larger hook size to loosen up the fabric a little. For baby blankets, super-fine cotton or washable wool yarns are the most baby friendly.

CROCHET RIB STITCH

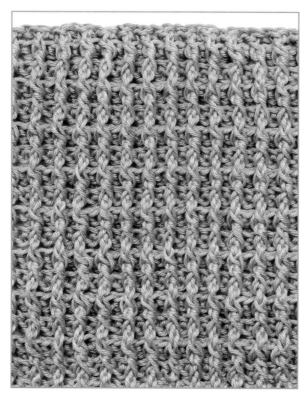

CROCHET DIAGRAM

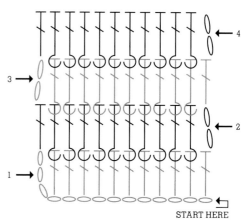

START HERE

CROCHET INSTRUCTIONS

Make a multiple of 2 ch.
Row 1 1 tr in 4th ch from hook, 1 tr in each of rem ch, turn.
Row 2 2 ch (counts as first st), miss first tr. *1 tr around post of next tr from front, 1 tr around post of next tr from back; rep from * to end, 1 tr in top of turning ch at end, turn.
Rep row 2 to form patt.

SIMPLE CROSSED STITCH

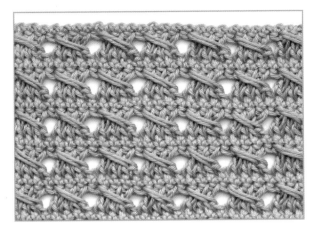

CROCHET DIAGRAM

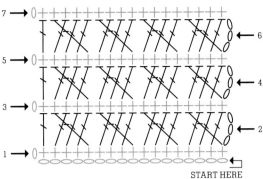

START HERE

CROCHET INSTRUCTIONS

Make a multiple of 4 ch, plus 2 extra.

Row 1 1 dc in 2nd ch from hook, 1 dc in each of rem ch, turn.

Row 2 (RS) 3 ch (counts as first tr), miss first dc, 1 tr in each of next 3 dc, yrh and insert hook from front to back in first dc (the missed dc), yrh and draw a long loop through (extending the loop so that it reaches back to position of work and does not squash 3-tr group just made), [yrh and draw through first 2 loops on hook] twice (called long tr), *miss next dc, 1 tr in each of next 3 dc, 1 long tr in last missed dc; rep from * to last dc, 1 tr in last dc, turn.

Row 3 1 ch (does NOT count as a st), 1 dc in each tr to end (do NOT work a dc in 3-ch turning chain), turn.

Rep rows 2 and 3 to form patt.

CLOSE SHELLS STITCH

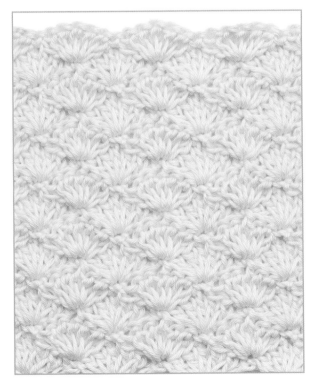

CROCHET DIAGRAM

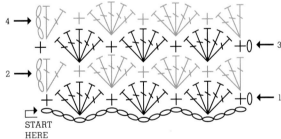

START HERE

CROCHET INSTRUCTIONS

Make a multiple of 6 ch, plus 2 extra.

Row 1 1 dc in 2nd ch from hook, *miss next 2 ch, 5 tr in next ch, miss next 2 ch, 1 dc in next ch; rep from * to end, turn.

Row 2 3 ch (counts as first tr), 2 tr in first dc, *miss next 2 tr, 1 dc in next tr, 5 tr in next dc (between shells); rep from *, ending last rep with 3 tr in last dc (instead of 5 tr), turn.

Row 3 1 ch (does NOT count as a st), 1 dc in first tr, *5 tr in next dc (between shells), miss next 2 tr, 1 dc in next tr; rep from *, working last dc in top of 3-ch at end, turn.

Rep rows 2 and 3 to form patt.

CLUSTER AND SHELL STITCH

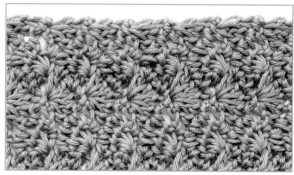

CROCHET DIAGRAM

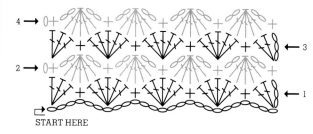

START HERE

CROCHET INSTRUCTIONS

Note: cluster (also called dc5tog) = over next 5 sts (which include 2 tr, 1 dc, 2 tr) work [yrh and insert hook in next st, yrh and draw a loop through, yrh and draw through first 2 loops on hook] 5 times (6 loops now on hook), yrh and draw through all 6 loops on hook (see pp.64–65).

Make a multiple of 6 ch, plus 4 extra.

Row 1 (RS) 2 tr in 4th ch from hook, miss next 2 ch, 1 dc in next ch, *miss next 2 ch, 5 tr in next ch, miss next 2 ch, 1 dc in next ch; rep from * to last 3 ch, miss next 2 ch, 3 tr in last ch, turn.

Row 2 1 ch (does NOT count as a st), 1 dc in first tr. *2 ch, 1 cluster over next 5 sts, 2 ch, 1 dc in next tr (centre tr of 5-tr group); rep from *, working last dc of last rep in top of 3-ch at end, turn.

Row 3 3 ch (counts as first tr), 2 tr in first dc, miss next 2 ch, 1 dc in next st (top of first cluster), *5 tr in next dc, miss next 2 ch, 1 dc in next st (top of next cluster); rep from *, ending with 3 tr in last dc, turn.

Rep rows 2 and 3 to form patt.

- -

SIMPLE BOBBLE STITCH

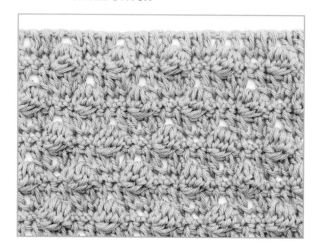

CROCHET DIAGRAM

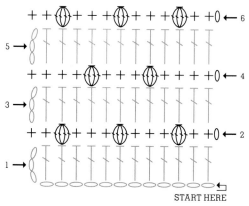

START HERE

CROCHET INSTRUCTIONS

Note: bobble = [yrh and insert hook in specified st, yrh and draw a loop through, yrh and draw through first 2 loops on hook] 4 times all in same st (5 loops now on hook), yrh and draw through all 5 loops on hook (see p.64).

Make a multiple of 4 ch, plus 3 extra.

Row 1 (WS) 1 tr in 4th ch from hook, 1 tr in each of rem ch, turn.

Row 2 (RS) 1 ch (does NOT count as a st), 1 dc in each of first 2 tr, *1 bobble in next tr, 1 dc in each of next 3 tr; rep from * to last 2 tr, 1 bobble in next tr, 1 dc in next tr, 1 dc in top of 3-ch at end, turn.

Row 3 3 ch (counts as first tr), miss first dc and work 1 tr in each st to end, turn.

Row 4 1 ch (does NOT count as a st), 1 dc in each of first 4 tr, *1 bobble in next tr, 1 dc in each of next 3 tr; rep from *, ending with 1 dc in top of 3-ch at end, turn.

Row 5 Rep row 3.

Rep rows 2–5 to form patt, ending with a patt row 5.

SHELLS AND CHAINS

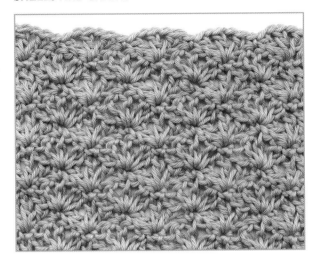

CROCHET DIAGRAM

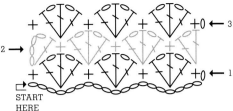

CROCHET INSTRUCTIONS

Make a multiple of 6 ch, plus 2 extra.

Row 1 (RS) 1 dc in 2nd ch from hook, *miss next 2 ch, work [1 tr, 1 ch, 1 tr, 1 ch, 1 tr] all in next ch, miss next 2 ch, 1 dc in next ch; rep from * to end, turn.

Row 2 4 ch (counts as 1 tr and a 1-ch sp), 1 tr in first dc, miss next tr, 1 dc in next tr (centre tr of shell). *work [1 tr, 1 ch, 1 tr, 1 ch, 1 tr] all in next dc (between shells), miss next tr, 1 dc in next tr (centre tr of shell); rep from *, ending with [1 tr, 1 ch, 1 tr] in last dc, turn.

Row 3 1 ch (does NOT count as a st), 1 dc in first tr, *work [1 tr, 1 ch, 1 tr, 1 ch, 1 tr] all in next dc, miss next tr, 1 dc in next tr (centre tr of shell); rep from *, working last dc of last rep in 3rd of 4-ch made at beg of previous row, turn.

Rep rows 2 and 3 to form patt.

POPCORN PATTERN STITCH

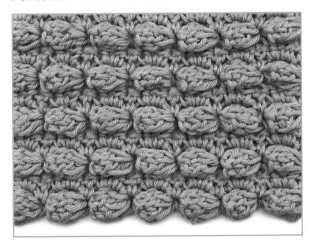

CROCHET DIAGRAM

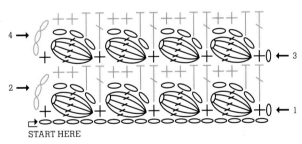

CROCHET INSTRUCTIONS

Note: popcorn = 5 tr all in same st, carefully remove loop from hook and insert it through top of first tr of this 5-tr group, pull loop (the one removed from hook) through first tr (see p.65).

Make a multiple of 4 ch, plus 2 extra.

Row 1 (RS) 1 dc in 2nd ch from hook. *3 ch, 1 popcorn in same place as last dc, miss next 3 ch, 1 dc in next ch; rep from * to end, turn.

Row 2 3 ch (counts as first tr), *work [2 dc, 1 htr] all in next 3-ch sp, 1 tr in next dc; rep from * to end, turn.

Row 3 1 ch (does NOT count as a st), 1 dc in first tr, *3 ch, 1 popcorn in same place as last dc, miss next 3 sts, 1 dc in next tr; rep from *, working last dc of last rep in top of 3-ch at end, turn.

Rep rows 2 and 3 to form patt.

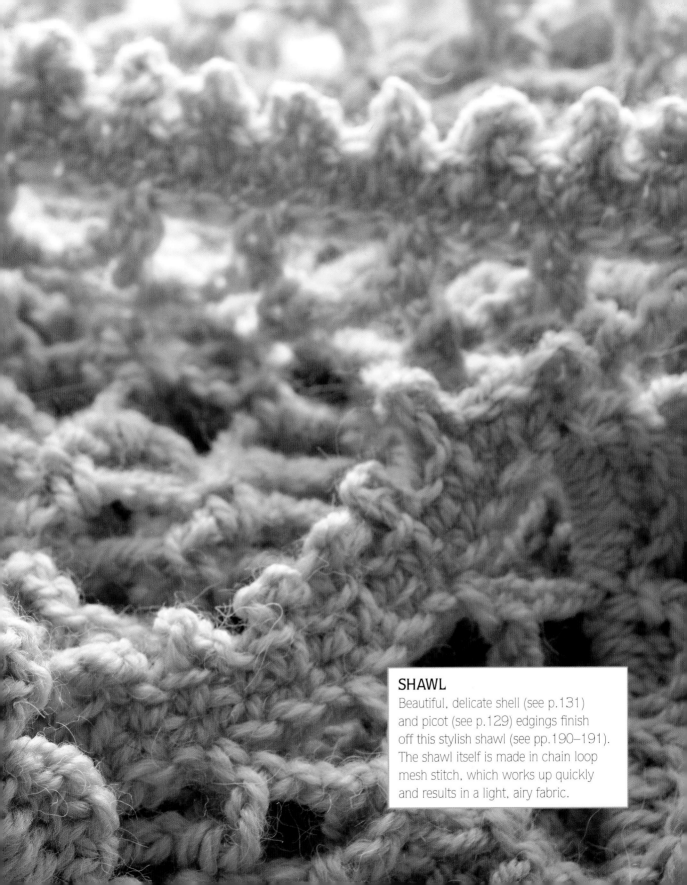

SHAWL

Beautiful, delicate shell (see p.131) and picot (see p.129) edgings finish off this stylish shawl (see pp.190–191). The shawl itself is made in chain loop mesh stitch, which works up quickly and results in a light, airy fabric.

SIMPLE PUFF STITCH

CROCHET DIAGRAM

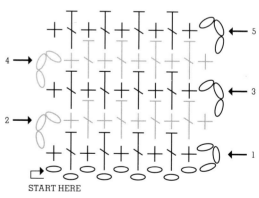

KEY

4-htr puff stitch

START HERE

CROCHET INSTRUCTIONS

Note: puff stitch = [yrh and insert hook in st] 4 times all in same st (9 loops now on hook), yrh and draw through all 9 loops on hook to complete 4-htr puff stitch.
Make a multiple of 2 ch.
Row 1 (RS) 1 dc in 2nd ch from hook, *1 ch, miss next ch, 1 dc in next ch; rep from * to end, turn.

Row 2 2 ch (counts as first htr), 1 puff st in first 1-ch sp, *1 ch, 1 puff st in next 1-ch sp; rep from *, ending with 1 htr in last dc, turn.
Row 3 1 ch (does NOT count as a st), 1 dc in first htr, *1 ch, 1 dc in next 1-ch sp; rep from *, working last dc of last rep in top of 2-ch at end, turn.
Rep rows 2 and 3 to form patt.

SIMPLE TEXTURE STITCH

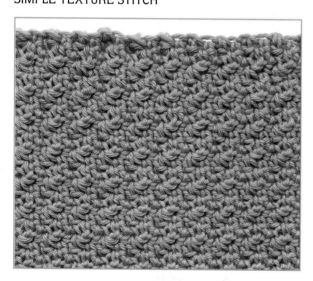

CROCHET DIAGRAM

(diagram)

START HERE

CROCHET INSTRUCTIONS

Make a multiple of 2 ch.
Row 1 (RS) 1 dc in 4th ch from hook, *1 tr in next ch, 1 dc in next ch; rep from * to end, turn.

Row 2 3 ch (counts as first tr), miss first dc, *1 dc in next tr, 1 tr in next dc; rep from *, ending with 1 dc in top of 3-ch at end, turn.
Rep row 2 to form patt.

Openwork

Whether worked with fine threads for lace collars, pillow edgings, and tablecloths or with soft wools for shawls, throws, and scarves, openwork crochet has an enduring appeal. As illustrated by the easy techniques on this page and the next, these airy lace textures are produced by working chain spaces and chain loops between the basic stitches.

Simple lace techniques

A few of the openwork stitch patterns on pp.84–88 are explained here to provide an introduction to some popular openwork crochet techniques – chain loops, shells, and picots. Refer to the instructions for the stitches when following the steps.

CHAIN LOOP MESH

1 After working the first row of chain loops into the foundation chain as explained (see p.84), work the 5-chain loops of the following rows into the loops below, joining them on with a dc as shown here.

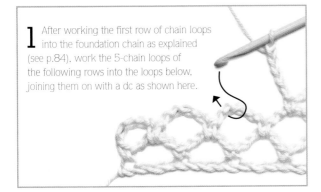

2 Remember to work the last dc of each row into the space inside the turning chain made at the beginning of the previous row. If you don't, your lace will become narrower.

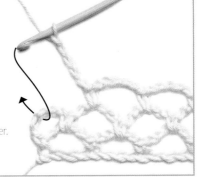

SHELL MESH STITCH

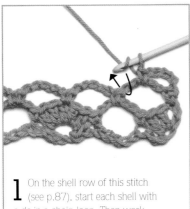

1 On the shell row of this stitch (see p.87), start each shell with a dc in a chain loop. Then work all the tr of the shell into a single dc as shown.

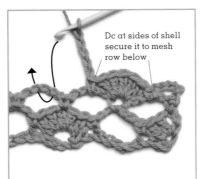

Dc at sides of shell secure it to mesh row below

2 Complete the shell with a dc worked into the following chain loop. Then work a chain loop and join it to the next chain loop with a dc as shown.

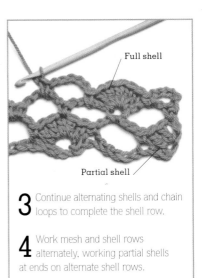

Full shell

Partial shell

3 Continue alternating shells and chain loops to complete the shell row.

4 Work mesh and shell rows alternately, working partial shells at ends on alternate shell rows.

PICOT NET STITCH

1 In this stitch pattern (see p.85), work 4 chains for each picot. Close the picot-ring by working a slip stitch in the fourth chain from the hook as shown.

2 Work 3 dc between each of the picots in each picot row as shown.

3 After each picot row, work a 2-chain space above each picot and a tr between the picots as shown.

Filet crochet

Filet crochet is the easiest of all the openwork techniques. Once you learn how to work the simple structure of the open filet mesh and the solid filet blocks, all you need to do is follow a simple chart to form the motifs and repeating patterns.

MAKING BASIC FILET MESH

When working the foundation chain for the basic filet mesh, there is no need to start with an exact number of chains, just make an extra long chain and unravel the unused excess later when finishing your crochet.

Filet mesh in symbols and words: The diagram provides the best explanation of how filet mesh is worked. If in doubt, work a mesh from the written pattern as follows: Make a multiple of 3 ch (3 ch for each mesh square needed), plus 5 extra (to form the right-side edge and top of the first mesh square of the first row).

Row 1 1 tr in 8th ch from hook. *2 ch, miss next 2 ch, 1 tr in next ch; rep from * to end.

Row 2 5 ch, miss first tr, 1 tr in next tr, *2 ch, 1 tr in next tr; rep from * working last tr in 3rd ch from last tr in row below.

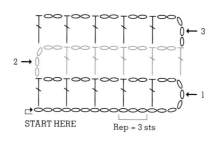

START HERE Rep = 3 sts

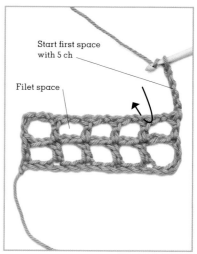

Start first space with 5 ch

Filet space

MAKING FILET BLOCKS

The pattern motifs on filet crochet are created by filling in some of the mesh squares and leaving others empty. In other words, the designs are built up with solid squares and square holes. Having learned how to work the filet mesh, understanding how to fill them in to form blocks is easy.

Filet blocks in symbols: The diagram illustrates how the blocks are made – instead of working 2 chains to form an empty square, work 2 trebles to fill in the square. An individual block consists of a treble on each side and 2 trebles in the centre. To work a block above a filet space, work the 2 centre trebles into the 2-chain space. To work a block above another block, work a treble into each of the trebles below.

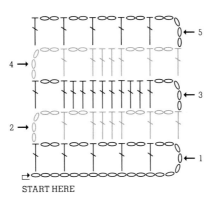

START HERE

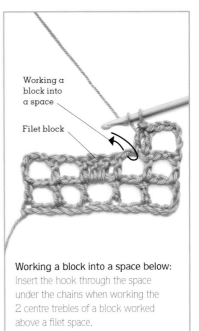

Working a block into a space

Filet block

Working a block into a space below: Insert the hook through the space under the chains when working the 2 centre trebles of a block worked above a filet space.

READING FILET CHARTS

This chart on the right shows the simple motif in the block symbol diagram above. Although actual filet charts are bigger and have elaborate patterns (see pp.80–83), the principle is the same as for this tiny chart. Each square on the chart represents either a filet space or a filet block. Please note that left-handed crocheters will need to work the diagram and instructions in a mirror image.

To start working from a chart, make 3 chains for each of the squares along the bottom row of the chart, plus 5 chains extra. (You can work the chart stitch-repeat as many times as desired.) Working the chart from the bottom upwards, make the blocks and spaces on the chart, while reading the first row and all following odd-numbered rows from right to left, and the even-numbered rows from left to right.

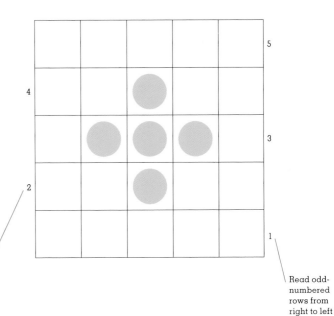

Read even-numbered rows from left to right

Read odd-numbered rows from right to left

KEY
□ = filet space
⬤ = filet block

Filet stitch patterns

Follow the instructions on pp.78–79 to work filet crochet from these charts. The best yarn to use for filet lace is a super-fine cotton yarn and a suitably small size crochet hook (see recommended hook sizes on p.18). Because filet crochet is reversible, it makes great curtains. It can also be used for edgings or insertions along the ends of pillowcases and hand towels.

SPECIAL NOTE AND SYMBOL KEY

• Repeat the charted motifs as many times as desired widthwise, and work across the stitches in rows until the chart is complete. To continue the pattern upwards, start at row 1 again.

KEY
☐ = filet space
⬤ = filet block

FLOWERS AND CIRCLES

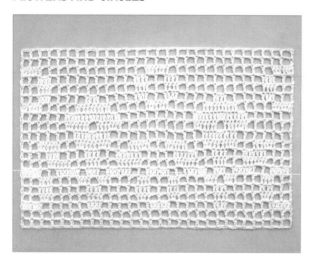

CROCHET CHART

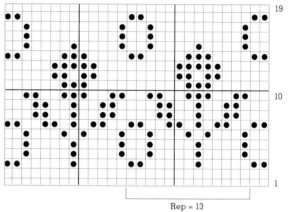

Rep = 13

DIAMONDS BORDER

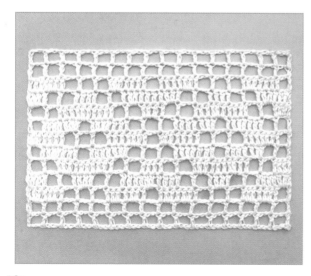

CROCHET CHART

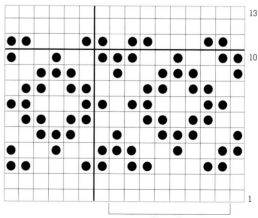

Rep = 8

80 Techniques

ZIGZAG BORDER

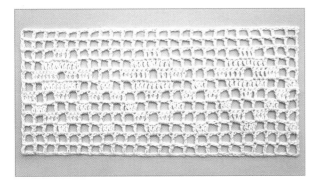

CROCHET CHART

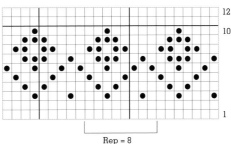

CROSSES BORDER

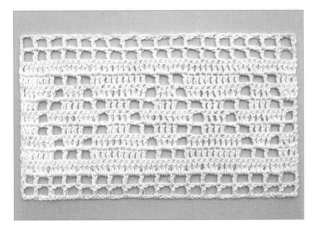

CROCHET CHART

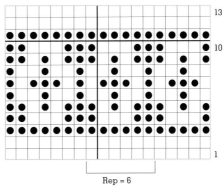

BLOOM

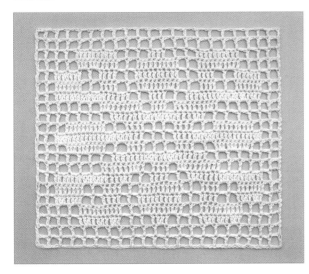

CROCHET CHART

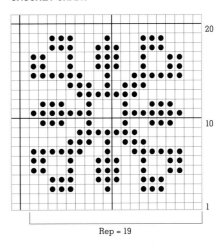

APPLE

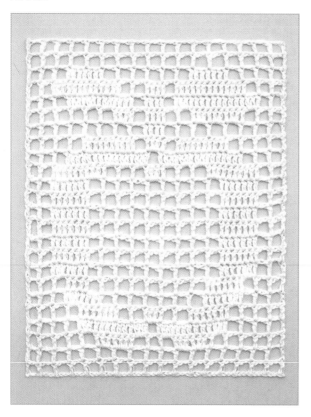

CROCHET CHART

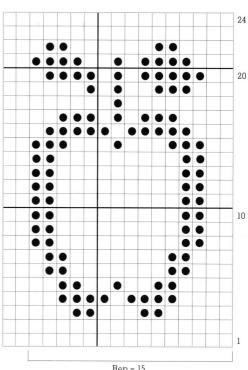

Rep = 15

BIRD

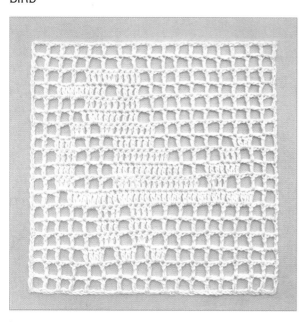

CROCHET CHART

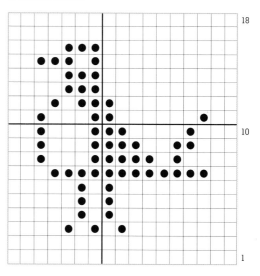

DOG

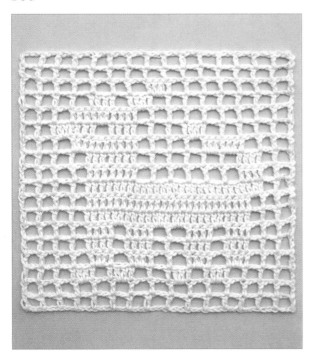

CROCHET CHART

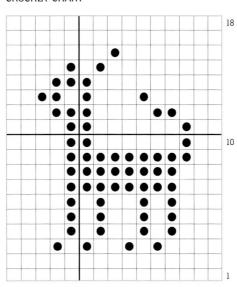

HEART

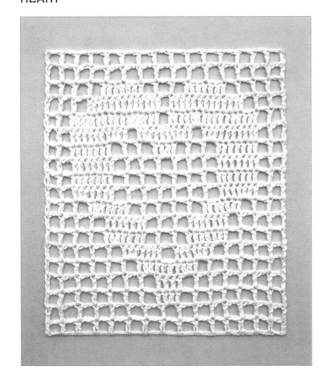

CROCHET CHART

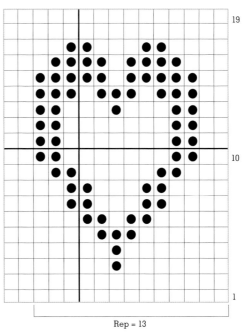

Rep = 13

Simple openwork stitch patterns

Openwork crochet stitches are always popular because of their lacy appearance and because they are quicker to work than solid crochet textures. They also drape gracefully due to their airy construction. Any of these easy stitch patterns would make an attractive shawl or scarf. Why not make small samples of the stitches to try them out? Then work your favourite in a range of yarns to see which texture you prefer (see Special Notes below). A glance at the symbol diagram will reveal which basic stitches and simple stitch techniques are involved.

SPECIAL NOTES

• Both written and symbol instructions are given for all the simple openwork stitch patterns. To get started, beginners should follow the written instructions for the first few rows, referring to the symbols for clarification. See pp.68–69 for a list of crochet abbreviations and basic stitch symbols. A complete explanation of how to read a crochet symbol diagram is included on pp.66–67.

• The written instructions explain how many chains to start with. So if working from the diagram, consult the written instructions to make the foundation chain. When working a very wide piece, such as a blanket, it is difficult to count and keep track of the number of foundation chains being made. In this case, you can make a chain a few centimetres longer than the correct approximate length and then unravel the excess later.

• Lacy shawls and scarves look best worked in super-fine to lightweight yarns of various textures. Always make a swatch with your chosen yarn before beginning to make a project with one of these openwork stitch patterns. Gossamer mohair-mix yarns will work with the very simplest stitches, but to show off intricate laces, use a smooth, tightly twisted wool or cotton yarn.

• Notice how the symbol diagrams for a stitch pattern usually show more rows than are given in the accompanying written instructions. This is done on purpose so that the build-up of the rows is completely clear to the crocheter. With simple openwork patterns like these, once you have completed all the rows of the diagram you will probably have committed the pattern to memory and will not have to refer to the instructions again.

CHAIN LOOP MESH

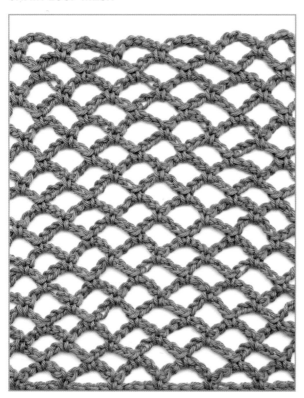

CROCHET DIAGRAM

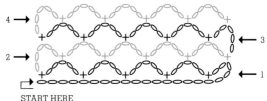

START HERE

CROCHET INSTRUCTIONS

Make a multiple of 4 ch, plus 2 extra.
Row 1 1 dc in 6th ch from hook, *5 ch, miss next 3 ch, 1 dc in next ch; rep from * to end, turn.
Row 2 *5 ch, 1 dc in next 5-ch loop; rep from * to end, turn.
Rep row 2 to form patt.

PICOT NET STITCH

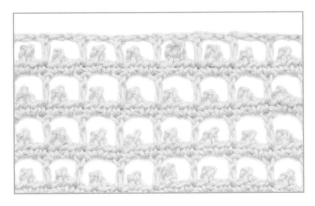

CROCHET DIAGRAM

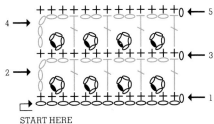

START HERE

CROCHET INSTRUCTIONS

Make a multiple of 3 ch, plus 2 extra.

Row 1 (RS) 1 dc in 2nd ch from hook, 1 dc in next ch,
*4 ch, 1 ss in 4th ch from hook (called 1 picot), 1 dc
in each of next 3 ch; rep from * omitting 1 dc at end of last
rep, turn.

Row 2 5 ch (counts as 1 tr and a 2-ch sp), miss first 3 dc (which
includes 2 dc before picot and 1 dc after picot), 1 tr in next

dc, *2 ch, miss next 2 dc (which includes 1 dc on each side
of picot), 1 tr in next dc; rep from * to end, turn.

Row 3 1 ch (does NOT count as a st), 1 dc in first tr, *work
[1 dc, 1 picot, 1 dc] all in next 2-ch sp, 1 dc in next tr; rep
from * working last dc of last rep in 3rd ch from last tr, turn.
Rep rows 2 and 3 to form patt.

OPEN SHELL STITCH

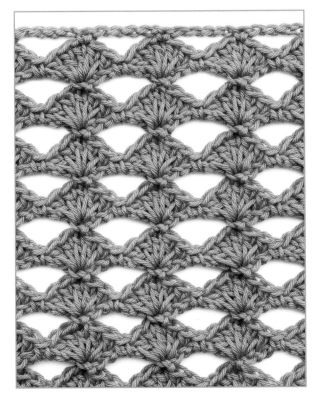

CROCHET DIAGRAM

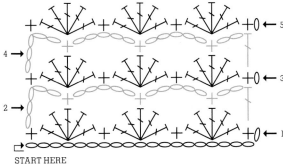

START HERE

CROCHET INSTRUCTIONS

Make a multiple of 6 ch, plus 2 extra.

Row 1 (RS) 1 dc in 2nd ch from hook, *miss next 2 ch, 5 tr in
next ch, miss next 2 ch, 1 dc in next ch; rep from * to end, turn.

Row 2 5 ch (counts as first tr and a 2-ch sp), 1 dc in centre tr of
first shell, *5 ch, 1 dc in centre tr of next shell; rep from *, ending
with 2 ch, 1 tr in last dc, turn.

Row 3 1 ch (does NOT count as a st), 1 dc in first tr, *5 tr in next dc,
1 dc in next 5-ch loop; rep from * working last dc of last rep in 3rd
ch from last dc, turn.
Rep rows 2 and 3 to form patt.

ARCHED MESH STITCH

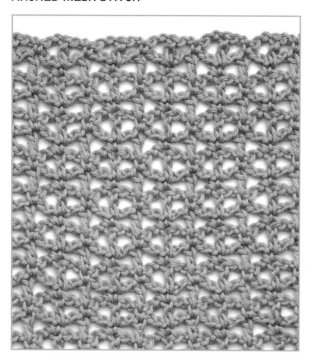

CROCHET DIAGRAM

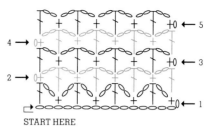

START HERE

CROCHET INSTRUCTIONS

Make a multiple of 4 ch.

Row 1 1 dc in 2nd ch from hook, 2 ch, miss next ch, 1 tr in next ch. *2 ch, miss next ch, 1 dc in next ch, 2 ch, miss next ch, 1 tr in next ch; rep from * to end, turn.

Row 2 1 ch (does NOT count as a st), 1 dc in first tr, 2 ch, 1 tr in next dc. *2 ch, 1 dc in next tr, 2 ch, 1 tr in next dc; rep from * to end, turn.

Rep row 2 to form patt.

BANDED NET STITCH

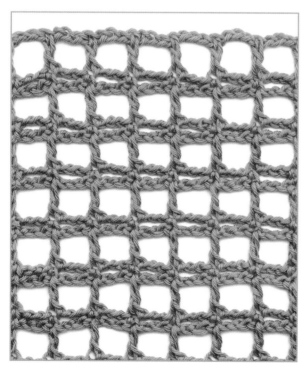

CROCHET DIAGRAM

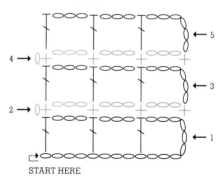

START HERE

CROCHET INSTRUCTIONS

Make a multiple of 4 ch, plus 2 extra.

Row 1 (RS) 1 tr in 10th ch from hook, *3 ch, miss next 3 ch, 1 tr in next ch; rep from * to end, turn.

Row 2 1 ch (does NOT count as a st), 1 dc in first tr, *3 ch, 1 dc in next tr; rep from *, ending with 3 ch, miss next 3 ch, 1 dc in next ch, turn.

Row 3 6 ch (counts as 1 tr and a 3-ch sp), miss first dc and first 3-ch sp, 1 tr in next dc. *3 ch, 1 tr in next dc; rep from * to end, turn.

Rep rows 2 and 3 to form patt.

SHELL MESH STITCH

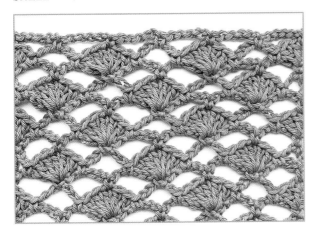

CROCHET DIAGRAM

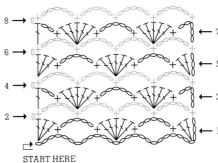

START HERE

CROCHET INSTRUCTIONS

Make a multiple of 12 ch, plus 4 extra.

Row 1 (RS) 2 tr in 4th ch from hook, *miss next 2 ch, 1 dc in next ch, 5 ch, miss next 5 ch, 1 dc in next ch, miss next 2 ch, 5 tr in next ch; rep from *, ending last rep with 3 tr (instead of 5 tr) in last ch, turn.

Row 2 1 ch (does NOT count as a st), 1 dc in first tr. *5 ch, 1 dc in next 5-ch loop, 5 ch, 1 dc in 3rd tr of next 5-tr shell; rep from * working last dc of last rep in top of 3-ch at end, turn.

Row 3 *5 ch, 1 dc in next 5-ch loop, 5 tr in next dc, 1 dc in next 5-ch loop; rep from *, ending with 2 ch, 1 tr in last dc, turn.

Row 4 1 ch (does NOT count as a st), 1 dc in first tr, *5 ch, 1 dc in 3rd tr of next 5-tr shell, 5 ch, 1 dc in next 5-ch loop; rep from * to end, turn.

Row 5 3 ch (counts as first tr), 2 tr in first dc, *1 dc in next 5-ch loop, 5 ch, 1 dc in next 5-ch loop, 5 tr in next dc; rep from * ending last rep with 3 tr (instead of 5 tr) in last dc, turn.

Rep rows 2–5 to form patt.

BLOCKS LACE

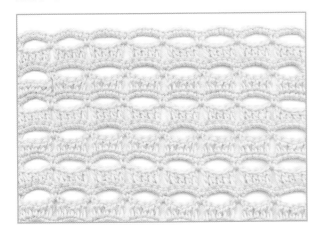

CROCHET DIAGRAM

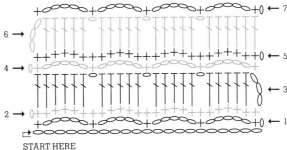

START HERE

Note: When working from diagram, rep rows 2–7 to form patt.

CROCHET INSTRUCTIONS

Make a multiple of 5 ch, plus 2 extra.

Row 1 (RS) 1 dc in 2nd ch from hook, *5 ch, miss next 4 ch, 1 dc in next ch; rep from * to end, turn.

Row 2 1 ch (does NOT count as a st), 1 dc in first dc, *5 dc in next 5-ch loop, 1 dc in next dc; rep from * to end, turn.

Row 3 3 ch (counts as first tr), miss first dc, 1 tr in each of next 5 dc, *1 ch, miss next dc, 1 tr in each of next 5 dc; rep from * to last dc, 1 tr in last dc, turn.

Row 4 1 ch (does NOT count as a st), 1 dc in first tr, *5 ch, 1 dc in next 1-ch sp; rep from * working last dc of last rep in top of 3-ch at end, turn.

Rep rows 2–4 to form patt.

TIARA LACE

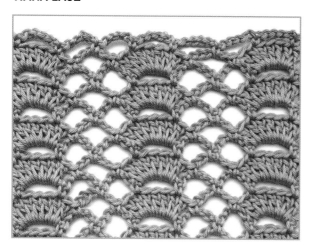

CROCHET DIAGRAM

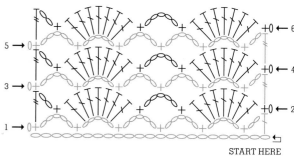

START HERE

CROCHET INSTRUCTIONS

Make a multiple of 12 ch.

Row 1 (WS) 1 dc in 2nd ch from hook, *5 ch, miss next 3 ch, 1 dc in next ch; rep from * to last 2 ch, 2 ch, miss next ch, 1 tr in last ch, turn.

Row 2 (RS) 1 ch (does NOT count as a st), 1 dc in first st, miss next 2-ch sp, 7 tr in next 5-ch loop, 1 dc in next 5-ch loop. *5 ch, 1 dc in next 5-ch loop, 7 tr in next 5-ch loop, 1 dc in next 5-ch loop; rep from *, ending with 2 ch, 1 dtr in last dc, turn.

Row 3 1 ch (does NOT count as a st), 1 dc in first dtr, 5 ch, 1 dc in 2nd of next 7-tr shell, 5 ch, 1 dc in 6th tr of same shell. *5 ch, 1 dc in next 5-ch loop, 5 ch, 1 dc in 2nd of next 7-tr shell, 5 ch, 1 dc in 6th tr of same shell; rep from *, ending with 2 ch, 1 dtr in last dc, turn.

Rep rows 2 and 3 to form patt.

FANS STITCH

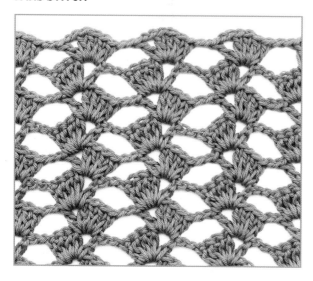

CROCHET DIAGRAM

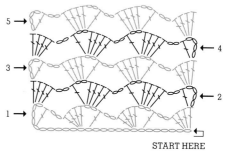

START HERE

CROCHET INSTRUCTIONS

Make a multiple of 7 ch, plus 4 extra.

Row 1 1 tr in 5th ch from hook, 2 ch, miss next 5 ch, 4 tr in next ch. *2 ch, 1 tr in next ch, 2 ch, miss next 5 ch, 4 tr in next ch; rep from * to end, turn.

Row 2 4 ch, 1 tr in first tr, *2 ch, miss next 2-ch sp and work [4 tr, 2 ch, 1 tr] all in following 2-ch sp; rep from * to last 2-ch sp, miss last 2-ch sp and work 4 tr in 4-ch loop at end, turn.

Rep row 2 to form patt.

Colourwork

One-colour crochet has its charms, but using your creative imagination to combine colours is both more challenging and more rewarding. All of the crochet colourwork techniques are easy to master and worth experimenting with. They include colourwork stitch patterns (see pp.94–95, 98–101), stripes, jacquard, and intarsia (see pp.91–93).

Simple stripes

Stripes worked in basic stitches have more potential for creativity than most crocheters realize. The only techniques you need to learn is how and when to change colours to start a new stripe, and how to carry the yarns up the side edge of the crochet.

CHANGING COLOURS

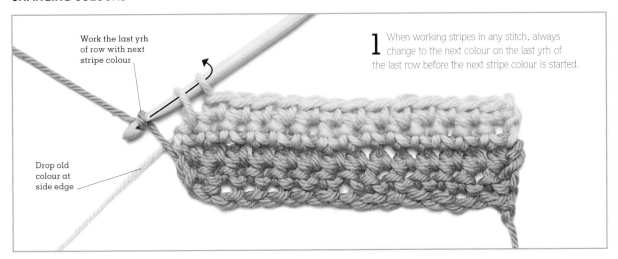

Work the last yrh of row with next stripe colour

Drop old colour at side edge

1 When working stripes in any stitch, always change to the next colour on the last yrh of the last row before the next stripe colour is started.

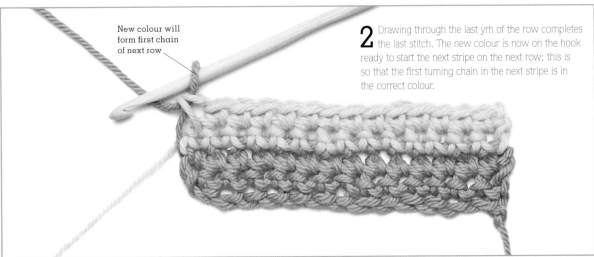

New colour will form first chain of next row

2 Drawing through the last yrh of the row completes the last stitch. The new colour is now on the hook ready to start the next stripe on the next row; this is so that the first turning chain in the next stripe is in the correct colour.

CARRYING COLOURS UP SIDE EDGE

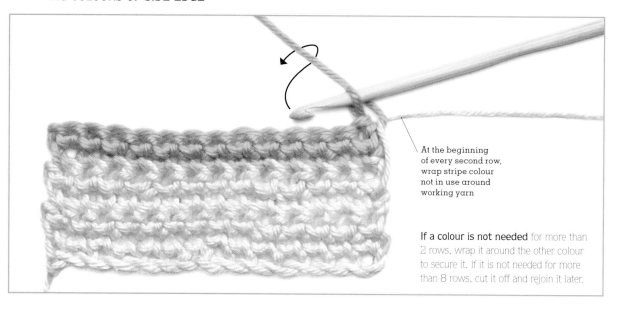

At the beginning
of every second row,
wrap stripe colour
not in use around
working yarn

If a colour is not needed for more than
2 rows, wrap it around the other colour
to secure it. If it is not needed for more
than 8 rows, cut it off and rejoin it later.

STRIPE COMBINATIONS

Smooth wool and fuzzy mohair stripe:
The repeated double crochet stripe
sequence here is two rows of a smooth
wool yarn and two rows of a fuzzy
mohair yarn, so each colour can simply
be dropped at the side of the work
and picked up when it is needed again.

Three-colour stripe: This double
crochet stripe has a repeated sequence
of two rows of each of three colours.
Wrap the working yarn around the
colours not in use on every second
row to keep them snug against the
edge. When changing colours, pull
in the new colour firmly but not too
tightly or it will pucker the edge.

**Double crochet and treble crochet
stripe:** Each of the two stripes in
this design is two rows tall. One stripe
is worked in double crochet and the
other in treble crochet. Adding in
the taller trebles gives the crochet
fabric a softer texture.

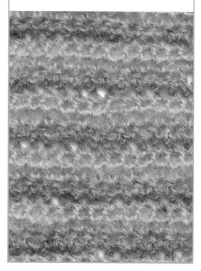

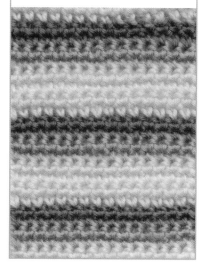

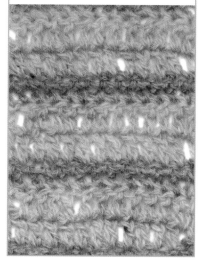

Jacquard and intarsia colourwork

Jacquard and intarsia crochet are both worked in double crochet stitches. Jacquard is usually worked with only two colours in a row; the colour not in use is carried across the top of the row below and stitches are worked over it to enclose it. When a colour is used only in an area of the crochet rather than across the entire row, the intarsia technique is required; a different length of yarn is used for each section of colour.

COLOURWORK CHARTS

The charted crochet design will reveal which technique to use – jacquard or intarsia. If the pattern on the chart shows two colours repeated across each horizontal row of squares, then the jacquard technique is required. Motifs worked in isolation require the intarsia technique. Each square on the charts represent one double crochet.

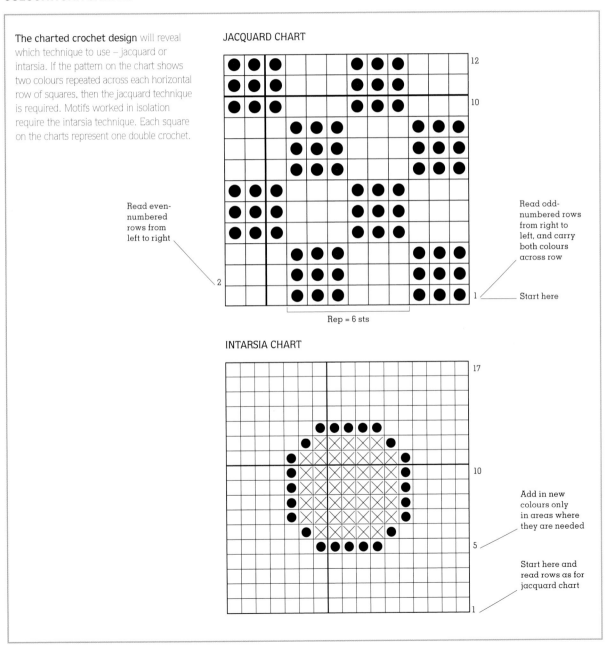

JACQUARD CHART

Read even-numbered rows from left to right

Read odd-numbered rows from right to left, and carry both colours across row

Start here

Rep = 6 sts

INTARSIA CHART

Add in new colours only in areas where they are needed

Start here and read rows as for jacquard chart

JACQUARD TECHNIQUE

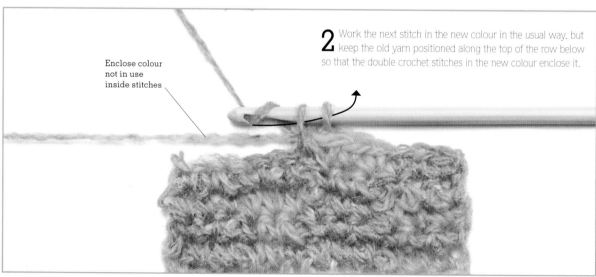

1 To change to a new colour in jacquard, work up to the last yrh of the double crochet stitch before the colour change, then pass the old colour to the front of the work over the top of the new colour and use the new colour to complete the stitch.

Pass old colour to front before picking up new colour

2 Work the next stitch in the new colour in the usual way, but keep the old yarn positioned along the top of the row below so that the double crochet stitches in the new colour enclose it.

Enclose colour not in use inside stitches

INTARSIA TECHNIQUE

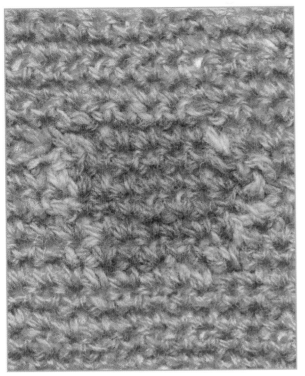

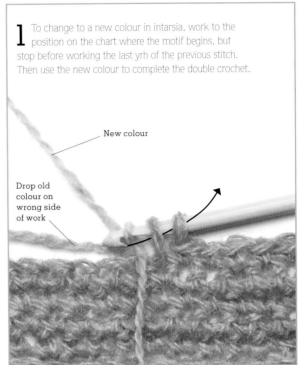

1 To change to a new colour in intarsia, work to the position on the chart where the motif begins, but stop before working the last yrh of the previous stitch. Then use the new colour to complete the double crochet.

New colour

Drop old
colour on
wrong side
of work

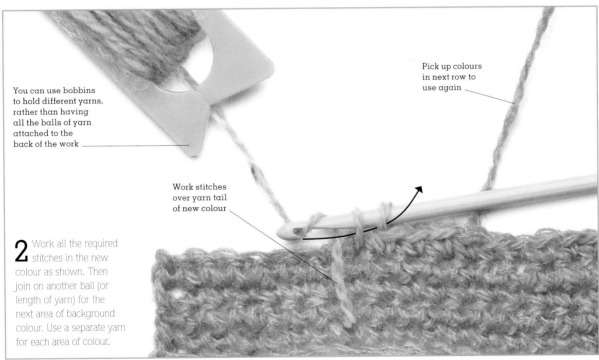

You can use bobbins
to hold different yarns,
rather than having
all the balls of yarn
attached to the
back of the work

Pick up colours
in next row to
use again

Work stitches
over yarn tail
of new colour

2 Work all the required stitches in the new colour as shown. Then join on another ball (or length of yarn) for the next area of background colour. Use a separate yarn for each area of colour.

Simple colourwork stitch patterns

Crochet colourwork stitch patterns are great fun to work. This selection of stitches, all easy to work, includes an array of textures, so you are sure to find one that catches your eye. Although some of the stitches have a right and wrong side, the back and front of these fabrics still look very similar. The reversibility of crochet is one of its best features. If you want to make a scarf, shawl, baby blanket, throw, or cushion cover with one of these stitches, take your time to choose the right colour combination (see Special Notes below). See pp.68–69 for abbreviations and basic stitch symbols. Any special symbols are given with the individual diagram.

SPECIAL NOTES

• When following the diagrams, use colours as explained in the written instructions. The symbol tones are used to denote row change and not colour change (except for the spike stitches). See pp.68–69 for a list of crochet abbreviations and basic stitch symbols.
• Choose yarn colours with care. Always buy only one ball of each colour first and test that the colours work well together.

For a successful combination, the chosen colours should stand out well against each other, either in tone (darkness and lightness) or in hue. It is best to work several colour combinations before deciding on the final one, especially if the item you are making is a large one like a blanket. Pin the swatches up and stand back to study them – the right one will pop right out at you.

SIMPLE ZIGZAG STITCH

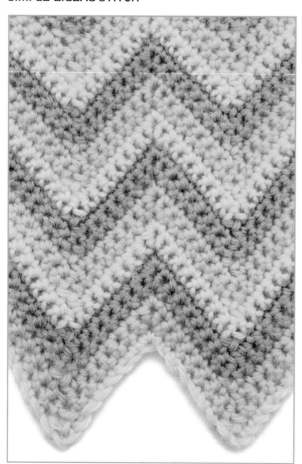

CROCHET DIAGRAM

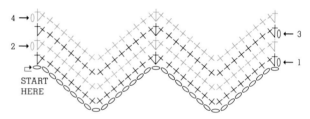

Note: When working from diagram, rep rows 2 and 3 for stitch pattern.

CROCHET INSTRUCTIONS

This pattern is worked in 3 colours (A, B, C).
Using C, make a multiple of 16 ch, plus 2 extra.
Row 1 (RS) Using A, 2 dc in 2nd ch from hook, *1 dc in each of next 7 ch, miss next ch, 1 dc in each of next 7 ch, 3 dc in next ch; rep from * to end, working 2 dc (instead of 3 dc) in last ch, turn.
Row 2 Using A, 1 ch (does NOT count as a st), 2 dc in first dc, *1 dc in each of next 7 dc, miss next 2 dc, 1 dc in each of next 7 dc, 3 dc in next dc; rep from * to end, working 2 dc (instead of 3 dc) in last dc, turn.
Rows 3 and 4 Using B, rep row 2.
Rows 5 and 6 Using C, [rep row 2] twice.
Rows 7 and 8 Using A, [rep row 2] twice.
Rep rows 3–8 to form patt.

COLOURED TWEED STITCH

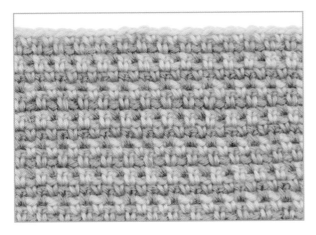

CROCHET DIAGRAM

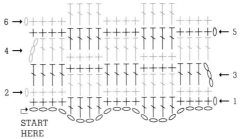

START HERE

CROCHET INSTRUCTIONS

This pattern is worked in 3 colours (A, B, C).

Using A, make a multiple of 2 ch.

Row 1 Using A, 1 dc in 2nd ch from hook, *1 ch, miss next ch, 1 dc in next ch; rep from * to end, turn.

Row 2 Using B, 1 ch (does NOT count as a st), 1 dc in first dc, 1 dc in next 1-ch sp, *1 ch, 1 dc in next 1-ch sp; rep from * to last dc, 1 dc in last dc, turn.

Row 3 Using C, 1 ch (does NOT count as a st), 1 dc in first dc, *1 ch, 1 dc in next 1-ch sp; rep from * to last 2 dc, 1 ch, miss next dc, 1 dc in last dc, turn.

Row 4 Using A, rep row 2.

Row 5 Using B, rep row 3.

Row 6 Using C, rep row 2.

Row 7 Using A, rep row 3.

Rep rows 2–7 to form patt.

GEM STITCH

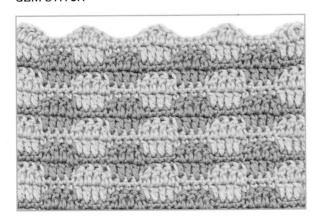

CROCHET DIAGRAM

START
HERE

CROCHET INSTRUCTIONS

This pattern is worked in 2 colours (A, B).

Using A, make a multiple of 8 ch, plus 5 extra.

Row 1 (RS) Using A, 1 dc in 2nd ch from hook, 1 dc in each of next 3 ch, *1 tr in each of next 4 ch, 1 dc in each of next 4 ch; rep from * to end, turn.

Row 2 Using A, 1 ch (does NOT count as a st), 1 dc in each of first 4 dc, *1 tr in each of next 4 tr, 1 dc in each of next 4 dc; rep from * to end, turn.

Row 3 Using B, 3 ch (counts as first tr), miss first dc, 1 tr in each of next 3 dc, *1 dc in each of next 4 tr, 1 tr in each of next 4 dc; rep from * to end, turn.

Row 4 Using B, 3 ch (counts as first tr), miss first tr, 1 tr in each of next 3 tr, *1 dc in each of next 4 dc, 1 tr in each of next 4 tr; rep from * to end, working last tr of last rep in top of 3-ch at end, turn.

Row 5 Using A, 1 ch (does NOT count as a st), 1 dc in each of first 4 tr, *1 tr in each of next 4 dc, 1 dc in each of next 4 tr; rep from * working last dc of last rep in top of 3-ch at end, turn.

Rep rows 2–5 to form patt.

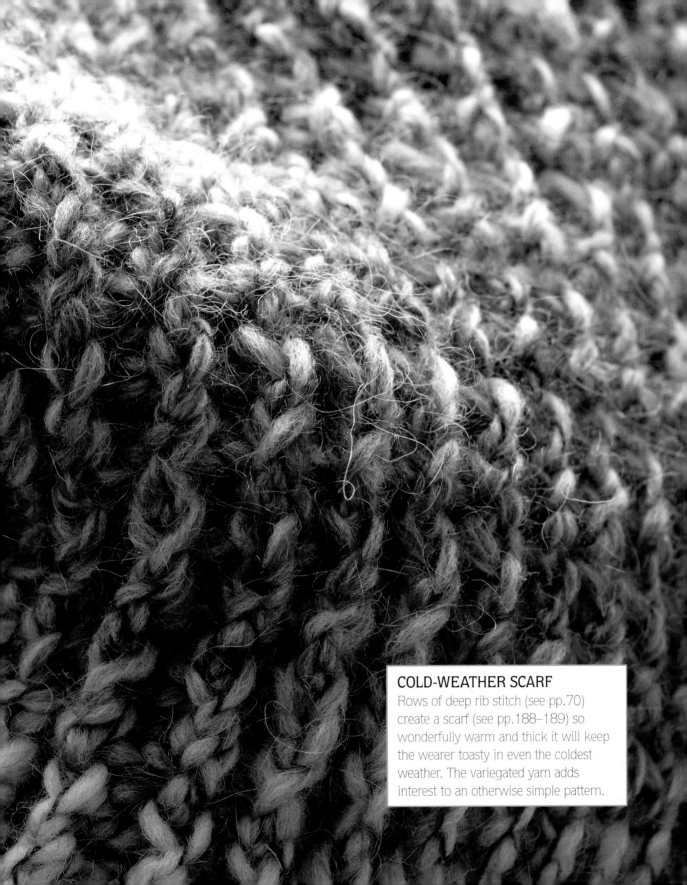

COLD-WEATHER SCARF
Rows of deep rib stitch (see pp.70) create a scarf (see pp.188–189) so wonderfully warm and thick it will keep the wearer toasty in even the coldest weather. The variegated yarn adds interest to an otherwise simple pattern.

DOUBLE ZIGZAG STITCH

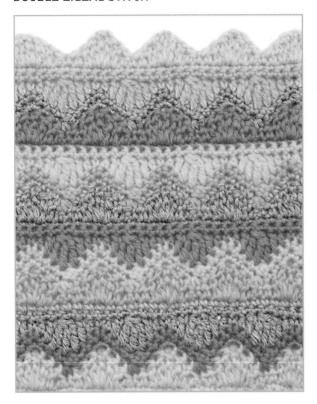

CROCHET DIAGRAM

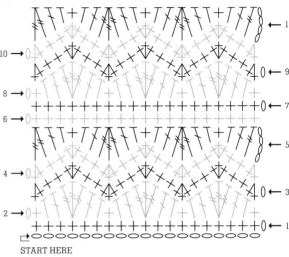

START HERE

CROCHET INSTRUCTIONS

NOTE: cluster (also called dtr3tog) = [yrh twice and insert hook in next st, yrh and draw a loop through, (yrh and draw through first 2 loops on hook) twice] 3 times (4 loops now on hook), yrh and draw through all 4 loops on hook; dtr2tog = [yrh twice and insert hook in next st, yrh and draw a loop through, (yrh and draw through first 2 loops on hook) twice] twice (3 loops now on hook), yrh and draw through all 3 loops on hook.

This pattern is worked in 4 colours (A, B, C, D).

Make a multiple of 6 ch, plus 2 extra.

Work the following rows in stripes, repeating this stripe sequence – 2 rows A, 2 rows B, 2 rows C, 2 rows D.

Row 1 (RS) 1 dc in 2nd ch from hook, 1 dc in each of rem ch, turn.

Row 2 1 ch (does NOT count as a st), 1 dc in first dc, *1 htr in next dc, 1 tr in next dc, 3 dtr in next dc, 1 tr in next dc, 1 htr in next dc, 1 dc in next dc; rep from * to end, turn.

Row 3 1 ch (does NOT count as a st), dc2tog over first 2 sts, 1 dc in each of next 2 sts, *3 dc in next st, 1 dc in each of next 2 sts, dc3tog over next 3 sts, 1 dc in each of next 2 sts; rep from * to last 5 sts, 3 dc in next st, 1 dc in each of next 2 sts, dc2tog over last 2 sts, turn.

Row 4 Rep row 3.

Row 5 4 ch, miss first st, 1 dtr in next dc (counts as first dtr2tog), 1 tr in next dc, 1 htr in next dc, 1 dc in next dc, 1 htr in next dc,

1 tr in next dc, *1 cluster over next 3 sts, 1 tr in next dc, 1 htr in next dc, 1 dc in next dc, 1 htr in next dc, 1 tr in next dc; rep from *, ending with dtr2tog over last 2 sts, turn.

Row 6 1 ch (does NOT count as a st), 1 dc in first st, 1 dc in next st and each st to end (do NOT work a dc in top of 4-ch turning ch at end), turn.

Row 7 1 ch (does NOT count as a st), 1 dc in each dc to end, turn.

Rep rows 2–7 to form patt, while continuing stripe sequence.

SPIKE STITCH STRIPES

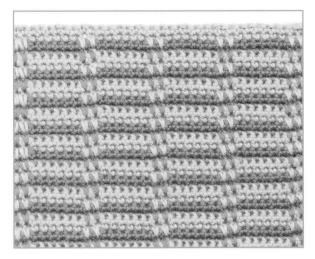

CROCHET DIAGRAM

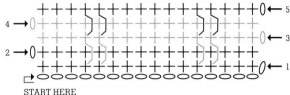

START HERE

KEY

┼ spike st in st one row below next st

CROCHET INSTRUCTIONS

NOTE: **spike st** = do not work into next st, but instead insert hook front to back through top of st one row below this st, yrh and draw a loop through, lengthening the loop to the height of the row being worked (and enclosing the missed st), yrh and draw through both loops on hook to complete an elongated dc.
This pattern is worked in 2 colours (A, B).
Using A, make a multiple of 8 ch, plus 1 extra.
Row 1 (RS) Using A, 1 dc in 2nd ch from hook, 1 dc in each of rem ch, turn.

Row 2 Using A, 1 ch (does NOT count as a st), 1 dc in each dc to end, turn.
Row 3 Using B, 1 ch (does NOT count as a st), *1 dc in each of next 3 dc, [1 spike st in top of st one row below next st] twice, 1 dc in each of next 3 dc; rep from * to end, turn.
Row 4 Using B, rep row 2.
Row 5 Using A, rep row 3.
Rep rows 2–5 to form patt.

COLOURED CLUSTER AND SHELL STITCH

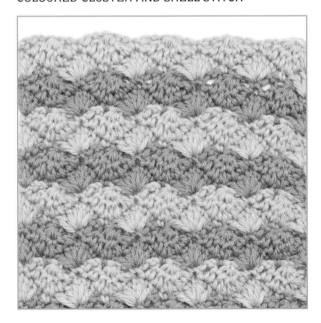

CROCHET INSTRUCTIONS

This pattern is worked in 2 colours (A, B).
Work as for cluster and shell stitch on p.72 as follows:
Using A, make the foundation ch. Then work in stripe patt, repeating the following stripe sequence – 2 rows A, 2 rows B.

BOBBLE STRIPE

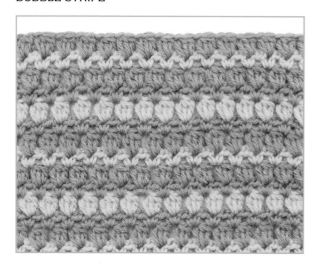

CROCHET DIAGRAM

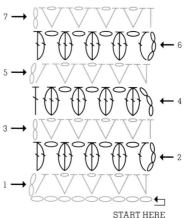

7 →
← 6
5 →
← 4
3 →
← 2
1 →
START HERE

CROCHET INSTRUCTIONS

NOTE: bobble = [yrh and insert hook in specified st, yrh and draw a loop through, yrh and draw through first 2 loops on hook] 3 times all in same st (4 loops now on hook), yrh and draw through all 4 loops on hook to complete 3-tr bobble (see pp.64).

This pattern is worked in 3 colours (A, B, C).

Using A, make a multiple of 2 ch, plus 1 extra.

Work the following rows in stripes, repeating this stripe sequence – 1 row A, 1 row B, 1 row C.

Row 1 (WS) 1 htr in 3rd ch from hook, *miss next ch, work [1 htr, 1 ch, 1 htr] all in next ch; rep from * to last 2 ch, miss next ch, 2 htr in last ch, turn.

Row 2 (RS) 3 ch (counts as first tr), 1 tr in first htr, *1 ch, 1 bobble in next 1-ch sp; rep from *, ending with 1 ch, work [yrh and insert

hook in top of 2-ch at end of row, yrh and draw a loop through, yrh and draw through first 2 loops on hook] twice all in same place (3 loops now on hook), yrh and draw through all 3 loops on hook, turn.

Row 3 2 ch (counts as first htr), *work [1 htr, 1 ch, 1 htr] all in next 1-ch sp; rep from *, ending with 1 htr in top of 3-ch, turn.

Row 4 3 ch (counts as first tr), 1 bobble in next 1-ch sp, *1 ch, 1 bobble in next 1-ch sp; rep from *, ending with 1 tr in top of 2-ch at end, turn.

Row 5 2 ch (counts as first htr), 1 htr in first tr, *work [1 htr, 1 ch, 1 htr] all in next 1-ch sp; rep from *, ending with 2 htr in top of 3-ch at end, turn.

Rep rows 2–5 to form patt, while continuing stripe sequence.

- -

COLOURED CLOSE SHELLS STITCH

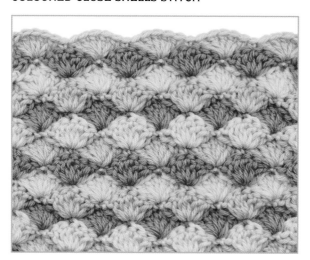

CROCHET INSTRUCTIONS

This pattern is worked in 3 colours (A, B, C).

Work as for close shells stitch on p.71 as follows:

Using A, make the foundation ch. Then work in stripe patt, repeating the following stripe sequence – 1 row A, 1 row B, 1 row C.

TRIANGLES SPIKE STITCH

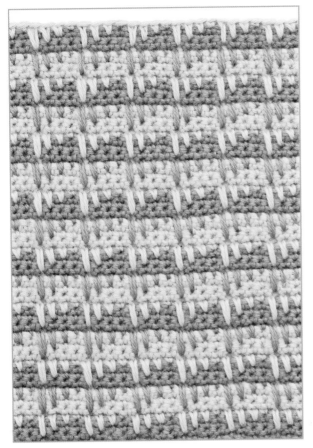

CROCHET DIAGRAM

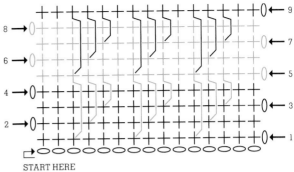

START HERE

KEY

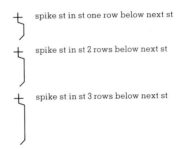

spike st in st one row below next st

spike st in st 2 rows below next st

spike st in st 3 rows below next st

CROCHET INSTRUCTIONS

NOTE: spike st = do not work into next st, but instead insert hook front to back through top of st 1, 2, or 3 rows below this st, yrh and draw a loop through, lengthening the loop to the height of the row being worked (and enclosing the missed st), yrh and draw through both loops on hook to complete an elongated dc.

This pattern is worked in 2 colours (A, B).

Using A, make a multiple of 4 ch.

Row 1 (RS) Using A, 1 dc in 2nd ch from hook, 1 dc in each of rem ch, turn.

Row 2 Using A, 1 ch (does NOT count as a st), 1 dc in each dc to end, turn.

Rows 3 and 4 Using A, [rep row 2] twice.

Row 5 (RS) Using B, 1 ch (does NOT count as a st), 1 dc in first dc, *1 dc in next dc, 1 spike st in top of dc one row below next dc,

1 spike st in top of dc 2 rows below next dc, 1 spike st in top of dc 3 rows below next dc; rep from * to last 2 dc, 1 dc in each of last 2 dc, turn.

Rows 6, 7, and 8 Using B, [rep row 2] 3 times.

Row 9 (RS) Using A, rep row 5.

Rep rows 2–9 to form patt, ending with a patt row 5 or 9.

Following a crochet pattern

Followed step by step and slowly, crochet patterns are not as difficult to understand as they appear. The guides here for a simple accessory and a garment give many tips for how to approach your first crochet patterns. This section also includes other techniques needed for working from a crochet pattern – simple increases and decreases for shaping garments, finishings such as edgings and button loops, and blocking and seams.

Simple accessory patterns

A beginner should choose an easy accessory pattern for a first crochet project. A striped cushion cover is given here as an example. Follow the numbered tips of the guide to familiarize yourself with the parts of a simple pattern.

1 The skill level required for the crochet is given at the beginning of most patterns. When starting out, work several easy patterns before progressing to the intermediate level.

2 Check the size of the finished item. If it is a simple square like this cushion, you can easily adjust the size by adding or subtracting stitches and rows.

3 It is sometimes advisable to use the yarn specified. But if you are unable to obtain this yarn, choose a substitute yarn.

8 Make a tension swatch before starting to crochet and change the hook size if necessary (see p.104).

9 Instructions for working a piece of crocheted fabric always start with how many chains to make for the foundation chain and which yarn or hook size to use. If there is only one hook size and one yarn, these may be absent here.

10 Consult the abbreviations list with your pattern for the meanings of abbreviations (see pp.68–69).

14 The back of a cushion cover is sometimes exactly the same as the front or it may have a fabric back. In this example, the stripes are reversed on the back for a more versatile cover.

15 After all the crocheted pieces are completed, follow the Finishing (or Making Up) section of the pattern.

STRIPED CUSHION COVER

Skill level
Easy

Size of finished cushion
40.5 x 40.5cm (16 x 16in)

Materials
7 x 25g/⅞oz (110m/120yd) balls of branded Scottish Tweed 4-Ply in Thatch 00018 (**A**)
4 x 25g/⅞oz (110m/120yd) balls of branded Scottish Tweed 4-Ply in Skye 00009 (**B**)
3.5mm (US size E-4) crochet hook
Cushion pad to fit finished cover

Tension
22 sts and 24 rows to 10cm (4in) over double crochet using 3.5mm (US size E-4) hook or size necessary to achieve correct tension. To save time, take time to check tension.

Front
Using 3.5mm (US size E-4) hook and A, make 89 ch.
Row 1 1 dc in 2nd ch from hook, 1 dc in each of rem ch, turn. 88 dc.
Row 2 1 ch (does NOT count as a st), 1 dc in each dc to end, turn.
Rep row 2 throughout to form dc fabric.
Always changing to new colour with last yrh of last dc of previous row, work in stripes as follows:
26 rows more in A, 8 rows B, [8 rows A, 8 rows B] twice, 28 rows A.
Fasten off.

Back
Work as for Front, but use B for A, and A for B.

Finishing
Darn in loose ends.
Block and press lightly on wrong side, following instructions on yarn label.
With wrong sides facing, sew three sides of back and front together. Turn right-side out, insert cushion pad, and sew remaining seam.

4 Always purchase the same total amount in metres/yards of a substitute yarn; NOT the same amount in weight.

5 If desired, select different colours to suit your décor; the colours specified are just suggestions.

6 Alter the hook size if you cannot achieve the correct tension with the specified size (see 8 left).

7 Extra items needed for your project will usually be listed under Materials or Extras.

11 Work in the specified stitch pattern, for the specified number of rows or cm/in.

12 Colours for stripes are always changed at the end of the previous row before the colour change so the first turning chain of the new stripe is in the correct colour (see p.89).

13 Fastening off completes the crochet piece.

16 See p.54 for how to darn in loose ends.

17 Make sure you look at the yarn label instructions before attempting to press any piece of crochet. The label may say that the yarn cannot be pressed or it can be pressed only with a cool iron. (See p.117 for blocking tips.)

18 See pp.118–121 for seaming options. Take time with seams on crochet, and when working your very first seams, get an experienced crocheter to help you.

Garment patterns

Garment instructions usually start with the Skill Level, followed by the Sizes, Materials, Tension, and finally the Instructions. Most important for successfully making a garment – or other fitted items such as hats, mittens, gloves, and socks – is choosing the right size and making a tension swatch.

TIPS

Choose a skill level that suits your crochet experience. If in doubt or if you haven't crocheted for many years, stick to an Easy or Beginner's level until you are confident you can go to the next level.

White is a good colour to use for your first crocheted sweater because the stitches are so easy to see clearly. But if you do choose white yarn, be sure to wash your hands every time you start crocheting; and when you stop, put away the yarn and sweater in a bag to keep it from becoming soiled.

Avoid black or other very dark yarn for a first crocheted sweater as the stitches are very difficult to distinguish, even for an accomplished crocheter.

Purchase yarn balls that have the same dye-lot number (see p.19).

Have a set of hook sizes at hand if you are starting to crochet sweaters. When checking tension (see p.104),

you may need other hook sizes in order to achieve the correct tension.

Always make the pieces in the order given in the instructions, whether you are crocheting a garment, accessory, or toy. On a garment, the back is usually crocheted first, followed by the front (or fronts if it is a cardigan or jacket), and lastly the sleeves. Pockets that are integrated into the fronts are crocheted before the fronts and those applied as patches are worked last.

Beginners should take care when modifying patterns as sizing/shaping and stitch patterns are often worked out in detail by the pattern designer and may turn out very differently if altered. However, beginners should not be afraid to try modifying a pattern to suit their preferences, as it can always be pulled back if it does not work as planned.

CHOOSING A GARMENT SIZE

Crochet garment sizes are usually listed as specific bust/chest sizes or in generic terms as Small, Medium, Large. (Children's sweater sizes are given in ages and chest sizes.) The best advice is not to stick strictly to choosing your preferred size by these criteria. Decide instead how you want the garment to fit you – how close-fitting or loose-fitting it should be. If you are planning to crochet a sweater, find one in your wardrobe that is comfortable and flattering and has a fabric weight and shape similar to the garment you are going to crochet. Smooth out the sweater and measure the width. Find the same, or closest, width to this on the sweater diagram of your crochet pattern – this is the size for you.

Make a photocopy of your pattern and circle or highlight all the figures that apply to your size throughout the pattern, starting with the number of balls of yarn to purchase, followed by the number of chains in the foundation chain for the sweater back, the length to the armhole, and so on. The figure for the smallest size is given first and all the figures for the larger sizes follow in parentheses. Where there is only one figure given in the instructions – be it a measurement, the number of rows, or the number of stitches – this figure applies to all sizes. Before starting your crochet, always check your tension (see p.104).

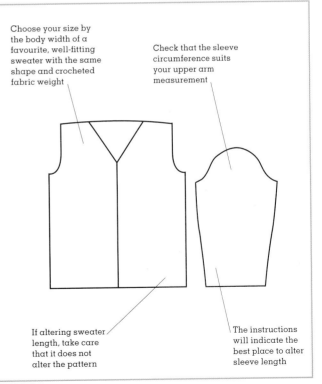

Choose your size by the body width of a favourite, well-fitting sweater with the same shape and crocheted fabric weight

Check that the sleeve circumference suits your upper arm measurement

If altering sweater length, take care that it does not alter the pattern

The instructions will indicate the best place to alter sleeve length

Measuring tension

It is essential to check your tension (stitch size) before beginning a crochet pattern if the final size of the piece matters. Not everyone crochets stitches with exactly the same tightness or looseness, so you may well need to use a different hook size to achieve the stitch size required by your pattern.

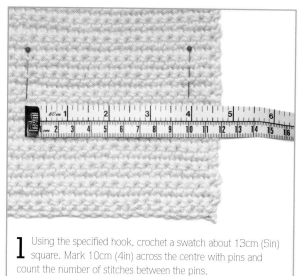

1 Using the specified hook, crochet a swatch about 13cm (5in) square. Mark 10cm (4in) across the centre with pins and count the number of stitches between the pins.

2 Count the number of rows to 10cm (4in) in the same way. If you have fewer stitches and rows than you should, try again with a larger hook size; if you have more, change to a smaller hook size. Use the hook size that best matches the correct tension. (Matching the stitch width is much more important than matching the row height.)

Shaping crochet

To move from making simple squares and rectangles, a crocheter needs to know how to increase and decrease the number of stitches in the row to make shaped pieces. The most commonly used simple shaping techniques are provided here.

DOUBLE CROCHET INCREASES

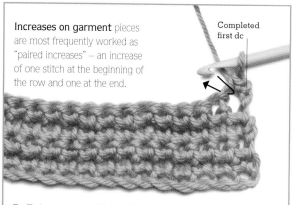

Increases on garment pieces are most frequently worked as "paired increases" – an increase of one stitch at the beginning of the row and one at the end.

Completed first dc

2 dc worked into same stitch

1 To increase one stitch at the beginning of a row of double crochet, work 1 dc into the first dc in the usual way. Next, insert the hook again into the first dc and work a second dc in the same stitch.

2 This completes the increase. Continue across the row, working 1 dc into each dc in the usual way.

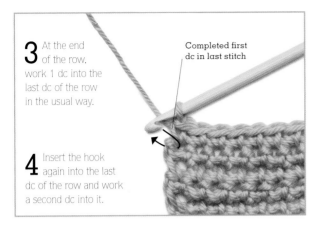

3 At the end of the row, work 1 dc into the last dc of the row in the usual way.

Completed first dc in last stitch

4 Insert the hook again into the last dc of the row and work a second dc into it.

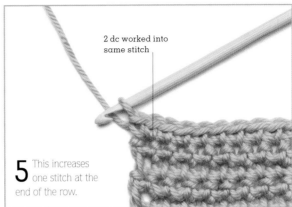

2 dc worked into same stitch

5 This increases one stitch at the end of the row.

TREBLE CROCHET INCREASES

Increases on garment pieces made using treble crochet are worked using the same techniques as for double crochet. Again, these increases are most frequently worked as "paired increases" – one stitch is increased at each end of the row.

1 To increase one stitch at the beginning of a row of treble crochet, first work the turning chain, then work 1 tr into the first tr in the row below. Because the first treble in the row below is usually missed, this creates an increase at the beginning of the row.

First tr worked into first tr in row below instead of missing it

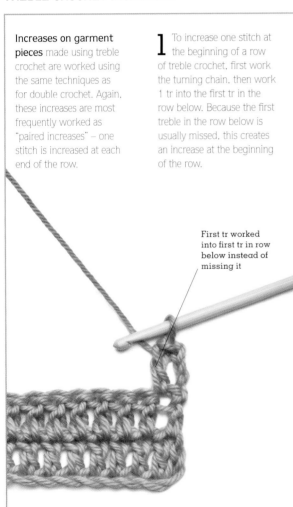

2 Continue across the row, working 1 tr into each tr in the usual way. At the end of the row, work 1 tr into the top of the turning chain in the row below in the usual way. Then work a second tr into the same turning chain.

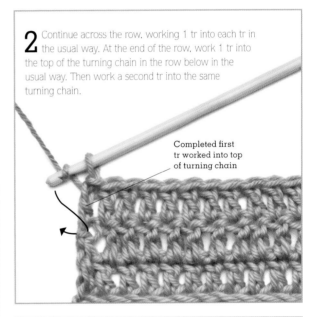

Completed first tr worked into top of turning chain

3 This completes the one stitch increase at the end of the row as shown.

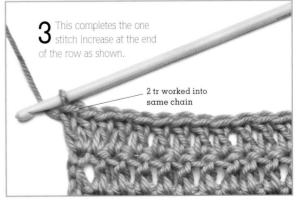

2 tr worked into same chain

STEP INCREASE AT BEGINNING OF ROW

1 Increases are also frequently worked in crochet so that they form little steps at the edge. As an example, to add a 3-stitch step increase at the beginning of a row of double crochet, begin by making 4 chains as shown here. (Always make one chain more than the number of extra double crochets required.)

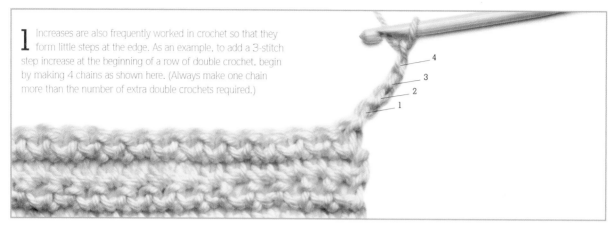

2 Work the first dc into the second chain from the hook. Then work 1 dc into each of the remaining 2 chains. This creates a 3-dc increase at the beginning of the row.

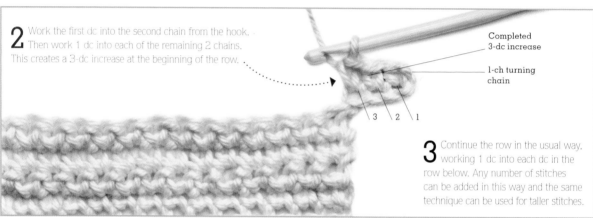

Completed 3-dc increase

1-ch turning chain

3 Continue the row in the usual way, working 1 dc into each dc in the row below. Any number of stitches can be added in this way and the same technique can be used for taller stitches.

STEP INCREASE AT END OF ROW

1 Before starting the row with the step increase at the end, remove the hook from the loop at the beginning of the row. Then, using a short length of matching yarn, place a slip knot on a spare hook and draw this loop through the last stitch in the row.

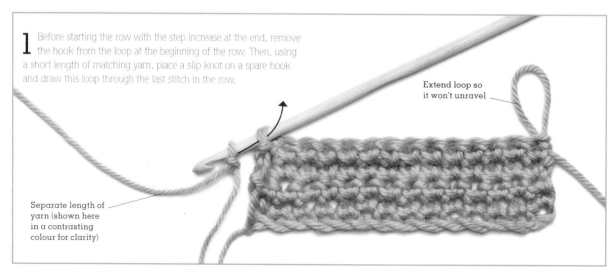

Extend loop so it won't unravel

Separate length of yarn (shown here in a contrasting colour for clarity)

2 There is now one loop on the hook – this forms the first extra chain at the end of the row. Continue making chains until you have made as many as the required number of extra stitches.

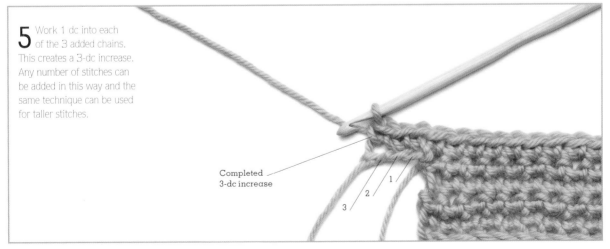

3 So for a 3-stitch step increase, make a total of 3 chains. Then fasten off.

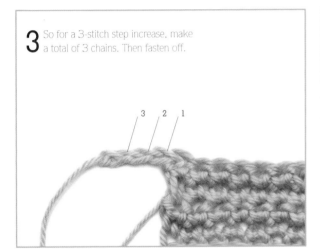

4 Return to the beginning of the row, slip the loop back onto the hook and tighten it, then work to the end of the row in the usual way until you reach the added chains.

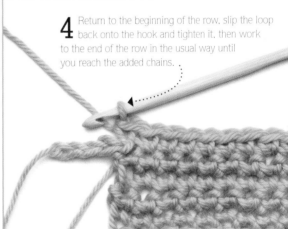

5 Work 1 dc into each of the 3 added chains. This creates a 3-dc increase. Any number of stitches can be added in this way and the same technique can be used for taller stitches.

Completed
3-dc increase

DOUBLE CROCHET DECREASES (Abbreviation = *dc2tog*)

Decreases on garment pieces, like increases, are most frequently worked as "paired decreases" – a decrease of one stitch at the beginning of the row and another at the end.

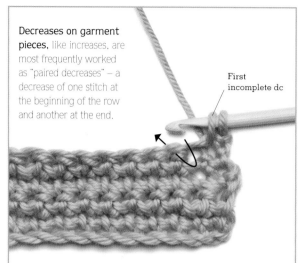

First incomplete dc

1 To decrease one stitch at the beginning of a row of double crochet, work up to the last yrh of the first dc in the usual way, but do not complete the stitch – there are now 2 loops on the hook. Insert the hook through the next stitch as shown and draw a loop through.

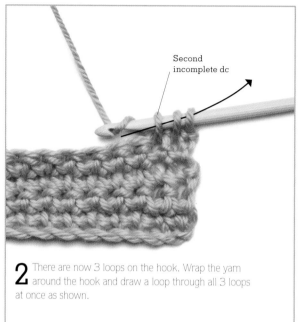

Second incomplete dc

2 There are now 3 loops on the hook. Wrap the yarn around the hook and draw a loop through all 3 loops at once as shown.

3 This completes the decrease – where there were 2 stitches, there is now only one.

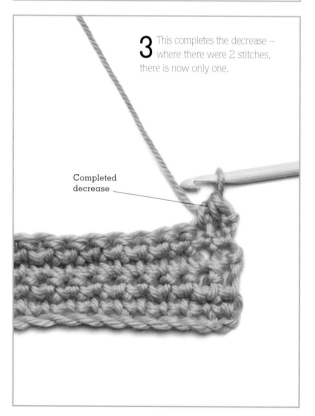

Completed decrease

4 Continue across the row, working 1 dc into each dc in the usual way up to the last 2 stitches of the row.

5 At the end of the row, insert the hook through the top of the second to last stitch and draw a loop through – there are now 2 loops on the hook.

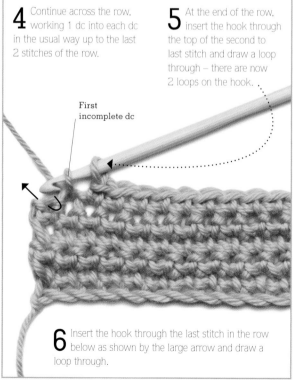

First incomplete dc

6 Insert the hook through the last stitch in the row below as shown by the large arrow and draw a loop through.

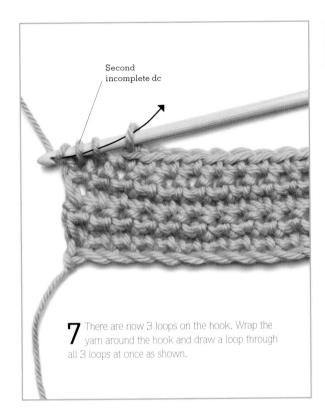

Second incomplete dc

7 There are now 3 loops on the hook. Wrap the yarn around the hook and draw a loop through all 3 loops at once as shown.

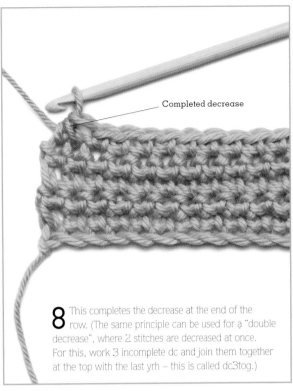

Completed decrease

8 This completes the decrease at the end of the row. (The same principle can be used for a "double decrease", where 2 stitches are decreased at once. For this, work 3 incomplete dc and join them together at the top with the last yrh – this is called dc3tog.)

TREBLE CROCHET DECREASES (Abbreviation = *tr2tog*)

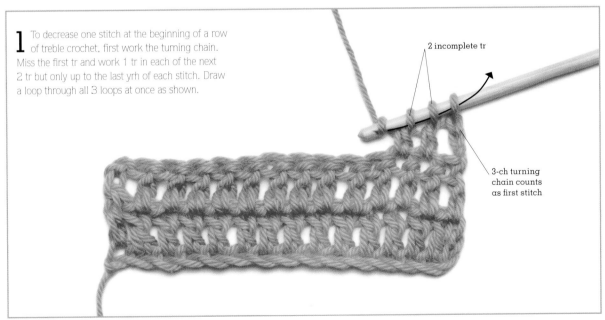

1 To decrease one stitch at the beginning of a row of treble crochet, first work the turning chain. Miss the first tr and work 1 tr in each of the next 2 tr but only up to the last yrh of each stitch. Draw a loop through all 3 loops at once as shown.

2 incomplete tr

3-ch turning chain counts as first stitch

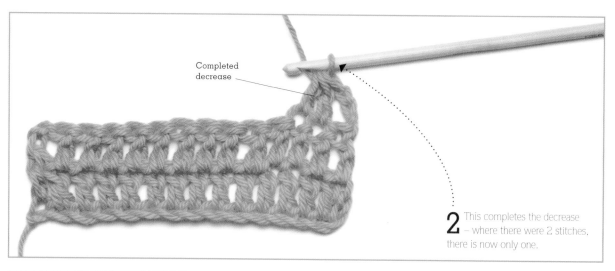

Completed decrease

2 This completes the decrease – where there were 2 stitches, there is now only one.

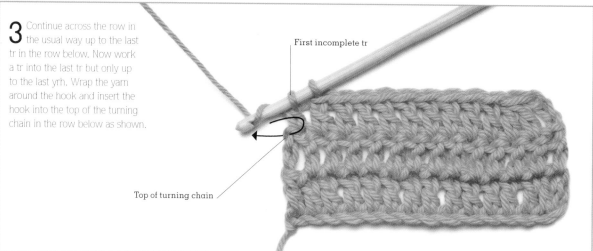

3 Continue across the row in the usual way up to the last tr in the row below. Now work a tr into the last tr but only up to the last yrh. Wrap the yarn around the hook and insert the hook into the top of the turning chain in the row below as shown.

First incomplete tr

Top of turning chain

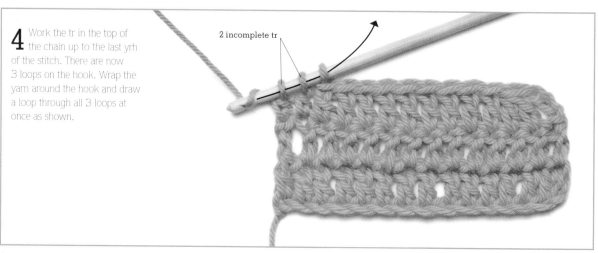

4 Work the tr in the top of the chain up to the last yrh of the stitch. There are now 3 loops on the hook. Wrap the yarn around the hook and draw a loop through all 3 loops at once as shown.

2 incomplete tr

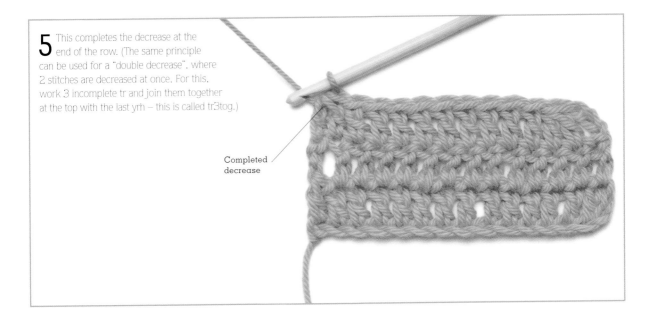

5 This completes the decrease at the end of the row. (The same principle can be used for a "double decrease", where 2 stitches are decreased at once. For this, work 3 incomplete tr and join them together at the top with the last yrh – this is called tr3tog.)

Completed decrease

STEP DECREASES

1 At beginning of row: Decreases, like increases, can also be worked so that they form little steps at the edge. As an example, to decrease 3 stitches at the beginning of a row of double crochet, work 1 chain and then 1 slip stitch into each of the first 4 dc. Next, work 1 chain, then work the first dc in the same place that the last slip stitch was worked. Continue along the row in the usual way.

Slip stitch to correct position

2 At end of row: For a 3-stitch step decrease at the end of the row, simply work up to the last 3 stitches at the end of the row and turn, leaving the last 3 stitches unworked. This technique can be used for all crochet stitches.

Turn before end

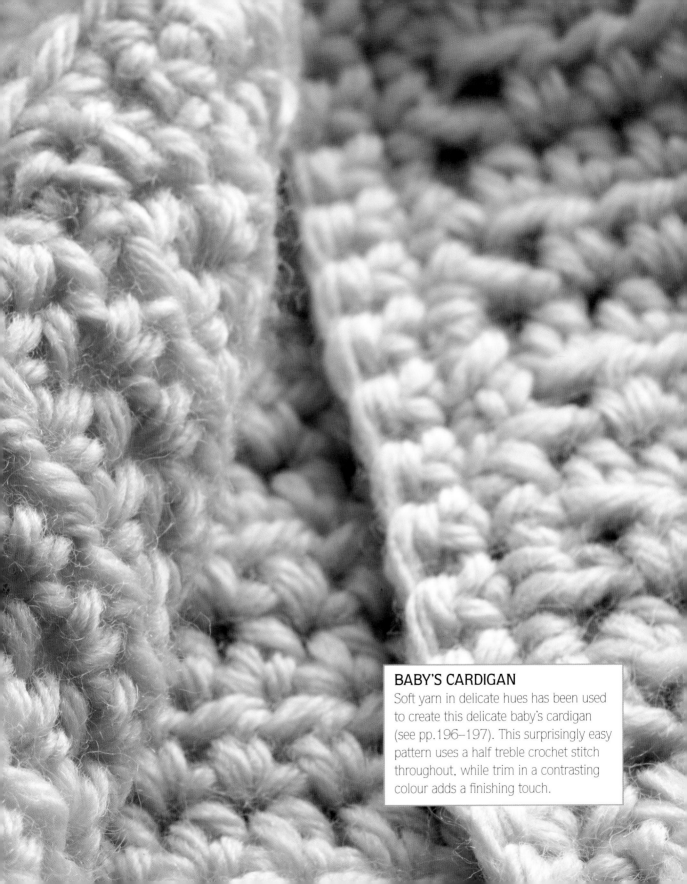

BABY'S CARDIGAN
Soft yarn in delicate hues has been used to create this delicate baby's cardigan (see pp.196–197). This surprisingly easy pattern uses a half treble crochet stitch throughout, while trim in a contrasting colour adds a finishing touch.

Finishing details

Finishings require slightly different crochet techniques. Some of the techniques most frequently used are shown here. Take your time with all finishings, and practise the methods on small swatches before adding them to your completed pieces.

DOUBLE CROCHET EDGING

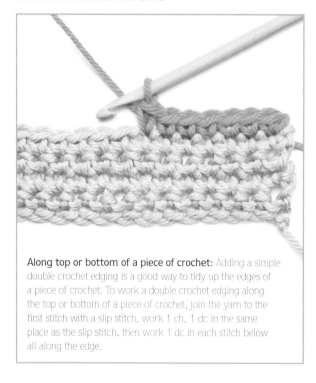

Along top or bottom of a piece of crochet: Adding a simple double crochet edging is a good way to tidy up the edges of a piece of crochet. To work a double crochet edging along the top or bottom of a piece of crochet, join the yarn to the first stitch with a slip stitch, work 1 ch, 1 dc in the same place as the slip stitch, then work 1 dc in each stitch below all along the edge.

Along row-ends of a piece of crochet: A double crochet edging is worked the same way along the row-ends of a piece of crochet, but it is not as easy to achieve an even edging. To create a perfect result, experiment with how many stitches to work per row-end. If the finished edging looks flared, try working fewer stitches per row-end; and if it looks puckered, try working more stitches per row-end.

CROCHETING EDGING DIRECTLY ONTO EDGE

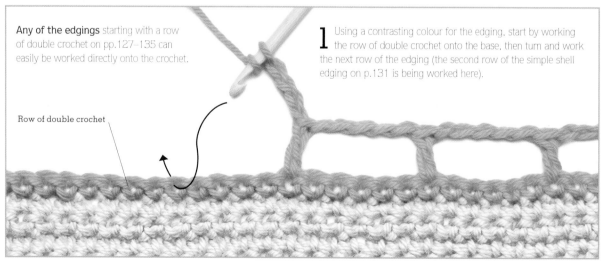

Any of the edgings starting with a row of double crochet on pp.127–135 can easily be worked directly onto the crochet.

Row of double crochet

1 Using a contrasting colour for the edging, start by working the row of double crochet onto the base, then turn and work the next row of the edging (the second row of the simple shell edging on p.131 is being worked here).

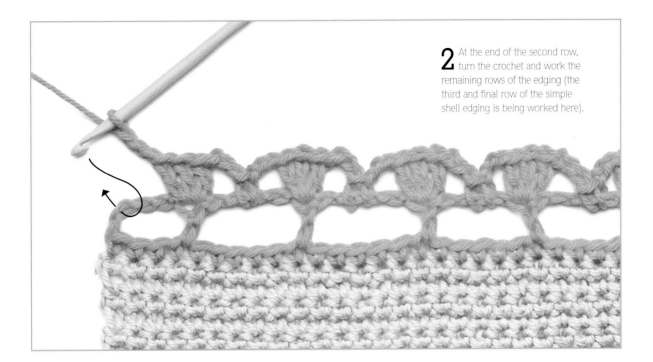

2 At the end of the second row, turn the crochet and work the remaining rows of the edging (the third and final row of the simple shell edging is being worked here).

ROUND BUTTONS

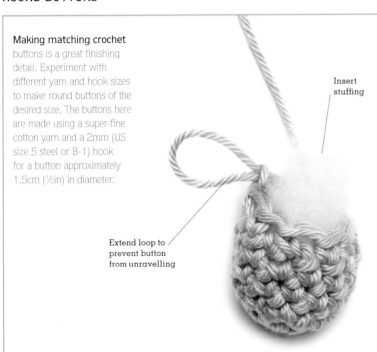

Making matching crochet buttons is a great finishing detail. Experiment with different yarn and hook sizes to make round buttons of the desired size. The buttons here are made using a super-fine cotton yarn and a 2mm (US size 5 steel or B-1) hook for a button approximately 1.5cm (½in) in diameter.

Insert stuffing

Extend loop to prevent button from unravelling

1 Make each button as follows: Make 4 ch and join with a ss to first ch to form a ring.
Round 1 (RS) 1 ch, 8 dc in ring (working over yarn tail while working dc into ring), join with a ss to first dc. (Do not turn at end of rounds, but work with RS always facing.)
Round 2 1 ch, 1 dc in same dc as last ss, 2 dc in next dc, [1 dc in next dc, 2 dc in next dc] 3 times, join with a ss to first dc. *12 dc.*
Round 3 1 ch, 1 dc in each dc to end, join with a ss to first dc.
Round 4 1 ch, 1 dc in same dc as last ss, [dc2tog over next 1 dc, 1 dc in next dc] 3 times, dc2tog over last 2 dc, join with a ss to first dc. *8 dc.*
Take the loop off the hook and extend it to prevent the button from unravelling, then push the yarn tail from round 1 into the inside of the button and stuff the button firmly with some toy filling.

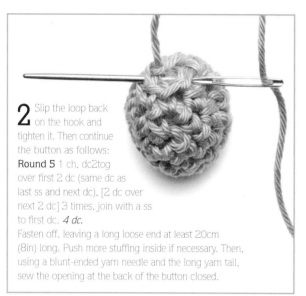

2 Slip the loop back on the hook and tighten it. Then continue the button as follows:
Round 5 1 ch, dc2tog over first 2 dc (same dc as last ss and next dc). [2 dc over next 2 dc] 3 times, join with a ss to first dc. *4 dc.*
Fasten off, leaving a long loose end at least 20cm (8in) long. Push more stuffing inside if necessary. Then, using a blunt-ended yarn needle and the long yarn tail, sew the opening at the back of the button closed.

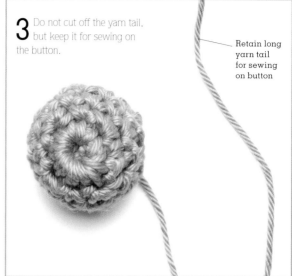

3 Do not cut off the yarn tail, but keep it for sewing on the button.

Retain long yarn tail for sewing on button

BUTTON LOOPS

Button loops are very easy to make along the edge of a cushion cover, the front of a cardigan, or for closings on baby garments.

1 Work in double crochet to the position of the button loop. Make 2, 3, or more chains, depending on the size of the button.

2 Skip the same number of stitches on the edge and work the next double crochet in the next stitch. Test the size of the first completed button loop with the button and adjust the number of chains if necessary.

3 Continue along the edge, working double crochet and button loops until the edging is complete. To make stronger loops, work a second row of double crochet along the first row, working the same number of double crochet stitches as chains into each loop.

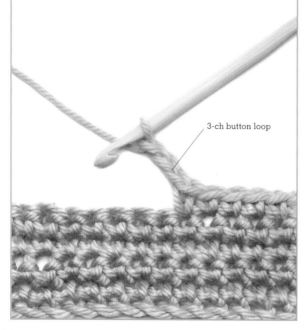

3-ch button loop

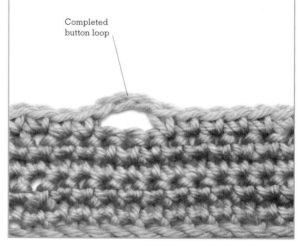

Completed button loop

Blocking and seams

Always sew the seams on a garment or accessory using a blunt-ended needle and a matching yarn (a contrasting yarn is used here just to show the seam techniques more clearly); and work them in the order given in the crochet pattern. But before sewing any seams, block your crochet pieces carefully. Press the finished seams very lightly with a cool iron on the wrong side after completion.

WET BLOCKING

If your yarn will allow it, wet blocking is the best way to even out crochet. Wet the pieces in a sink full of lukewarm water. Then squeeze out the water and roll the crochet in a towel to remove excess dampness. Smooth the crochet into shape right-side down on layers of dry towels covered with a sheet, pinning at intervals. Add as many pins as is necessary to refine the shape. Do not move the crochet until it is completely dry.

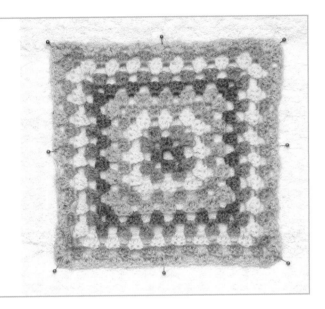

STEAM BLOCKING

For a speedier process you may prefer steam blocking (if your yarn label allows it). First, pin the crochet right-side down into the correct shape. Then steam the crochet gently using a clean damp cloth, but barely touching the cloth with the iron. Never rest the weight of an iron on your crochet or it will flatten the texture. Leave the steamed piece to dry completely before unpinning it.

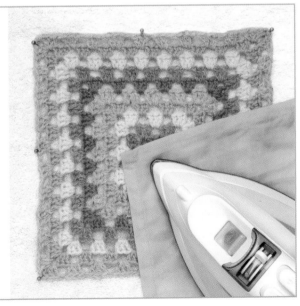

BACKSTITCH SEAM

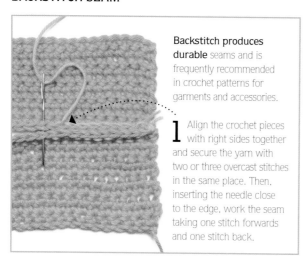

Backstitch produces **durable** seams and is frequently recommended in crochet patterns for garments and accessories.

1 Align the crochet pieces with right sides together and secure the yarn with two or three overcast stitches in the same place. Then, inserting the needle close to the edge, work the seam taking one stitch forwards and one stitch back.

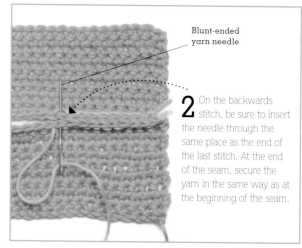

Blunt-ended yarn needle

2 On the backwards stitch, be sure to insert the needle through the same place as the end of the last stitch. At the end of the seam, secure the yarn in the same way as at the beginning of the seam.

OVERCAST STITCH SEAM (ALSO CALLED WHIP STITCH)

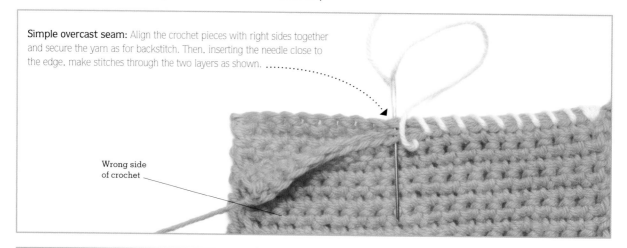

Simple overcast seam: Align the crochet pieces with right sides together and secure the yarn as for backstitch. Then, inserting the needle close to the edge, make stitches through the two layers as shown.

Wrong side of crochet

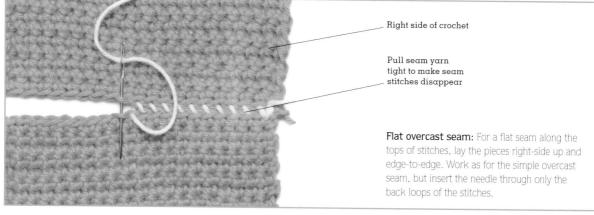

Right side of crochet

Pull seam yarn tight to make seam stitches disappear

Flat overcast seam: For a flat seam along the tops of stitches, lay the pieces right-side up and edge-to-edge. Work as for the simple overcast seam, but insert the needle through only the back loops of the stitches.

EDGE-TO-EDGE SEAM (ALSO CALLED MATTRESS STITCH)

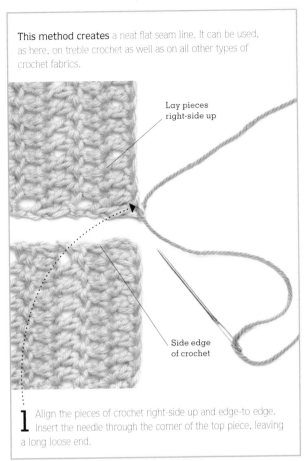

This method creates a neat flat seam line. It can be used, as here, on treble crochet as well as on all other types of crochet fabrics.

Lay pieces right-side up

Side edge of crochet

1 Align the pieces of crochet right-side up and edge-to edge. Insert the needle through the corner of the top piece, leaving a long loose end.

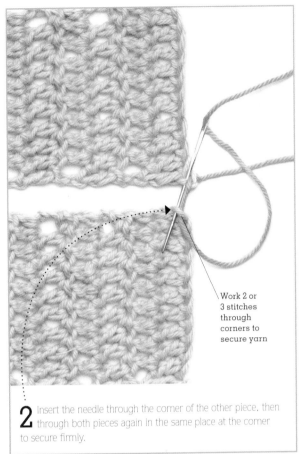

Work 2 or 3 stitches through corners to secure yarn

2 Insert the needle through the corner of the other piece, then through both pieces again in the same place at the corner to secure firmly.

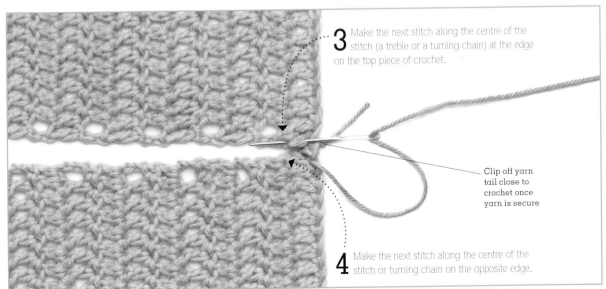

3 Make the next stitch along the centre of the stitch (a treble or a turning chain) at the edge on the top piece of crochet.

Clip off yarn tail close to crochet once yarn is secure

4 Make the next stitch along the centre of the stitch or turning chain on the opposite edge.

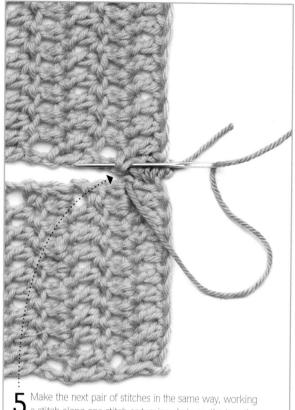

5 Make the next pair of stitches in the same way, working a stitch along one stitch or turning chain on the top piece, then, on the opposite piece.

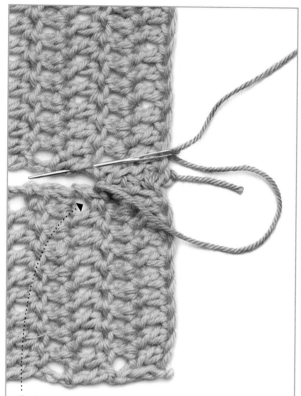

6 Continue along the seam, taking a stitch in each side alternately. Take shorter stitches on each piece if the yarn used for the pieces is bulky.

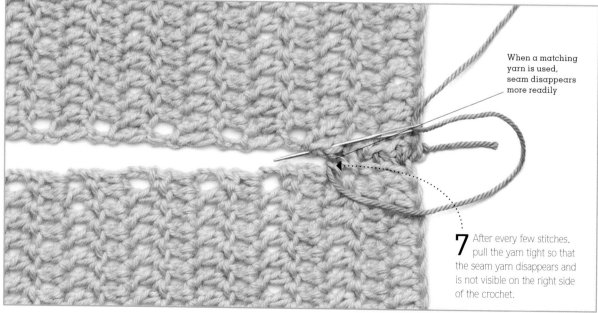

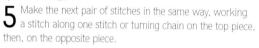

When a matching yarn is used, seam disappears more readily

7 After every few stitches, pull the yarn tight so that the seam yarn disappears and is not visible on the right side of the crochet.

SLIP STITCH SEAM

1 Instead of using a yarn needle to join your seam, you can use a crochet hook to work a quicker seam. Although seams can be worked with double crochet, slip stitch seams are less bulky. Start by placing a slip knot on the hook.

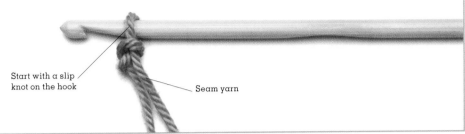

Start with a slip knot on the hook

Seam yarn

2 Align the two layers of crochet with the right sides together.

3 Then with the slip knot on the hook, insert the hook through the two layers at the starting end of the seam, wrap the yarn around the hook, and draw a loop through the two layers and the loop on the hook.

4 Continue in this way and fasten off at the end. When working the seam along the tops of stitches (as here), insert the hook through only the back loops of the stitches. Along row-end edges, work through the layers one stitch in from the edge.

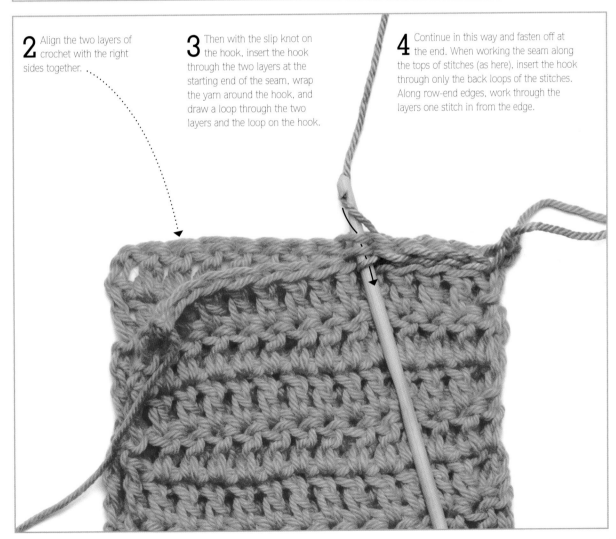

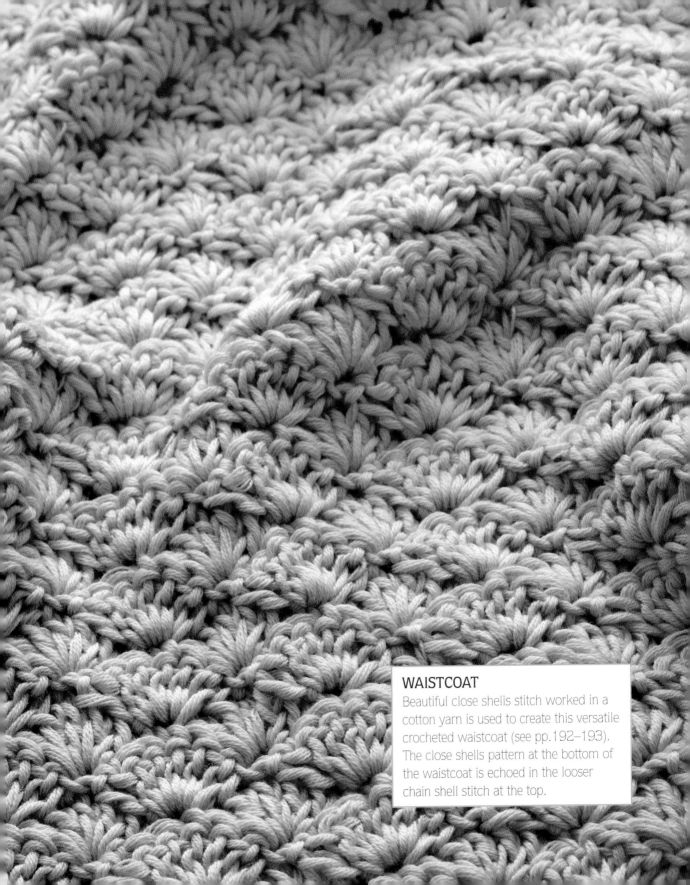

WAISTCOAT

Beautiful close shells stitch worked in a cotton yarn is used to create this versatile crocheted waistcoat (see pp.192–193). The close shells pattern at the bottom of the waistcoat is echoed in the looser chain shell stitch at the top.

Embellishments for crochet

There are many ways to add subtle or bold embellishments to your crochet. Although it may seem unimportant, choosing the right buttons when they are required comes top of the list, so always select buttons carefully and take your finished crochet along to try them out before purchasing any. Other adornments that will dress up your crochet include beads, ribbons, pompoms and fringe, edgings, and embroidery.

Beaded crochet

Beads can be sewn onto your finished crochet if you are only adding a few. But for an allover effect, work the beads into the fabric as you crochet. The most common beaded crochet technique uses double crochet as the background to the beads.

WORKING BEADED DOUBLE CROCHET

Beaded crochet is suitable for a range of simple, spaced-out, all-over geometric patterns. But beware of using too many beads on the crochet or beads that are too big, as they can add so much extra weight to the fabric that they stretch it out.

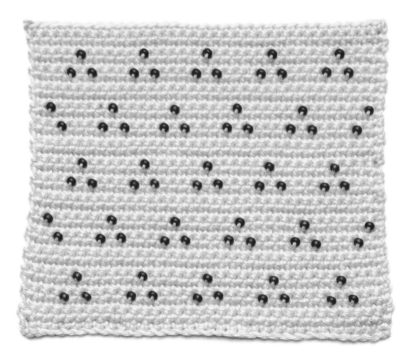

1 Beaded double crochet is usually worked from a chart that shows the positions of the beads on the fabric. The chart is read as for a chart for colourwork (see p.91) and the key provided with the chart indicates which stitches are worked as plain double crochet and which have beads.

2 Loop the end of the yarn into a loop of sewing thread as shown, then thread the beads onto the needle and down onto the yarn.

3 Follow the chart for the bead pattern, sliding the beads along the yarn until they are needed. The beads are always positioned on wrong-side rows. When a bead position is reached, work the next double crochet up to the last yrh – there are now 2 loops on the hook. Slide a bead up close to the crochet and wrap the yarn around the hook.

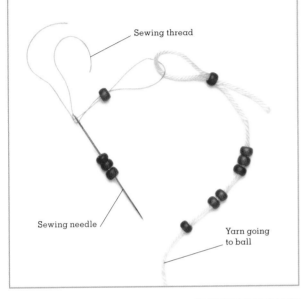

Sewing thread

Sewing needle

Yarn going to ball

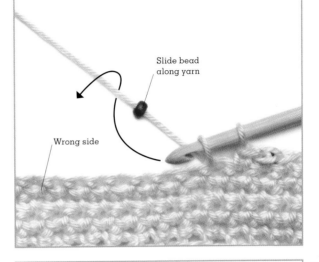

Slide bead along yarn

Wrong side

4 Draw a loop through both loops on the hook to complete the double crochet.

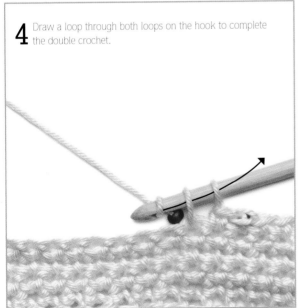

5 Complete the double crochet tightly, so that the bead sits snugly against the fabric on the right side of the crochet.

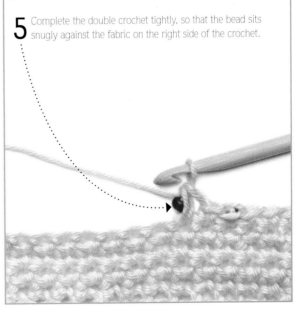

Embroidery on crochet

Because double crochet creates such a firm fabric, it is easy to work embroidery onto it. Many embroidery stitches are suitable for crochet and a few of the most popular ones are given here. Use the same yarn for the embroidery as the yarn used for the crochet, or a slightly thicker yarn, so that the stitches will show up well. Always work the stitches with the same type of blunt-ended yarn needle that is used for seams.

BLANKET STITCH

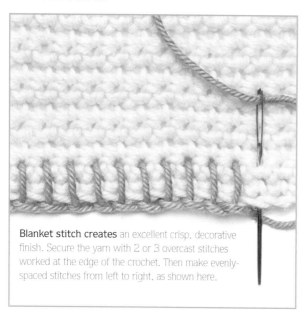

Blanket stitch creates an excellent crisp, decorative finish. Secure the yarn with 2 or 3 overcast stitches worked at the edge of the crochet. Then make evenly-spaced stitches from left to right, as shown here.

CHAIN STITCH

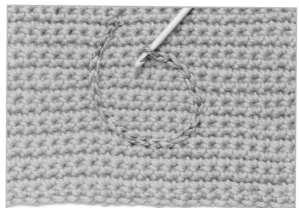

Chain stitch is perfect for curved motifs. Hold the yarn on the wrong side of the fabric and draw loops through with the hook. To fasten off, pull the yarn end through the last loop and then back to the wrong side over the loop. Darn in the ends on the wrong side.

CROSS STITCH

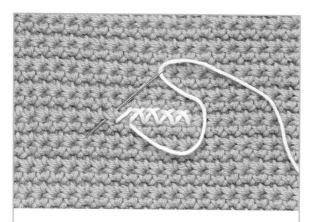

1 Work each individual cross stitch on double crochet over a single double crochet stitch. Complete each cross stitch before moving on to the next. Keep the stitches fairly loose so they don't distort the crochet.

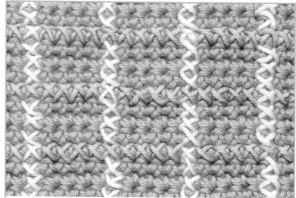

2 Adding lines of cross stitches is an effective way to create an interesting plaid pattern on a base of plain double crochet. This is the perfect technique for dressing up a simple piece of double crochet.

Edgings on crochet

Several edging patterns are provided on pp.127–135 because they are excellent, simple adornment for your crochet. Some edgings can be worked directly onto your crochet (see pp.114–115), and others made separately and then sewn on.

ADDING EDGINGS

To sew an edging in place, use a yarn that matches the base crochet and a blunt-ended yarn needle. Secure the yarn at the right-hand end of the seam with 2 or 3 overcast stitches. Then work evenly spaced overcast stitches through both the base crochet and the edging, as shown.

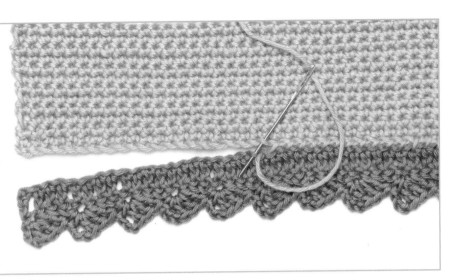

Simple edging patterns

Adding a decorative crochet edging to an otherwise mundane-looking piece of crochet can transform it, giving it a touch of elegance. All the simple crochet edgings that follow are worked widthwise, so you start with a length of chain roughly equivalent to the length of edging you need. Suitable even for beginners, these edgings are perfect for dressing up towel ends, throws, baby blankets, necklines, and cuffs. When making an edging that will encircle a blanket, be sure to add extra for turning the corners; the edging can then be gathered at each corner to allow for the turning. Use a short test swatch to calculate how much extra you will need at each corner. See pp.68–69 for abbreviations and symbols.

GRAND EYELET EDGING

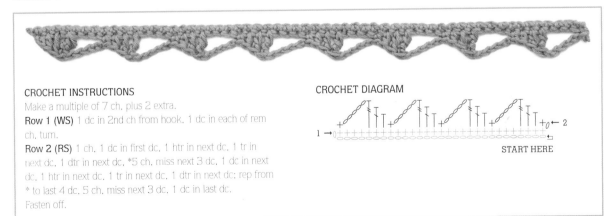

CROCHET INSTRUCTIONS
Make a multiple of 7 ch, plus 2 extra.
Row 1 (WS) 1 dc in 2nd ch from hook, 1 dc in each of rem ch, turn.
Row 2 (RS) 1 ch, 1 dc in first dc, 1 htr in next dc, 1 tr in next dc, 1 dtr in next dc, *5 ch, miss next 3 dc, 1 dc in next dc, 1 htr in next dc, 1 tr in next dc, 1 dtr in next dc; rep from * to last 4 dc, 5 ch, miss next 3 dc, 1 dc in last dc.
Fasten off.

CROCHET DIAGRAM

START HERE

BOLD SCALLOP EDGING

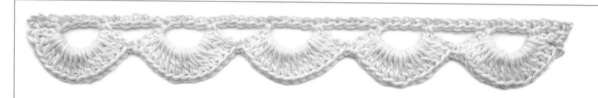

CROCHET INSTRUCTIONS

Make a multiple of 10 ch, plus 2 extra.

Row 1 (RS) 1 dc in 2nd ch from hook, 1 dc in each of rem ch, turn.

Row 2 1 ch, 1 dc in first dc, 2 ch, miss next 2 dc, 1 dc in next dc, 7 ch, miss next 3 dc, 1 dc in next dc, *6 ch, miss next 5 ch, 1 dc in next dc, 7 ch, miss next 3 dc, 1 dc in next dc; rep from * to last 3 dc, 2 ch, miss next 2 dc, 1 dc in last dc, turn.

Row 3 1 ch, 1 dc in first dc, 13 tr in 7-ch loop, *1 dc in next 6-ch sp, 13 tr in next 7-ch loop; rep from *, ending with 1 dc in last dc.
Fasten off.

CROCHET DIAGRAM

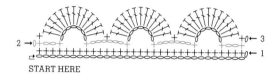

DIAMOND EDGING

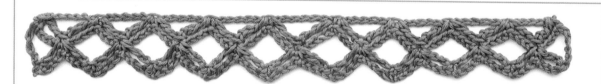

CROCHET INSTRUCTIONS

Make a multiple of 6 ch, plus 2 extra.

Row 1 (RS) 1 dc in 2nd ch from hook, *4 ch, yrh twice and insert hook in same place as last dc, [yrh and draw first 2 loops on hook] twice, yrh twice, miss next 5 ch and insert hook in next ch, [yrh and draw first 2 loops on hook] twice, yrh and draw through all 3 loops on hook (called dtr2tog). 4 ch, 1 dc in same place as last dtr; rep from * to end, turn.

Row 2 5 ch, 1 dtr in first dtr2tog, 4 ch, 1 dc in same place as last dtr, *4 ch, dtr2tog over last dtr worked into and next dtr, 4 ch, 1 dc in same place as last dtr; rep from *, 4 ch, yrh twice and insert hook in same place as last dc, [yrh and draw first 2 loops on hook] twice, yrh 3 times and insert hook in last dc in previous row, [yrh and draw first 2 loops on hook] 3 times, yrh and draw through all 3 loops on hook.
Fasten off.

CROCHET DIAGRAM

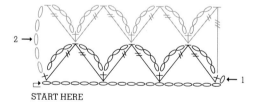

TRIPLE PICOT EDGING

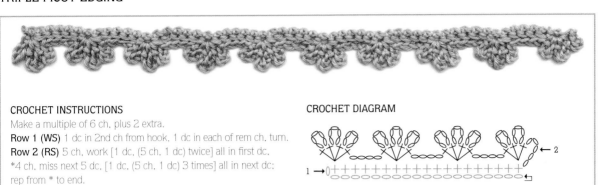

CROCHET INSTRUCTIONS

Make a multiple of 6 ch, plus 2 extra.
Row 1 (WS) 1 dc in 2nd ch from hook, 1 dc in each of rem ch, turn.
Row 2 (RS) 5 ch, work [1 dc, (5 ch, 1 dc) twice] all in first dc,
*4 ch, miss next 5 dc, [1 dc, (5 ch, 1 dc) 3 times] all in next dc;
rep from * to end.
Fasten off.

CROCHET DIAGRAM

PICOT SCALLOP EDGING

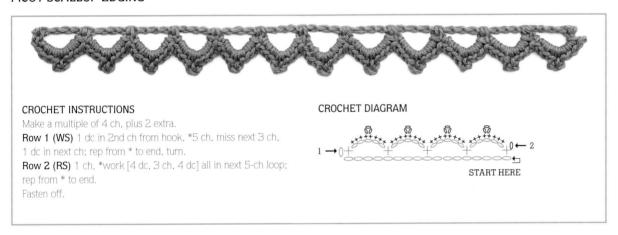

CROCHET INSTRUCTIONS

Make a multiple of 4 ch, plus 2 extra.
Row 1 (WS) 1 dc in 2nd ch from hook, *5 ch, miss next 3 ch,
1 dc in next ch; rep from * to end, turn.
Row 2 (RS) 1 ch, *work [4 dc, 3 ch, 4 dc] all in next 5-ch loop;
rep from * to end.
Fasten off.

CROCHET DIAGRAM

PILLAR EDGING

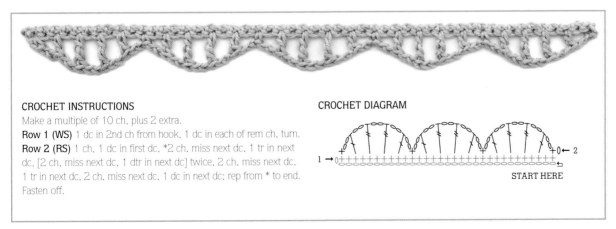

CROCHET INSTRUCTIONS

Make a multiple of 10 ch, plus 2 extra.
Row 1 (WS) 1 dc in 2nd ch from hook, 1 dc in each of rem ch, turn.
Row 2 (RS) 1 ch, 1 dc in first dc, *2 ch, miss next dc, 1 tr in next
dc, [2 ch, miss next dc, 1 dtr in next dc] twice, 2 ch, miss next dc,
1 tr in next dc, 2 ch, miss next dc, 1 dc in next dc; rep from * to end.
Fasten off.

CROCHET DIAGRAM

TWIRL FRINGE

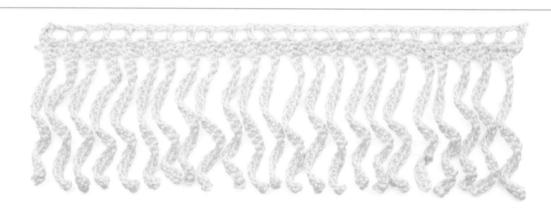

CROCHET INSTRUCTIONS

Note: The fringe will twirl naturally; do not press out the twirls.

To start edging, make a multiple of 2 ch.

Row 1 (WS) 1 dtr in 4th ch from hook, *1 ch, miss next ch, 1 dtr in next ch; rep from * to end, turn.

Row 2 (RS) 1 ch, 1 dc in first dtr, *24 ch, 1 dc in 2nd ch from hook, 1 dc in each of rem 22 ch, 1 dc in next dtr; rep from * to end.

Fasten off.

CROCHET DIAGRAM

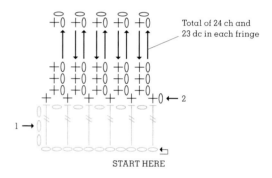

Total of 24 ch and 23 dc in each fringe

START HERE

DOUBLE LOOP EDGING

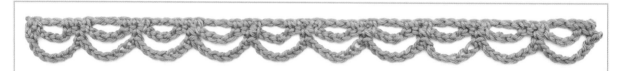

CROCHET INSTRUCTIONS

To start edging, make a multiple of 5 ch, plus 2 extra.

Row 1 (WS) 1 dc in 2nd ch from hook, 1 dc in next ch, *5 ch, miss next 2 ch, 1 dc in each of next 3 ch; rep from * to last 4 ch, 5 ch, miss next 2 ch, 1 dc in each of last 2 ch, turn.

Row 2 (RS) 1 ch, 1 dc in first dc, *8 ch, 1 dc in centre dc of next group of 3-dc (at other side of 5-ch loop); rep from * working last dc in last dc of row 1.

Fasten off.

CROCHET DIAGRAM

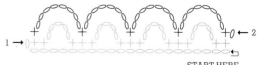

START HERE

CLUSTER SCALLOP EDGING

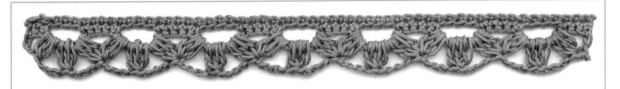

CROCHET INSTRUCTIONS

Make a multiple of 8 ch, plus 2 extra.

Row 1 (RS) 1 dc in 2nd ch from hook, 1 dc in each of rem ch, turn.

Row 2 1 ch, 1 dc in first dc, 1 dc in each of next 2 dc, *6 ch, miss next 3 dc, 1 dc in each of next 5 dc; rep from * to last 6 dc, 6 ch, miss next 3 dc, 1 dc in each of last 3 dc, turn.

Row 3 3 ch, work [yrh, insert hook in ch sp, yrh and draw a loop through, yrh and draw through first 2 loops on hook] 3 times in next 6-ch sp, 4 loops now on hook, yrh and draw through all 4 loops on hook to close 3-tr group (called 3-tr cluster), *4 ch, 3-tr cluster in same ch sp, 4 ch, 3-tr cluster in same ch sp BUT do not close cluster (leave last 4 loops on hook), 3-tr cluster in next 6-ch sp and close this cluster and last cluster at the same time by drawing a loop through all 7 loops on hook; rep from * to last 6-ch sp, [4 ch, 3-tr cluster in same ch sp] twice, 1 tr in last dc of row 2.
Fasten off.

CROCHET DIAGRAM

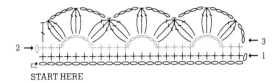

START HERE

SIMPLE SHELL EDGING

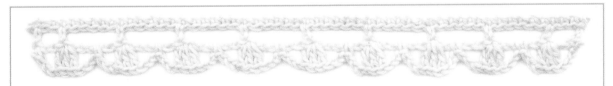

CROCHET INSTRUCTIONS

Make a multiple of 6 ch, plus 2 extra.

Row 1 (RS) 1 dc in 2nd ch from hook, 1 dc in each of rem ch, turn.

Row 2 5 ch, miss first 3 dc, 1 tr in next dc, *5 ch, miss next 5 dc, 1 tr in next dc; rep from * to last 3 dc, 2 ch, miss next 2 dc, 1 tr in last dc, turn.

Row 3 1 ch, 1 dc in first tr, 3 ch, 3 tr in next tr, *3 ch, 1 dc in next 5-ch space, 3 ch, 3 tr in next tr; rep from *, ending with 3 ch, miss first 2 ch of last 5-ch, 1 dc in next ch.
Fasten off.

CROCHET DIAGRAM

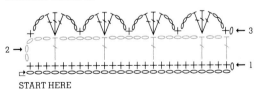

START HERE

LONG LOOP EDGING

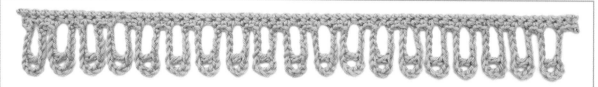

CROCHET INSTRUCTIONS

Make a multiple of 3 ch.
Row 1 (WS) 1 dc in 2nd ch from hook, 1 dc in each of rem ch, turn.
Row 2 (RS) 1 ch, 1 dc in first dc, 9 ch, 1 tr in 6th ch from hook, 4 ch, *1 dc in each of next 3 dc, 9 ch, 1 tr in 6th ch from hook, 4 ch; rep from * to last dc, 1 dc in last dc.
Fasten off.

CROCHET DIAGRAM

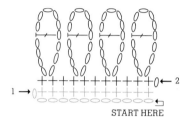

START HERE

DOUBLE SCALLOP EDGING

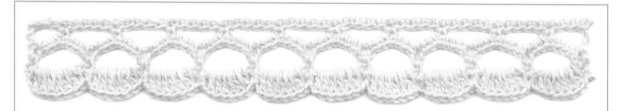

CROCHET INSTRUCTIONS

Make a multiple of 5 ch, plus 2 extra.
Row 1 (RS) 1 dc in 2nd ch from hook, 1 dc in each of rem ch, turn.
Row 2 6 ch, miss first 2 dc, 1 dc in next dc, *5 ch, miss next 4 dc, 1 dc in next dc; rep from * to last 3 dc, 3 ch, miss next 2 dc, 1 tr in last dc, turn.
Row 3 3 ch, 3 dc in first 3-ch sp, 1 dc in next dc (between loops), *work [3 dc, 3 ch, 3 dc] all in next 5-ch loop, 1 dc in next dc; rep from *, ending with [3 dc, 3 ch, 1 dc] in last 6-ch loop, turn.
Row 4 1 ch, 1 dc in first 3-ch picot, *5 ch, 1 dc in next 3-ch picot; rep from * to end, turn.
Row 5 1 ch, 1 dc in first dc, *1 ch, 6 tr in next 5-ch loop, 1 ch, 1 dc in next dc; rep from * to end.
Fasten off.

CROCHET DIAGRAM

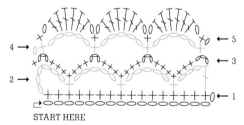

START HERE

CIRCLES EDGING

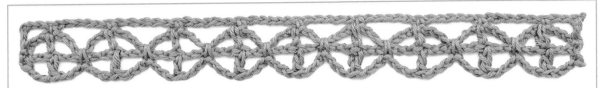

CROCHET INSTRUCTIONS

Make a multiple of 6 ch.
Row 1 (RS) 1 dc in 9th ch from hook.
*7 ch, miss next 5 ch, 1 dc in next ch;
rep from * to last 3 ch, 3 ch, miss next
2 ch, 1 dc in last ch, turn.
Row 2 1 ch, 1 dc in first tr, 2 ch, 1 tr in
next dc, *5 ch, 1 tr in next dc; rep from *,
ending with 2 ch, 1 dc in 4th ch from last
dc in previous row, turn.
Row 3 1 ch, 1 dc in first dc, *3 ch, 1 tr
in next tr, 3 ch, 1 dc in 7-ch loop of row
1 (catching 5-ch loop in previous row
inside dc); rep from * to end working
last dc of last rep in last dc of row 2.
Fasten off.

CROCHET DIAGRAM

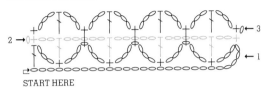

START HERE

PETAL EDGING

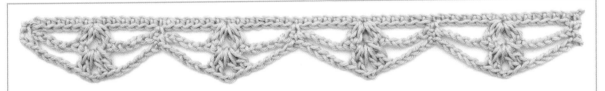

CROCHET INSTRUCTIONS

Make a multiple of 14 ch, plus 2 extra.
Row 1 (RS) 1 dc in 2nd ch from hook.
1 dc in each of rem ch, turn.
Row 2 1 ch, 1 dc in first dc, *6 ch, miss
next 6 dc, work [2 tr, 2 ch, 2 tr] all in next
dc, 6 ch, miss next 6 dc, 1 dc in next dc;
rep from * to end, turn.
Row 3 1 ch, 1 dc in first dc, *6 ch, work
[2 tr, 2 ch, 2 tr] all in next 2-ch sp, 6 ch,
1 dc in next dc; rep from * to end.
Fasten off.
Note: When blocking this edging, pin out
each point at each 2-ch sp to achieve
correct shape.

CROCHET DIAGRAM

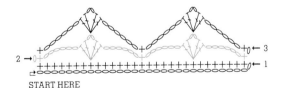

START HERE

CHAIN FRINGE

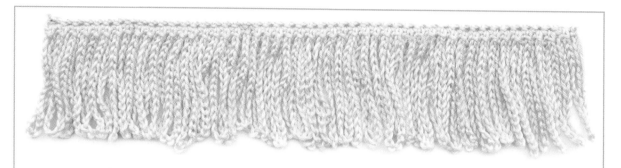

CROCHET INSTRUCTIONS

Note: This fringe is worked onto a row of dc. The length of the fringe can be altered by changing the number of chains in each fringe loop. To start the edging, make 1 ch more than the required number of dc.

Row 1 (WS) 1 dc in 2nd ch from hook, 1 dc in each of rem ch, turn.

Row 2 (RS) 1 ch, 1 dc in first dc, 29 ch, 1 dc in same place as last dc, *1 dc in next dc, 29 ch, 1 dc in same place as last dc; rep from * to end.

Fasten off.

CROCHET DIAGRAM

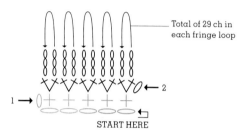

Total of 29 ch in each fringe loop

START HERE

STEP EDGING

CROCHET INSTRUCTIONS

Make a multiple of 4 ch, plus 3 extra.

Row 1 (WS) 1 tr in 4th ch from hook, 1 tr in each of rem ch, turn.

Row 2 (RS) 3 ch, 3 tr in first tr, *miss next 3 tr, work [1 dc, 3 ch, 3 tr] all in next tr; rep from * to last 3 tr, miss last 3 tr, 1 dc in top of 3-ch at end.

Fasten off.

CROCHET DIAGRAM

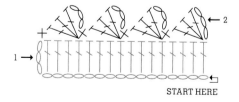

START HERE

SIMPLE MULTIPLE-STITCH EDGING

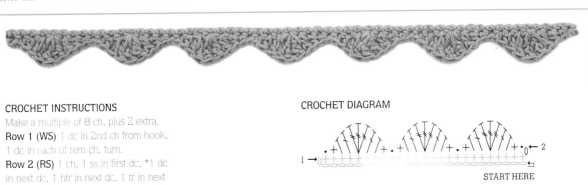

CROCHET INSTRUCTIONS

Make a multiple of 8 ch, plus 2 extra.
Row 1 (WS) 1 dc in 2nd ch from hook,
1 dc in each of rem ch, turn.
Row 2 (RS) 1 ch, 1 ss in first dc. *1 dc
in next dc, 1 htr in next dc, 1 tr in next
dc; 3 dtr in next dc, 1 tr in next dc, 1 htr
in next dc, 1 dc in next dc, 1 ss in next dc,
rep from * to end.
Fasten off.

CROCHET DIAGRAM

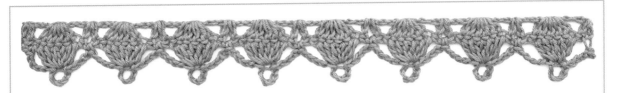

START HERE

CLUSTER AND SHELL EDGING

CROCHET INSTRUCTIONS

Make a multiple of 8 ch, plus 4 extra.
Row 1 (WS) 1 tr in 4th ch from hook. *miss
next 3 ch, 6 tr in next ch (to make a shell),
miss next 3 ch, work [1 tr, 1 ch, 1 tr] all in
next ch; rep from * to last 8 ch, miss next
3 ch, 6 tr in next ch, miss next 3 ch, 2 tr in
last ch, turn.
Row 2 (RS) 1 ch, miss first tr, 1 dc in next tr,
*4 ch, [yrh, insert hook in next tr, yrh and draw
a loop through, yrh and draw through first
2 loops on hook] 6 times (once into each of
6 tr of shell), yrh and draw through all 7 loops
on hook to complete cluster, 6 ch, 1 ss in top
of cluster just made, 4 ch, 1 dc in next 1-ch sp
(between 2 tr); rep from * to end, working last
dc of last rep in top of 3-ch at end.
Fasten off.

CROCHET DIAGRAM

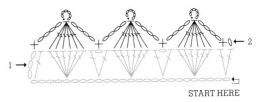

START HERE

Circular crochet

Crochet can be worked not only back and forth in rows, but round and round in circles to form tubes or flat shapes started from the centre (called medallions). The basic techniques for crocheting in the round are very easy to learn, even for a beginner, so it is not surprising that many popular crochet accessories are made with circular crochet, including flowers and afghan motifs, as well as seamless toys, hats, mittens, containers, and bags.

Crocheting tubes

Tubular crochet is started on a long foundation chain joined to form a ring, and the rounds of stitches are worked around this ring. The easiest of all crochet cylinders is double crochet worked in a spiral without turning chains.

STARTING A TUBE

1 Start the crochet cylinder, or tube, with the length of chain specified in your crochet pattern. Then insert the hook through the first chain.

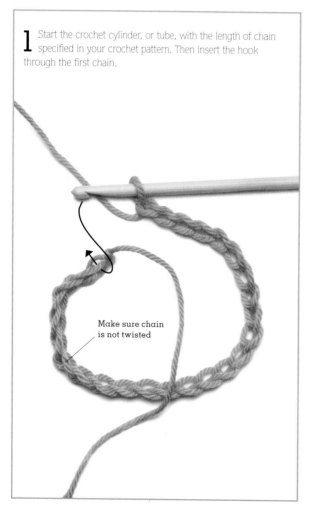

Make sure chain is not twisted

2 Draw a loop through the chain and at the same time through the loop on the hook to complete the slip stitch. This joins the chain into a ring. Work the first and following rounds as directed in your pattern.

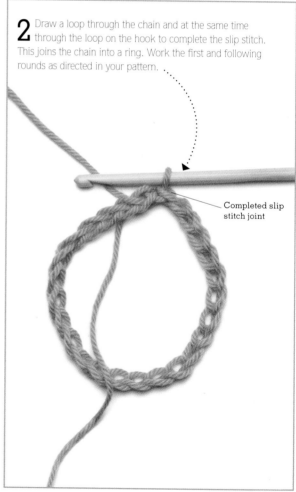

Completed slip stitch joint

DOUBLE CROCHET SPIRAL TUBE

1 Make the foundation ring and work one chain. Work the first double crochet into the same place as the slip stitch. Then work 1 dc into each of the remaining chains of the ring.

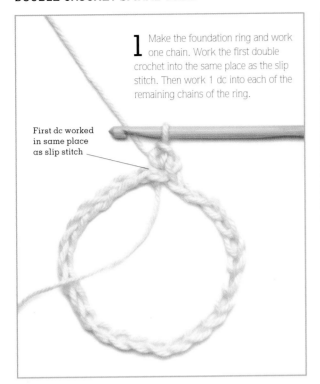

First dc worked in same place as slip stitch

2 Place a stitch marker on the last stitch of the first round to keep track of where the rounds begin and end.

3 To begin the second round, work the next stitch into the first stitch of the previous round.

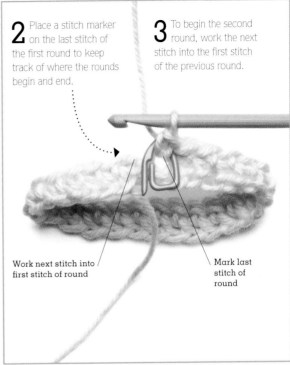

Work next stitch into first stitch of round

Mark last stitch of round

4 On the second round, work 1 dc in each dc in the round below.

5 At the end of the round move the marker up onto the last stitch of this round. (As the spiral grows, the beginning of the round moves gradually to the right.)

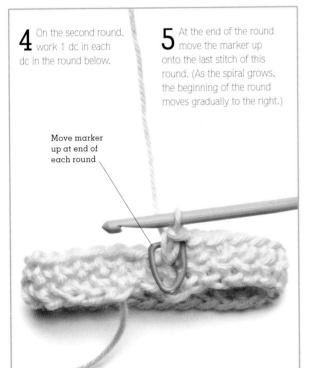

Move marker up at end of each round

6 Continue round and round in the same way until the crochet tube is the required length.

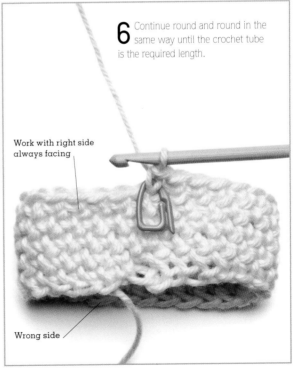

Work with right side always facing

Wrong side

TREBLE CROCHET TUBE WITHOUT TURNS

When basic stitches taller than double crochet are used to make crochet tubes, each round is started with a turning chain.

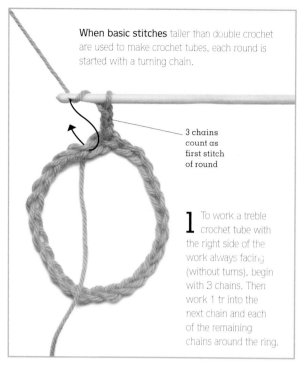

3 chains count as first stitch of round

1 To work a treble crochet tube with the right side of the work always facing (without turns), begin with 3 chains. Then work 1 tr into the next chain and each of the remaining chains around the ring.

2 At the end of the round, join the last stitch to the top of the turning chain at the beginning of the round by working a slip stitch into the third of the 3 chains.

Join with a slip stitch to top of 3 chains

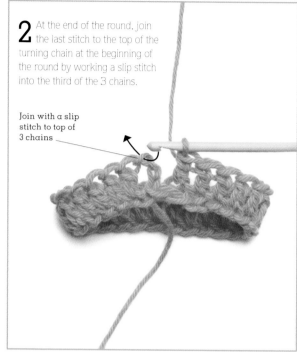

3 Start the second round with 3 chains. There is no need to mark the end of the round with a stitch marker as the turning chain shows where each round begins. Continue around the tube again, working 1 tr into each tr in the previous round.

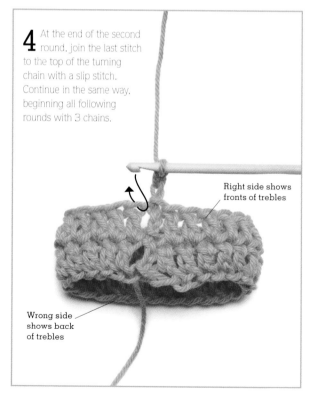

3 chains count as first stitch

4 At the end of the second round, join the last stitch to the top of the turning chain with a slip stitch. Continue in the same way, beginning all following rounds with 3 chains.

Right side shows fronts of trebles

Wrong side shows back of trebles

TREBLE CROCHET TUBE WITH TURNS

If a treble crochet tube needs to match crochet worked in rows in other parts of an item, then the work can be turned at the end of each round.

1 Work the first round in treble crochet as for a tube without turns. Then turn the work, make 3 chains as shown, and complete the round.

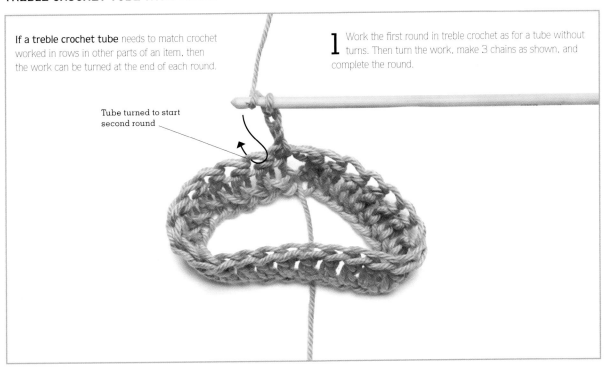

Tube turned to start second round

2 To begin the third round, turn the work and start with 3 chains.

3 Continue in this way, joining the last stitch with a slip stitch to the top of the turning chain at the end of each round, then turning the work to start the next round. The fabric looks just like treble crochet that has been worked in ordinary rows.

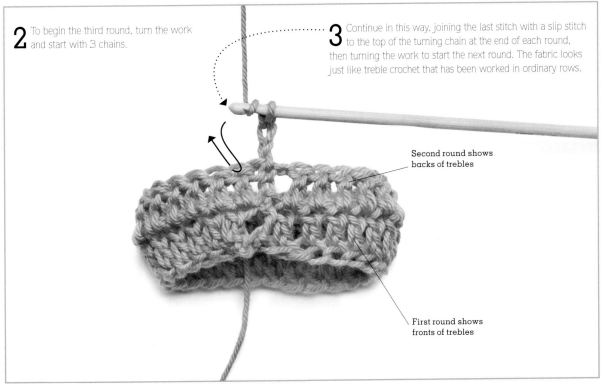

Second round shows backs of trebles

First round shows fronts of trebles

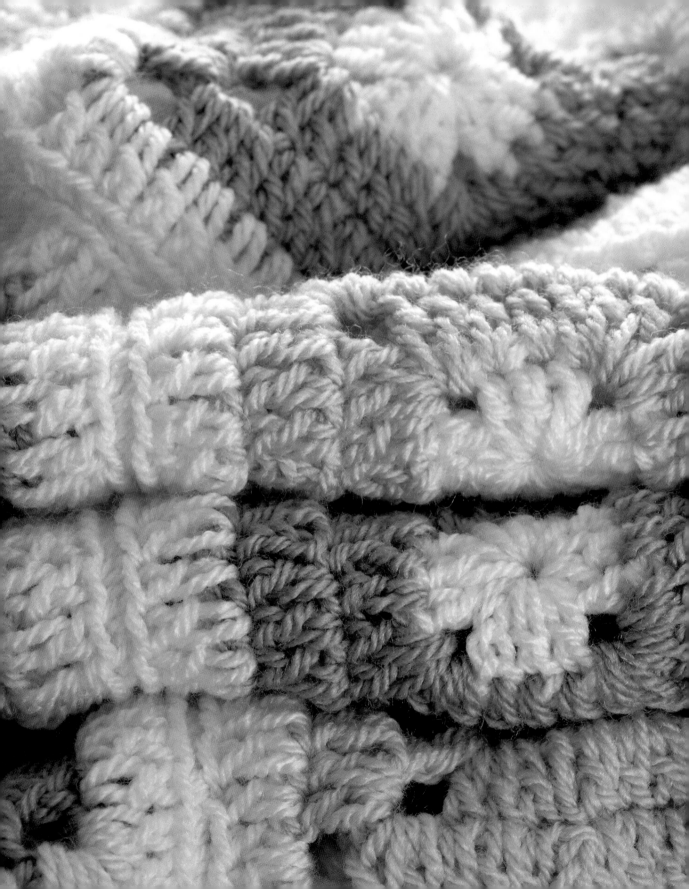

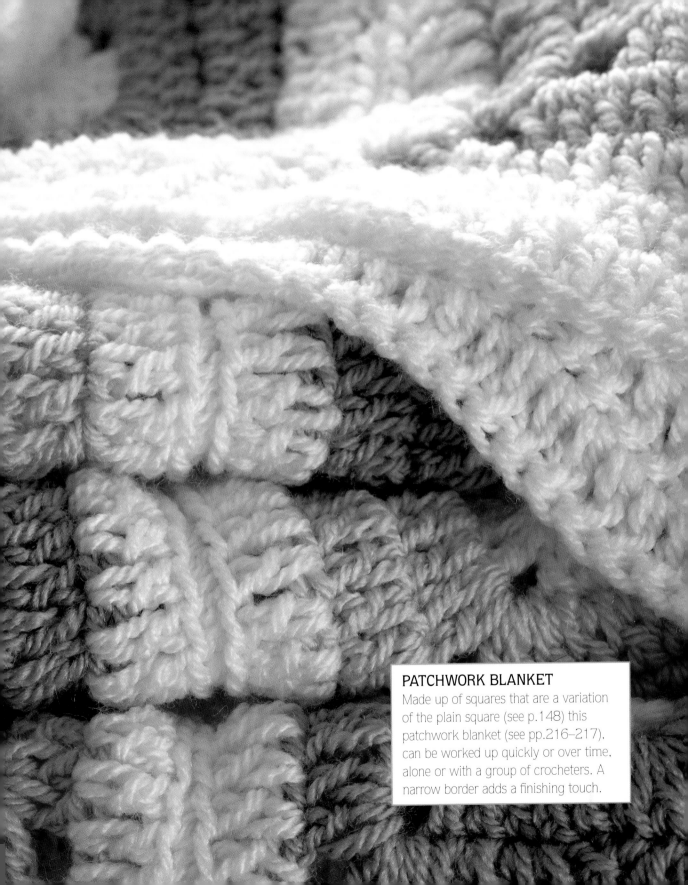

PATCHWORK BLANKET
Made up of squares that are a variation of the plain square (see p.148) this patchwork blanket (see pp.216–217). can be worked up quickly or over time. alone or with a group of crocheters. A narrow border adds a finishing touch.

Flat circles

Making a simple circle is a good example for how other flat medallion shapes are started and then worked round and round from the centre. The circle is also used in conjunction with the crochet tube to make containers (see pp.156–157) or the parts of toys, so it is well worth practising.

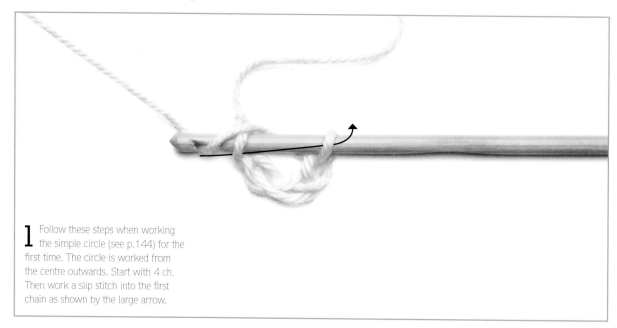

1 Follow these steps when working the simple circle (see p.144) for the first time. The circle is worked from the centre outwards. Start with 4 ch. Then work a slip stitch into the first chain as shown by the large arrow.

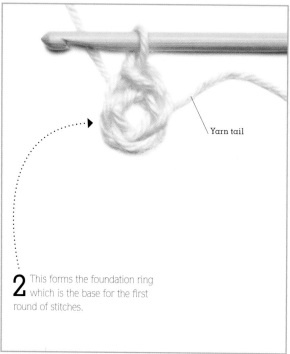

Yarn tail

2 This forms the foundation ring which is the base for the first round of stitches.

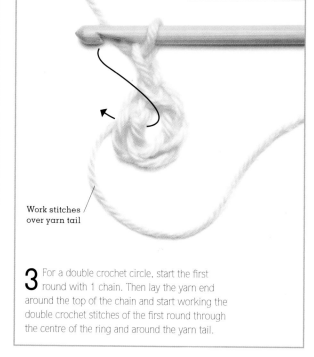

Work stitches over yarn tail

3 For a double crochet circle, start the first round with 1 chain. Then lay the yarn end around the top of the chain and start working the double crochet stitches of the first round through the centre of the ring and around the yarn tail.

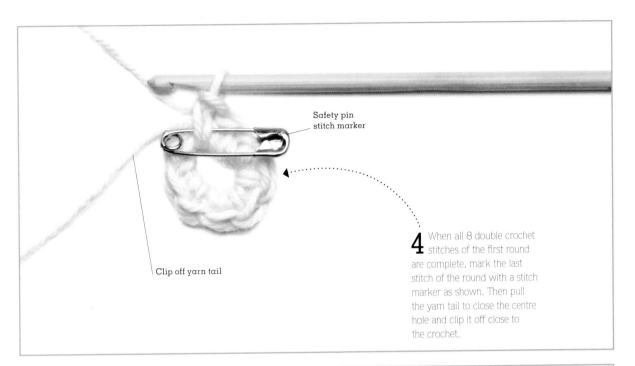

Safety pin
stitch marker

Clip off yarn tail

4 When all 8 double crochet stitches of the first round are complete, mark the last stitch of the round with a stitch marker as shown. Then pull the yarn tail to close the centre hole and clip it off close to the crochet.

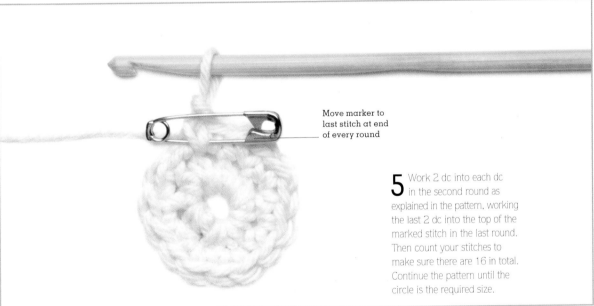

Move marker to
last stitch at end
of every round

5 Work 2 dc into each dc in the second round as explained in the pattern, working the last 2 dc into the top of the marked stitch in the last round. Then count your stitches to make sure there are 16 in total. Continue the pattern until the circle is the required size.

ALTERNATIVE METHODS FOR WORKING FLAT CIRCLES

2-chain: Start with 2 ch. Work required number of dc into 2nd ch from hook, then ss in first dc to close.

Magic loop: Make a loop with yarn (do not start with slip stitch). Insert hook into loop and pull working yarn through. 1 ch.

Working under both loop and tail, insert hook into loop and make required number of dc. Then pull tail to close loop.

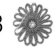

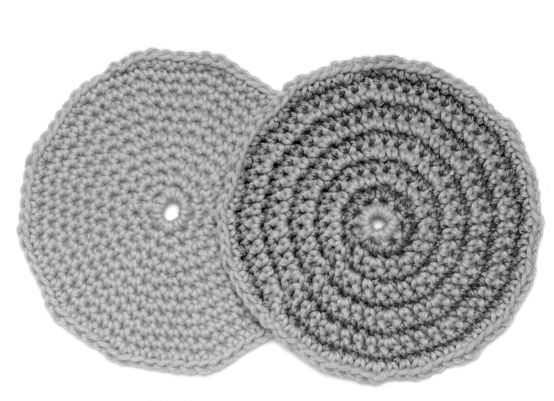

Single colour Two colours

This pattern is for a classic simple crochet circle.
(See pp.68–69 for abbreviations.)

Note: Work the circle in a single colour or in two colours (A and B).
For a two-colour circle, work the foundation ring and round 1 in A,
then work the following rounds in B and A alternately, changing
to the new colour with the last yrh of the last dc of each round
and carrying the colours up the wrong side of the circle.
Make 4 ch and join with a ss in first ch to form a ring.
Round 1 (RS) 1 ch, 8 dc in ring. Do not turn at end of rounds,
but work with RS always facing.
Note: Mark the last stitch of round 1, and at the end of each of
the following rounds, move this marker to the last stitch of the
round just worked.
Round 2 2 dc in each dc. *16 dc.*
Round 3 *1 dc in next dc, 2 dc in next dc; rep from *. *24 dc.*
Round 4 1 dc in each dc.
Round 5 *1 dc in next dc, 2 dc in next dc; rep from *. *36 dc.*

Round 6 Rep round 4.
Round 7 *1 dc in each of next 2 dc, 2 dc in next dc;
rep from *. *48 dc.*
Round 8 Rep round 4.
Round 9 *1 dc in each of next 3 dc, 2 dc in next dc;
rep from *. *60 dc.*
Round 10 Rep round 4.
Round 11 1 dc in each of first 2 dc, 2 dc in next dc, *1 dc
in each of next 4 dc, 2 dc in next dc; rep from *, ending
with 1 dc in each of last 2 dc. *72 dc.*
Work 1 ss in next dc and fasten off.
To make a bigger circle, continue in this way, adding
12 extra dc in every alternate round (by working one more
stitch between increases) and altering the position of the
first increase on every increase round.

Tips for medallions

The principle for starting any medallion shape and working it in rounds is the same as for the simple circle, and many simple crochet flowers are also worked using these techniques (see pp.150–153). If you find it awkward to fit all the stitches of the first round into a tiny foundation ring (see pp.142–143), try the simple loop ring below. Two other useful tips are the techniques for starting new colours and for joining motifs together (see p.146).

MAKING A SIMPLE LOOP RING

1 Making the simple loop ring is a quick way to start working a flat shape in the round, and it allows you to make the centre hole as tight or as open as desired. Start as if you are making a slip knot (see p.32), by forming a circle of yarn and drawing the yarn through the centre of it.

2 Leave the circle of yarn open. Then, to start a round of double crochet stitches, make 1 chain.

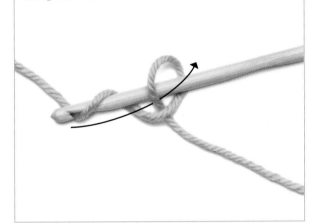

3 Work the first round of double crochet stitches, working them into the ring and over the yarn tail as shown by the large arrow.

4 When all the required stitches are worked into the ring, pull the yarn tail to close the ring. Then continue as explained in the pattern instructions.

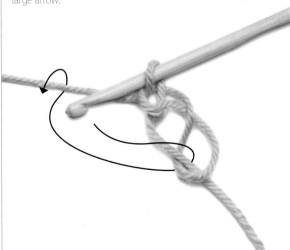

Pull to close ring

JOINING ON A NEW COLOUR

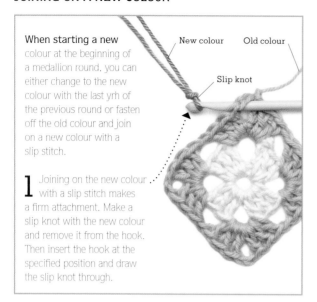

When starting a new colour at the beginning of a medallion round, you can either change to the new colour with the last yrh of the previous round or fasten off the old colour and join on a new colour with a slip stitch.

New colour Old colour

Slip knot

1 Joining on the new colour with a slip stitch makes a firm attachment. Make a slip knot with the new colour and remove it from the hook. Then insert the hook at the specified position and draw the slip knot through.

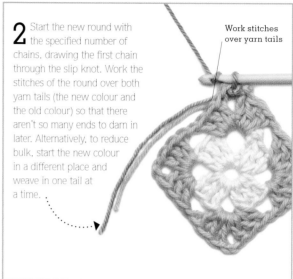

2 Start the new round with the specified number of chains, drawing the first chain through the slip knot. Work the stitches of the round over both yarn tails (the new colour and the old colour) so that there aren't so many ends to darn in later. Alternatively, to reduce bulk, start the new colour in a different place and weave in one tail at a time.

Work stitches over yarn tails

JOINING MEDALLIONS

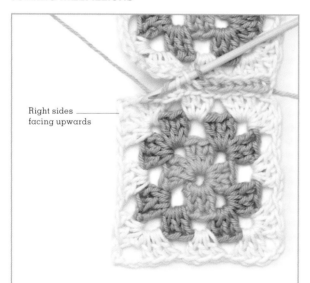

Right sides facing upwards

Flat slip-stitch seam: Working seams with crochet stitches are the quickest way to join medallions. For a slip-stitch seam, lay the two medallions side by side. Work each slip stitch through only 1 loop (the back loop) of the top of a stitch on each medallion. (Use a hook one size smaller than the hook used for the medallions, but work the stitches very loosely.)

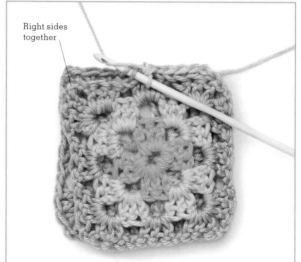

Right sides together

Double-crochet seam: A double crochet seam is also quick to work. It forms a ridge, which can either be a feature on the right side, or hidden on the wrong side of the work. Place the two medallions together, either wrong side to wrong side (ridge on right side), or right side to right side (ridge on wrong side). Then work each double crochet through only 1 loop of the top of a stitch on each medallion (the loop closest to you on the top medallion and the loop farthest from you on the bottom medallion).

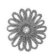

Simple medallion patterns

Making crochet medallions is a great way to use up yarn scraps, and this was probably the reason they became so popular. You can stitch medallions together to form small items like bags or cushion covers, or to form larger items like throws and baby blankets. Joined medallions also make great scarves and shawls, especially when made in gossamer mohair. But if you are a beginner, stick to less hairy yarns when making your first medallions as it is easier to learn the technique with a smooth standard lightweight or medium-weight wool yarn.

SPECIAL NOTES

• When following diagrams, use colours as explained in the written instructions. The tones used in the diagram are used to distinguish the rows and do not indicate colour changes. (See pp.68–69 for a list of crochet abbreviations and basic stitch symbols.)

• Join on new colours as explained opposite.
• Do not turn the medallions at the end of the rounds, but work with the right side always facing.

TRADITIONAL AFGHAN SQUARE

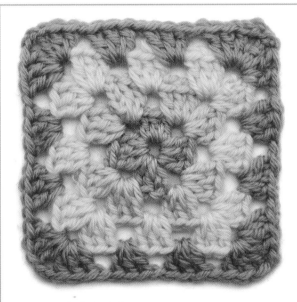

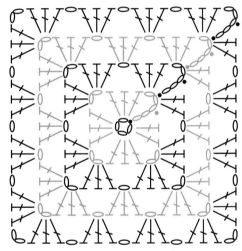

CROCHET DIAGRAM

CROCHET INSTRUCTIONS

This square is worked in 4 colours (A, B, C, D), a different colour for each round.

Using A, make 4 ch and join with a ss to first ch to form a ring.

Round 1 (RS) Using A, 5 ch (counts as 1 tr and a 2-ch sp), [3 tr in ring, 2 ch (these 2-ch form a corner sp)] 3 times, 2 tr in ring, join with a ss to 3rd of 5-ch. Fasten off A.

Round 2 Using B, join with a ss to a 2-ch corner sp, 5 ch, 3 tr in same corner sp, *1 ch, [3 tr, 2 ch, 3 tr] in next 2-ch corner sp; rep from * twice more, 1 ch, 2 tr in same corner sp as 5-ch at beg of round, join with a ss to 3rd of 5-ch. Fasten off B.

Round 3 Using C, join to a 2-ch corner sp, 5 ch, 3 tr in same corner sp, *1 ch, 3 tr in next 1-ch sp, 1 ch, [3 tr, 2 ch, 3 tr] in next 2-ch corner sp; rep from * twice more, 1 ch, 3 tr in next

1-ch sp, 1 ch, 2 tr in same sp as 5-ch at beg of round, join with a ss to 3rd of 5-ch. Fasten off C.

Round 4 Using D, join to a 2-ch corner sp, 5 ch, 3 tr in same corner sp, *[1 ch, 3 tr in next 1-ch sp] twice, 1 ch, [3 tr, 2 ch, 3 tr] in next 2-ch corner sp; rep from * twice more, [1 ch, 3 tr in next 1-ch sp] twice, 1 ch, 2 tr in same sp as 5-ch at beg of round, join with a ss to 3rd of 5-ch.

Fasten off.

PLAIN SQUARE

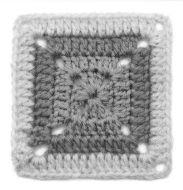

CROCHET DIAGRAM

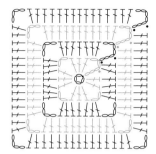

CROCHET INSTRUCTIONS

This square is worked in 3 colours (A, B, C).
Using A, make 4 ch and join with a ss to first ch to form a ring.
Round 1 (RS) 5 ch (counts as 1 tr and a 2-ch sp), [3 tr in ring, 2 ch] 3 times, 2 tr in ring, join with a ss to 3rd of 5-ch.
Round 2 1 ss in next ch, 7 ch (counts as 1 tr and a 4-ch sp), 2 tr in same 2-ch corner sp, *1 tr in each of next 3 tr, [2 tr, 4 ch, 2 tr] in next 2-ch corner sp; rep from * twice more, 1 tr in each of next 3 sts (working last of these tr in top of turning

ch at beg of previous round), 1 tr in same sp as 7-ch at beg of round, join with a ss to 3rd of 7-ch. Fasten off A.
Round 3 Using B, join to a 4-ch corner sp, 7 ch, 2 tr in same corner sp, *1 tr in each of tr along this side of square, [2 tr, 4 ch, 2 tr] in next 4-ch corner sp; rep from * twice more, 1 tr in each of tr along this side of square (working last of these tr in top of turning ch at beg of previous round), 1 tr in same sp as 7-ch at beg of round, join with a ss to 3rd of 7-ch. Fasten off B.
Round 4 Using C, rep round 3.
Fasten off.

FLOWER HEXAGON

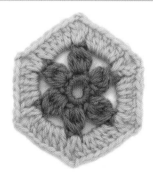

CROCHET DIAGRAM

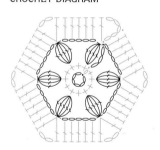

CROCHET INSTRUCTIONS

Note: bobble = [yrh and insert hook in dc, yrh and draw a loop through, yrh and draw through first 2 loops on hook] 5 times all in same dc (6 loops now on hook), yrh and draw through all 6 loops on hook.
This hexagon is worked in 2 colours (A, B).
Using A, make 6 ch and join with a ss to first ch to form a ring.
Round 1 (RS) 1 ch, 12 dc in ring, join with a ss to first dc.
Round 2 3 ch, [yrh and insert hook in same dc as last ss, yrh and draw a loop through, yrh and draw through first 2 loops on hook]

4 times all in same dc (5 loops now on hook), yrh and draw through all 5 loops on hook (counts as first bobble), *5 ch, miss next dc, 1 bobble in next dc; rep from * 4 times more, 5 ch, join with a ss to top of first bobble.
Fasten off A.
Round 3 Using B, join with a ss to top of a bobble, 5 ch (counts as 1 tr and a 2-ch sp), 1 tr in same place as ss, *5 tr in next 5-ch sp, [1 tr, 2 ch, 1 tr] in top of next bobble; rep from * 4 times more, 5 tr in next 5-ch sp, join with a ss to 3rd of 5-ch at beg of round.
Fasten off.

SIMPLE HEXAGON

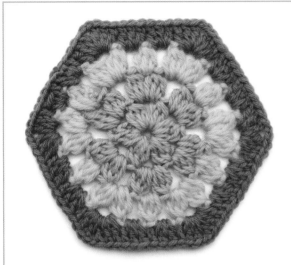

CROCHET DIAGRAM

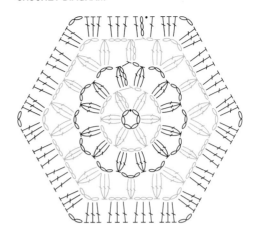

CROCHET INSTRUCTIONS

Note: cluster (cl) = [yrh and insert hook in sp, yrh and draw a loop through, yrh and draw through first 2 loops on hook] 3 times all in same sp (4 loops now on hook), yrh and draw through all 4 loops on hook.

This hexagon is worked in 3 colours (A, B, C).

Using A, make 6 ch and join with a ss to first ch to form a ring.

Round 1 (RS) 3 ch, tr2tog (counts as first cl), [3 ch, 1 cl in ring] 5 times, 1 ch, join with 1 htr in top of first cl.

Round 2 3 ch, tr2tog in sp formed by 1-htr, *3 ch, [1 cl, 3 ch, 1 cl] in next 3-ch sp; rep from * 4 times more, 3 ch, 1 cl in next

1-ch sp, 1 ch, join with 1 htr in top of first cl changing to B with last yrh of htr. Cut off A.

Round 3 Using B, 3 ch, tr2tog in sp formed by 1-htr, *3 ch, [1 cl, 3 ch, 1 cl] in next 3-ch sp, 3 ch, 1 cl in next 3-ch sp; rep from * 4 times more, 3 ch, [1 cl, 3 ch, 1 cl] in next 3-ch sp, 1 ch, join with 1 htr in top of first cl changing to C with last yrh of htr. Cut off B.

Round 4 Using C, 3 ch, 1 tr in sp formed by 1-htr, *3 tr in next 3-ch sp, [3 tr, 2 ch, 3 tr] in next 3-ch sp, 3 tr in next 3-ch sp; rep from * 4 times more, 3 tr in next 3-ch sp, [3 tr, 2 ch, 3 tr] in next 3-ch sp, 1 tr in next 1-ch sp, join with a ss to 3rd of 3-ch at beg of round. Fasten off.

Simple flower patterns

Crochet flowers are very attractive – even simple ones like these, which are all easy and very quick to make. You may want to try them out right away but wonder what to do with them. First, they make great individual brooches, which, in turn, are perfect gifts. Just sew brooch pins to the back and maybe a button or an artificial pearl to the flower centre. Crochet flowers and leaves can also be used to decorate crocheted hats, the ends of scarves, glove cuffs, or bags. Sprinkled over a cushion cover, they will make a bold statement in a room as well.

SPECIAL NOTES

- When following diagrams, use colours as explained in written instructions. The symbol tones are used to distinguish the rows and do not indicate colour changes. (See pp.68–69 for a list of crochet abbreviations and basic stitch symbols.)

- Join on new yarn colours as explained on p.146.
- Do not turn at the end of the rounds, but work with the right side of the flowers always facing.

BUTTON FLOWER

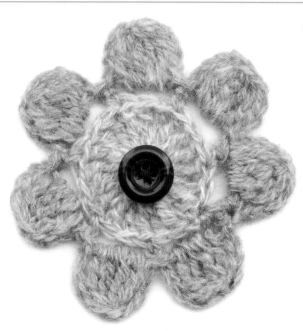

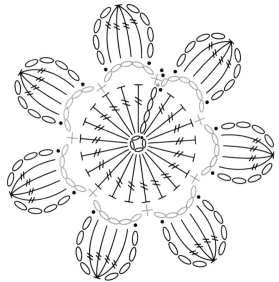

CROCHET DIAGRAM

CROCHET INSTRUCTIONS

Note: cluster = [yrh twice and insert hook in sp, yrh and draw a loop through, (yrh and draw through first 2 loops on hook) twice] 4 times all in same sp (5 loops now on hook), yrh and draw through all 5 loops now on hook.

This flower is worked in 2 colours (A, B).

Using A, make 4 ch and join with a ss to first ch to form a ring.

Round 1 (RS) 4 ch (counts as first dtr), 20 dtr in ring, join with a ss to 4th of 4-ch. Fasten off A.

Round 2 Using B, join with a ss to same place as last ss, 1 ch (does NOT count as a st), 1 dc in same place as last ss, [5 ch,

miss next 2 dtr, 1 dc in next dtr] 6 times, 5 ch, join with a ss to first dc of round.

Round 3 *Work [1 ss, 4 ch, 1 cluster, 4 ch, 1 ss] all in next 5-ch loop; rep from * 6 times more, join with a ss to last dc in round 2. Fasten off. Sew a small button onto the centre of the flower.

SHORT LOOP FLOWER

CROCHET DIAGRAM

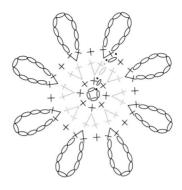

CROCHET INSTRUCTIONS
This flower is worked in 2 colours (A, B).
Using A, make 4 ch and join with a ss to first ch to form a ring.
Round 1 (RS) 1 ch (does NOT count as a st), 8 dc in ring, join with a ss to first dc of round.
Round 2 1 ch (does NOT count as a st), 2 dc in same place as ss, *2 dc in next dc; rep from * to end, join with a ss to first dc of round. 16 dc. Fasten off A.

Round 3 Using B, join with a ss to a dc, 1 ch, work [1 dc, 9 ch, 1 dc] all in same place as last ss, 1 dc in next dc, *work [1 dc, 9 ch, 1 dc] all in next dc, 1 dc in next dc; rep from * 6 times more, join with a ss to first dc of round.
Fasten off.

LONG LOOP FLOWER

CROCHET DIAGRAM

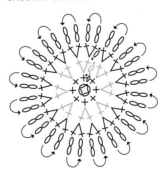

CROCHET INSTRUCTIONS
This flower is worked in 3 colours (A, B, C).
Using A, make 4 ch and join with a ss to first ch to form a ring.
Round 1 (RS) 1 ch (does NOT count as a st), 8 dc in ring, join with a ss to first dc of round. Fasten off A.
Round 2 Using B, join with a ss to a dc, 1 ch (does NOT count as a st), 2 dc in same place as last ss, *2 dc in next dc;

rep from * to end, join with a ss to first dc of round. 16 dc.
Fasten off B.
Round 3 Using C, join with a ss to a dc, 1 ch, work [1 dc, 17 ch, 1 dc] all in same place as last ss, *work [1 dc, 17 ch, 1 dc] all in next dc; rep from * 14 times more, join with a ss to first dc of round.
Fasten off.

PENTAGON FLOWER

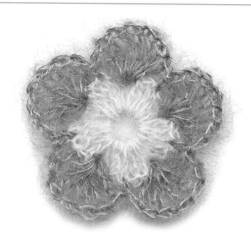

CROCHET DIAGRAM

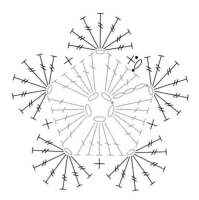

CROCHET INSTRUCTIONS

This flower is worked in 2 colours (A, B).
Using A, make 5 ch and join with a ss to first ch to form a ring.
Round 1 (RS) 3 ch (counts as first tr), 4 tr in ring, [1 ch, 5 tr in ring] 4 times, 1 ch, join with a ss to top of 3-ch at beg of round.
Fasten off A.

Round 2 Using B, join with a ss to a centre tr of a 5-tr group. 1 ch, 1 dc in same place as last ss, [7 dtr in next 1-ch sp, 1 dc in centre tr of next 5-tr group] 4 times, 7 dtr in next 1-ch sp, join with a ss to first dc of round.
Fasten off.

SQUARE PETAL FLOWER

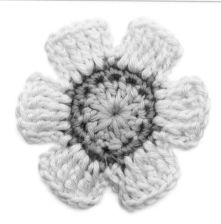

CROCHET DIAGRAM

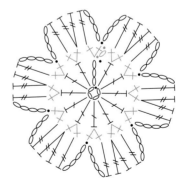

CROCHET INSTRUCTIONS

This flower is worked in 3 colours (A, B, C).
Using A, make 4 ch and join with a ss to first ch to form a ring.
Round 1 (RS) 3 ch (counts as first tr), 11 tr in ring, join with a ss to top of 3-ch at beg of round. Fasten off A.
Round 2 Using B, join with a ss same place as last ss, 1 ch (does NOT count as a st), 2 dc in same place as last ss, 2 dc in each tr to end, join with a ss to first dc of round. 24 dc. Fasten off B.

Round 3 Using C, join with a ss to a dc, *4 ch, 1 dtr in next dc, 2 dtr in next dc, 1 dtr in next dc, 4 ch, 1 ss in next dc; rep from * 5 times more working last ss in same place as first ss of round. Fasten off.

SIMPLE LEAF

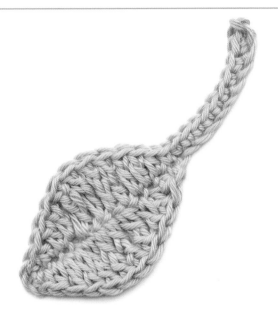

CROCHET DIAGRAM

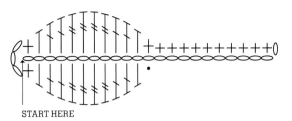

START HERE

CROCHET INSTRUCTIONS

Note: The leaf is worked in one row, around both sides of the foundation chain.

To begin leaf and stem, make 23 ch.

Row 1 (RS) Working into only one loop of each foundation chain, work 1 dc in 2nd ch from hook, 1 dc in each of next 10 ch (this completes the stem), 1 htr in next ch, 1 tr in each of next 2 ch, 1 dtr in each of next 4 ch, 1 tr in each of next 2 ch, 1 htr in next ch, 1 dc in next ch (this is the last ch), 3 ch, then continue working around other side of foundation ch (working into other loop of each ch) as follows – 1 dc in first ch, 1 htr in next ch, 1 tr in each of next 2 ch, 1 dtr in each of next 4 ch, 1 tr in each of next 2 ch, 1 htr in next ch, 1 ss in next ch.

Fasten off.

Press stem flat.

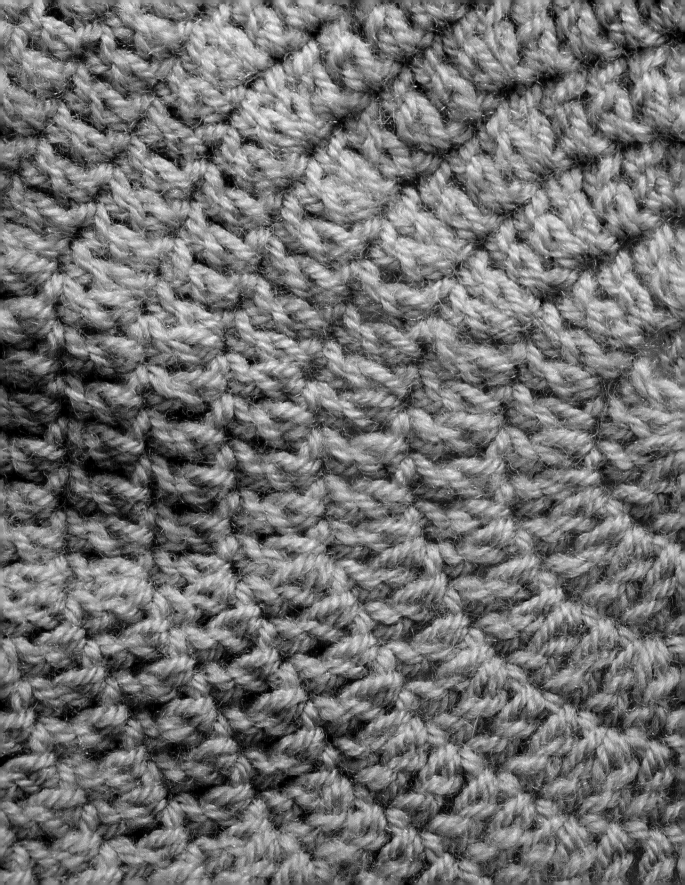

SLOUCHY HAT
Concentric circles of treble crochet are used to create this very comfortable slouchy hat (see pp.178–179). The circles are increased up to the widest part of the hat, and then decreased again to create the brim.

Unusual yarns

If you want to break the monotony of working with wool yarns, why not try out some unusual materials? String, wire, rag strips, and plastic strips are great fun to crochet with, and the materials used can be recycled ones. To take you through the techniques involved, a quick-to-make item is shown with each of these "yarns". It isn't advisable to try to learn to crochet with unusual yarns, so make sure you are deft at forming double crochet stitches before attempting to work with them.

String crochet

Tightly crocheted string forms a sturdy fabric suitable for containers. Because it is usually neither too thick nor too thin, garden twine is a good choice for a first string crochet project. It is also easy to obtain and forms a fabric that holds its shape well.

CROCHETING A ROUND STRING CONTAINER

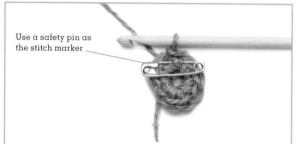

Use a safety pin as the stitch marker

1 Select a hook size for your chosen string that will form a firm, tight double crochet fabric. As an example, a 4.5mm (US size 7) crochet hook was used here with a natural garden twine. To try out string crochet, make a small round container. Start with round 1 of the flat circle instructions on pp.142–143.

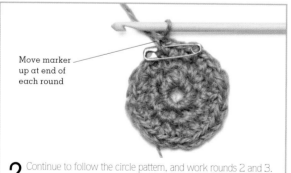

Move marker up at end of each round

2 Continue to follow the circle pattern, and work rounds 2 and 3. Work the stitches as tightly as you can. If the crochet doesn't seem tight enough, start again with a smaller hook size.

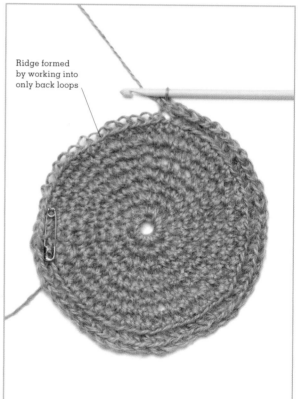

Ridge formed by working into only back loops

3 Keep working rounds of the circle pattern until the circle is the desired size for the base of the container. Then to start the sides of the container, work 1 dc into the back loop only of the top of each stitch in the next round as shown. This forms a ridge.

156 Techniques

4 On all the remaining rounds of the container, work 1 dc in each stitch of the previous round, working through both loops of the top of the stitch below in the usual way. This will form a tube (see pp.136–137 for tips on working spiral crochet). Continue until the container is the desired height.

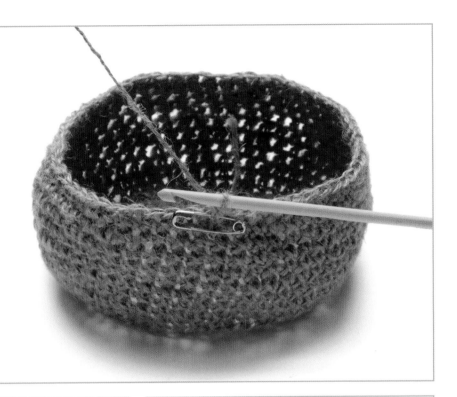

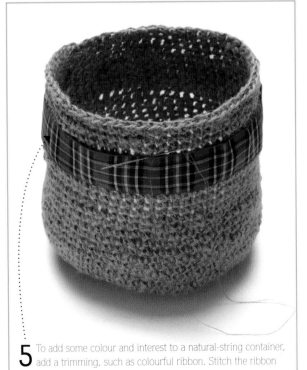

5 To add some colour and interest to a natural-string container, add a trimming, such as colourful ribbon. Stitch the ribbon to the crochet using a sewing needle and matching thread.

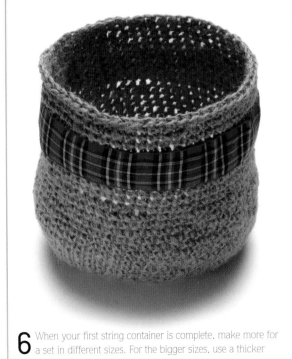

6 When your first string container is complete, make more for a set in different sizes. For the bigger sizes, use a thicker twine and a larger hook size.

Wire crochet

As long as it is fine enough, wire is easy to crochet with even though it takes a little practice to produce even stitches. As with string crochet, it is best to stick to simple double crochet for wire – more exotic stitches are difficult to distinguish among the bendy, airy wire loops. Adding beads to wire crochet is the best way to jazz it up and turn it into simple jewellery like the easy-to-make, bendy bangle shown here.

CROCHETING A BEADED WIRE BANGLE

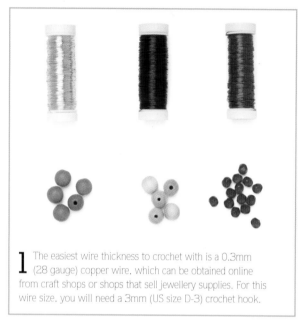

1 The easiest wire thickness to crochet with is a 0.3mm (28 gauge) copper wire, which can be obtained online from craft shops or shops that sell jewellery supplies. For this wire size, you will need a 3mm (US size D-3) crochet hook.

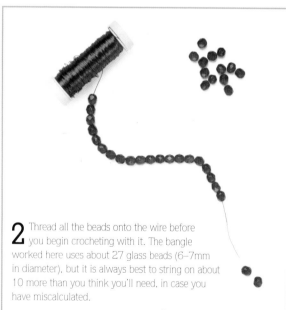

2 Thread all the beads onto the wire before you begin crocheting with it. The bangle worked here uses about 27 glass beads (6–7mm in diameter), but it is always best to string on about 10 more than you think you'll need, in case you have miscalculated.

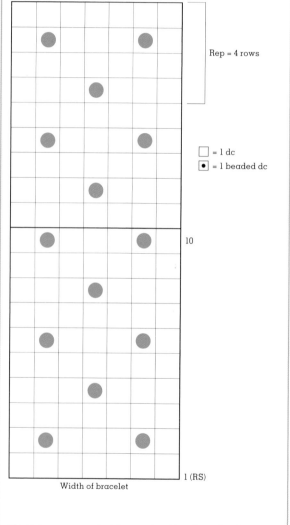

Rep = 4 rows

☐ = 1 dc
⦿ = 1 beaded dc

10

1 (RS)

Width of bracelet

3 Make your own chart for your bead jewellery, showing where the beads are to be placed. This is the chart used for the simple bangle. (See pp.124–125 for how to work bead crochet.)

4 Using the wire with the beads on it, make 8 chains to start the featured bangle. Then follow the chart to work the beaded crochet, working the stitches loosely. Whenever the position of a bead is reached (always on a wrong-side row), work up to the last yrh of the stitch, then slide the bead up close to the crochet and complete the stitch. Count the stitches frequently to make sure you still have the correct number.

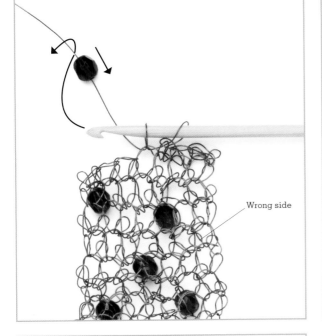

Wrong side

5 Work the bangle until it is the desired length. End with a right-side (non-bead) row so that the wrong side will be facing for the next row. Place the other end of the bangle behind the next row and work the last row through both layers of the bangle by inserting the hook through the foundation chain of the second layer as shown.

Wrong side

Right side

6 After completing the double crochet seam, cut the wire and fasten off. Darn in the wire tails along the double crochet seam, using a blunt-ended yarn needle and wrapping the wire tightly a few times around the edge of the crochet. Then cut off the remaining wire close to the bangle. Turn the bangle right side out.

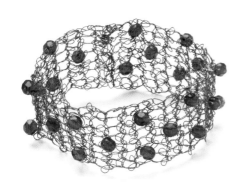

ALTERNATIVE BUTTON BANGLE

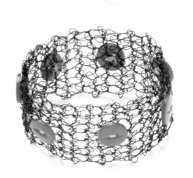

You can also make plain wire crochet bangles and decorate them once they have been completed. This bangle has been worked plain without any beads. Buttons have been sewn along the centre of the bangle with a bright contrasting silk button thread.

Rag-strip crochet

The biggest advantage of rag-strip crochet is its limitless colour palette – the "yarn" can be made from any cotton shirt-weight or patchwork-weight fabric. To try out the technique, work circles with rag strips and make them into a bag.

PREPARING FABRIC STRIPS

1 To make a continuous fabric strip 2cm (¾in) wide, cut or tear the fabric from selvedge to selvedge, stopping each tear/cut about 1.5cm (½in) from the edge.

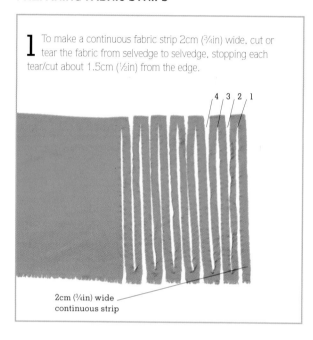

4 3 2 1

2cm (¾in) wide
continuous strip

2 As you tear the strips, wind them into balls. Rag crochet uses up a lot of fabric. To start your project, you can prepare some rag yarn in each of the colours you need and make more later as required.

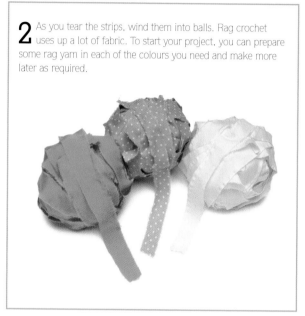

CROCHETING TWO CIRCLES FOR A BAG

1 For a firm crochet fabric, use a 10mm (US size N-15) crochet hook and 2cm (¾in) wide patchwork-fabric-weight cotton strips. Simple double crochet is the best stitch to use for rag crochet. To begin a circle for a bag, work round 1 of the flat circle pattern on pp.142–143 (but leave the yarn tail at the back of the work and do not attempt to work the stitches of this round over it).

A large paper clip is
the best stitch marker
for rag-strip crochet

2 Continuing to follow the circle pattern, introduce new colours for stripes as desired. Work the circle until it is the size you want for a bag front. Then work a second circle the same size. Using the hook, pull any yarn tails through a few stitches on the wrong side to secure them and trim off the ends.

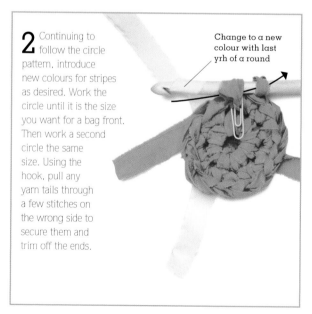

Change to a new
colour with last
yrh of a round

3 Line the two circles with a harmonizing fabric print. (The edge of the lining should reach the base of the tops of the double crochet stitches of the last row.)

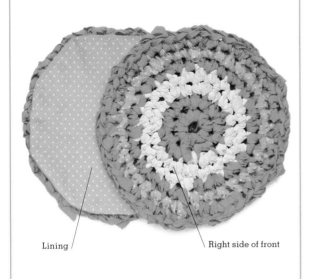

Lining

Right side of front

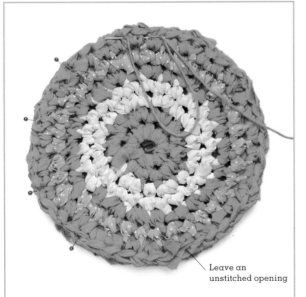

Leave an unstitched opening

4 With the wrong sides facing, pin the bag front and back together. Then using a sewing needle and matching thread or thin cotton yarn, stitch the seam just under the tops of the double crochet stitches of the last round, leaving an opening at the top.

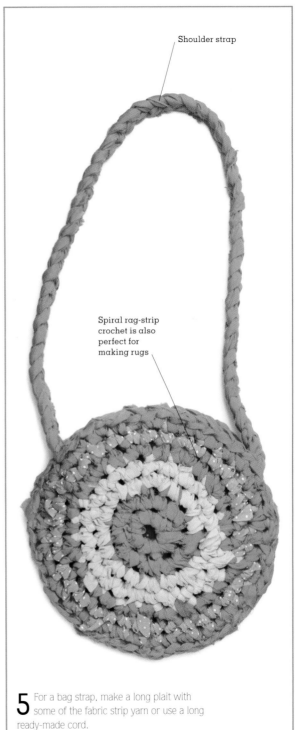

Shoulder strap

Spiral rag-strip crochet is also perfect for making rugs

5 For a bag strap, make a long plait with some of the fabric strip yarn or use a long ready-made cord.

Plastic-strip crochet

Recycling your colourful plastic shopping bags is a great way to help the environment. You can create plastic yarn (or plarn) very quickly using the quick cutting technique shown here. Then use it to experiment with plastic-strip crochet by making a simple bag.

PREPARING PLARN STRIPS

1 Use lightweight plastic bags for plarn. To cut a continuous strip from a bag, begin by laying it flat and smoothing it out. Trim off the seam at the lower edge of the bag and the handles at the top.

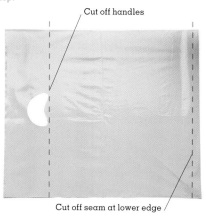

Cut off handles

Cut off seam at lower edge

2 Fold the plastic tube in half, bringing the lower edge up to 3cm (1¼in) from the top.

3cm (1¼in)

Fold line

3 Fold the bag twice more, bringing the lower edge up to within 3cm (1¼in) of the top with each fold.

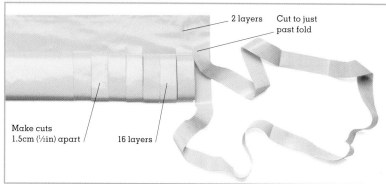

2 layers Cut to just past fold

Make cuts 1.5cm (½in) apart

16 layers

4 Make vertical cuts through the 16 layers at 1.5cm (½in) intervals, stopping each cut about 1.5cm (½in) from the two-layer top fold. Make cuts in this way all along the folded bag.

Second cut
First cut

5 Open out the bag so that you can see the area where the strips are still joined together. To create the continuous strip, make diagonal cuts as shown and wind the strip into a ball.

CROCHETING A PLARN MAKE-UP BAG

1 Use a size 5mm (US size H-8) hook to crochet plarn prepared as shown opposite. To make a small make-up bag, work a spiral tube of double crochet (see p.137).

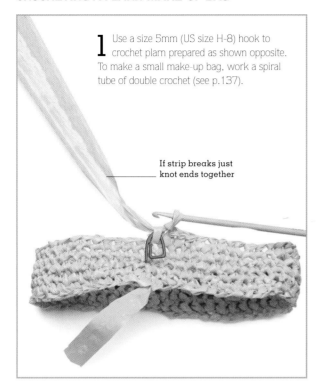

If strip breaks just knot ends together

2 To add a little loop handle to the top of the bag, make extra chains before starting the next round.

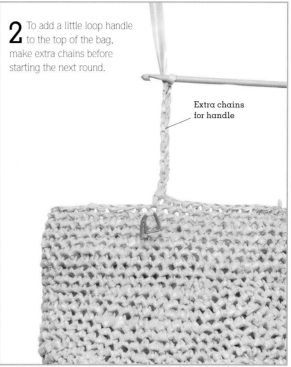

Extra chains for handle

3 On the next round, work double crochet stitches along the extra chains added for the handle. Then work more rounds until the handle is the desired width. Change to the contrasting colour of plarn for the last round and fasten off.

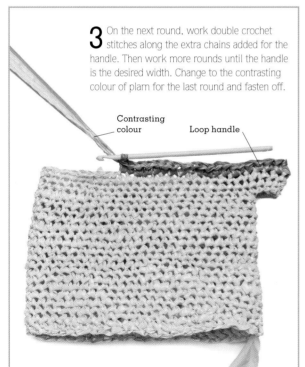

Contrasting colour

Loop handle

4 Join the seam along the lower edge by working a row of double crochet through both layers with contrasting plarn. Using a matching thread and a sewing needle, sew the two layers of the handle together level with the side edge of the bag to form an open loop. Line the bag with a matching fabric and add a zip.

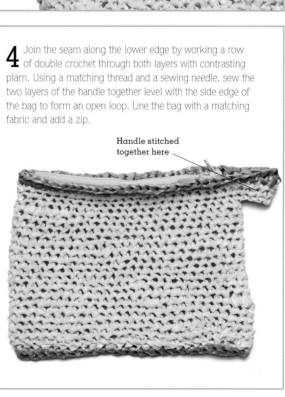

Handle stitched together here

Finishing off

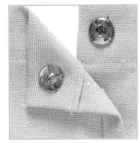

Fastenings

Many types of fastenings can be used on crocheted items. While some of them are purely functional, securing closings on garments and accessories, others can serve as a decorative finish as well as being practical. Always attach fastenings with care.

Buttons

Buttons are one of the oldest forms of fastening. They come in many shapes and sizes, and can be made from a variety of materials including shell, bone, plastic, nylon, and metal. Buttons are sewn to the fabric either through holes on their face, or through a hole in a stalk called a shank, which is on the back of the button. Buttons are normally sewn on by hand, although a 2-hole button can be sewn on by machine.

DIRECTORY OF BUTTONS

2-HOLE BUTTON

4-HOLE BUTTON

COVERED BUTTON

NOVELTY BUTTON

RIVET BUTTON

SHANKED BUTTON

Other fastenings

There are many alternative ways to fasten garments, craft projects, and other items, some of which can be used instead of, or in conjunction with, other fasteners. These include hooks and eyes, snaps, tape fasteners, zips, and laced eyelets.

DIRECTORY OF OTHER FASTENINGS

HOOK AND LOOPED EYE

SKIRT/TROUSER HOOK AND EYE

VELCRO™

SNAP TAPE

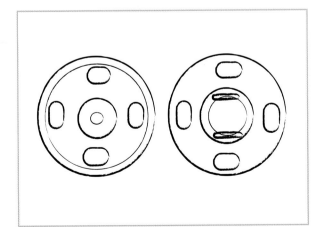

SNAP FASTENER

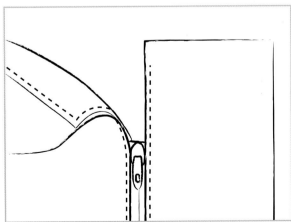

OPEN-ENDED ZIP

Sewing on a 2-hole button

This is the most popular type of button and requires a thread shank to be made when sewing in place. A cocktail stick will help you to sew on this type of button.

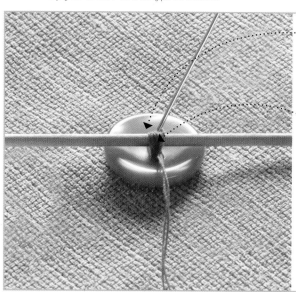

1 Position the button on the fabric. Start with double thread in the needle. Take a stitch, and loop back through it to form a double stitch [to secure the thread].

2 Place a cocktail stick on top of the button. Stitch up and down through the holes, going over the stick.

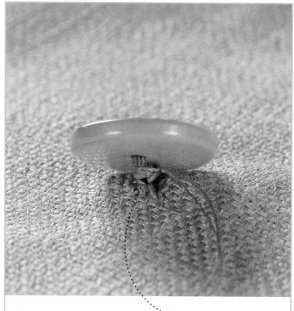

3 Remove the cocktail stick.

4 Wrap the thread around the thread loops under the button to make a shank.

5 Take the thread through to the back of the fabric.

6 Take short, closely-spaced stitches (known as buttonhole stitches) over the loop of threads on the back of the work.

Sewing on a 4-hole button

A 4-hole button is attached in the same way as a 2-hole button, except the thread is passed through the holes in alternating diagonals, forming an X over the button front.

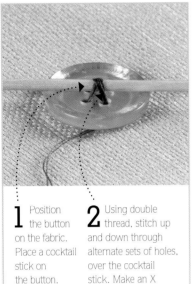

1 Position the button on the fabric. Place a cocktail stick on the button.

2 Using double thread, stitch up and down through alternate sets of holes, over the cocktail stick. Make an X shape as you stitch.

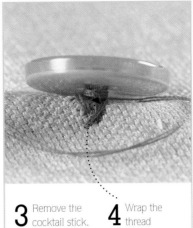

3 Remove the cocktail stick.

4 Wrap the thread around the thread loops under the button to make the shank.

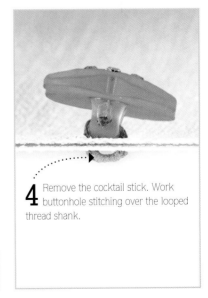

5 On the reverse of the fabric, take short, closely-spaced buttonhole stitches over the thread loops in an X shape.

Sewing on a shanked button

When sewing this type of button in place, use a cocktail stick under the button to enable you to make a thread shank on the underside of the fabric.

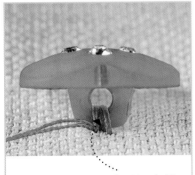

1 Position the button on the fabric. Hold a cocktail stick on the other side of the fabric, behind the button.

2 Using double thread, stitch the button to the fabric, through the shank.

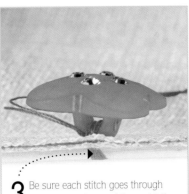

3 Be sure each stitch goes through the fabric and around the cocktail stick beneath.

4 Remove the cocktail stick. Work buttonhole stitching over the looped thread shank.

Sewing on a reinforced button

A large, heavy button often features a second button sewn to it on the wrong side and stitched on with the same threads that secure the larger button. The smaller button helps support the weight of the larger button.

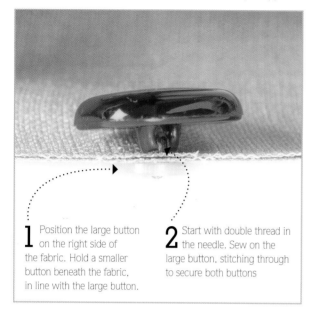

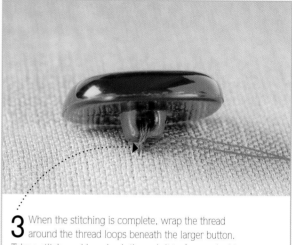

1 Position the large button on the right side of the fabric. Hold a smaller button beneath the fabric, in line with the large button.

2 Start with double thread in the needle. Sew on the large button, stitching through to secure both buttons

3 When the stitching is complete, wrap the thread around the thread loops beneath the larger button. Take a stitch, and loop back through it to form a double stitch to secure the thread.

Oversized and layered buttons

There are some huge buttons available, many of which are really more decorative than functional. By layering buttons of varying sizes together, you can make an unusual feature on a garment or item of soft furnishing.

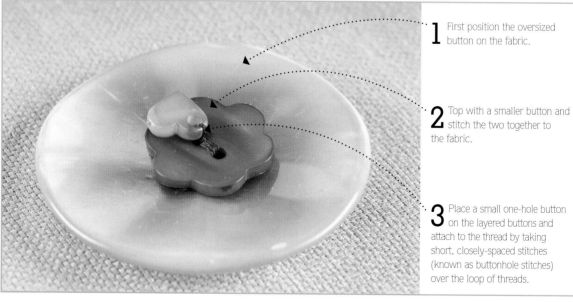

1 First position the oversized button on the fabric.

2 Top with a smaller button and stitch the two together to the fabric.

3 Place a small one-hole button on the layered buttons and attach to the thread by taking short, closely-spaced stitches (known as buttonhole stitches) over the loop of threads.

Hooks and eyes

There is a multitude of different types of hook and eye fasteners. Purchased hooks and eyes are made from metal and are normally silver or black in colour. Differently shaped hooks and eyes are used on different garments – large, broad hooks and eyes can be decorative and stitched to show on the outside, while tiny fasteners are meant to be discreet. A hook that goes into a hand-worked eye produces a neat, close fastening.

ATTACHING HOOKS AND EYES

1 Secure the hook and eye in place with long stitches known as tacking stitches. Make sure they are in line with each other.

2 Stitch around each circular end by taking short, closely-spaced stitches (known as buttonhole stitches) over the loop of threads.

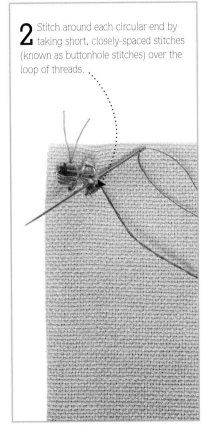

3 Place a few over-stitches around the middle of the hook to stop it moving around.

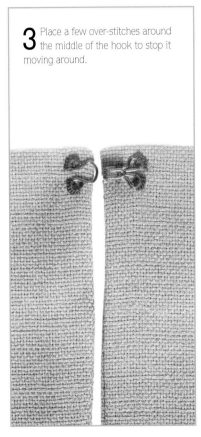

Snaps

A snap is a ball and socket fastener that is used to hold two overlapping edges closed. The ball side goes on top and the socket side underneath. Snaps can be round or square and can be made from metal or plastic.

1 Using long stitches, known as tacking stitches, secure the ball and socket halves of the snap in place.

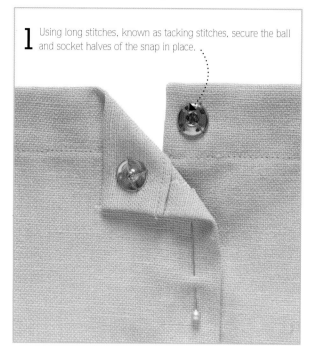

2 Secure permanently using short, closely-spaced stitches (known as buttonhole stitches) through the holes in the outer edges of the snap halves.

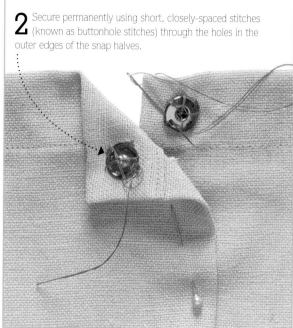

3 Remove the tacks.

PLASTIC SNAPS

A plastic snap may be white or clear plastic and is usually square in shape. Stitch in place as for a metal snap.

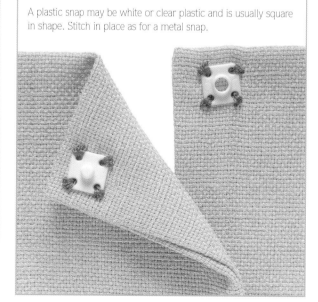

Handmade yarn embellishments

Yarn embellishments for crochet are easy to make, but be sure to take your time so that they look absolutely perfect. Fringe is often used to edge throws and scarves; tassels are ideal for the corners of a cushion cover or the top of a hat. Instructions for making fringe and tassels are given here, but you could also add pompoms – handmade or ready-made – to almost any accessory.

MAKING FRINGE

1 Cut two lengths of yarn, twice the length of the finished fringe, plus at least 2.5cm (1in) extra for the knots.

2 Align the two strands and fold them in half. With the wrong side of the fabric facing, insert a crochet hook from front to back, 5mm (¼in) from the edge. Draw the loop through.

Wrong side

3 Using the crochet hook, pull the ends of the strands through the loop on the hook. Tighten the loop to secure the fringe.

4 Measure your fringe after making this first fringe knot to ensure that it is long enough, and adjust the length of the strands if necessary.

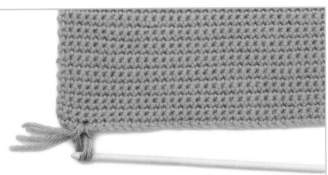

5 Add fringe knots along the edge of the fabric, spacing them evenly apart. For a plumper fringe, use more than two strands at a time. If you have trouble pulling the fringe through the fabric, experiment using a smaller or larger hook.

6 After completing the fringe, trim it slightly to straighten the ends if necessary.

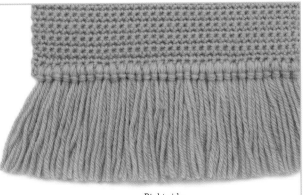

Right side

MAKING A TASSEL

1 Cut a piece of cardboard 8cm (3in) wide and twice as long as the desired length for the finished tassel. Fold the cardboard in half widthways with the fold at the top.

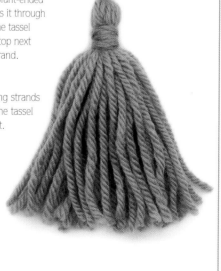

4 Insert the tip of a pair of scissors between the two layers of cardboard at the lower end of the tassel. Cut through the strands.

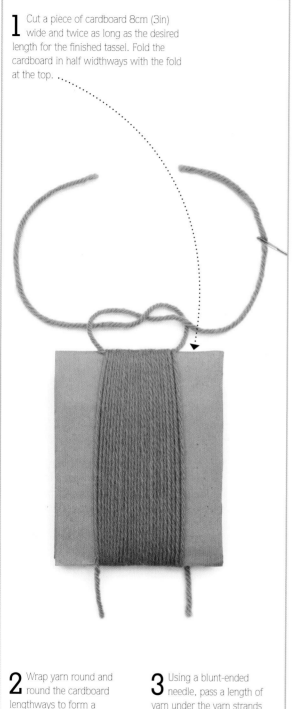

5 Wrap one of the long strands at the top several times around the tassel, about 2cm (¾in) from the top. Thread this strand onto a blunt-ended needle and pass it through the centre of the tassel and out at the top next to the other strand.

6 Use the long strands to attach the tassel to your crochet.

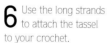

2 Wrap yarn round and round the cardboard lengthways to form a plump tassel.

3 Using a blunt-ended needle, pass a length of yarn under the yarn strands at the top and tie tightly.

Care of crochet

As you have invested so much time and effort in your crochet, take care when cleaning and storing it. Start by referring to the care instructions on the labels supplied with the yarn.

Care of your project

Keep a thorough record of all projects, to include the pattern, the tension swatch, a small winding of the yarn/s, and most importantly a yarn label for each of the yarns used. Care instructions for any special ready-made trimming, ribbons, zips, or press studs should also be included.

Preparing for washing

Remove any special buttons or trims that can be damaged by water or dry-cleaning. To retain the shape of openings, tack them closed using a fine cotton yarn that can be easily pulled out when dry. Measure the piece in all directions and record these dimensions so you can mould it into the correct shape when it is still damp.

Washing

Refer to your yarn label for washing instructions. Yarns labelled "superwash" or "machine washable" can be washed in a washing machine on a gentle cycle and at a cool temperature. Many yarn labels, however, recommend hand washing.

Wash your animal fibre crochet with great care, avoiding friction (rubbing), agitation (swirling the water), and hot water, which can cause felting in wool yarns and damage other fibres.

Dissolve a mild detergent in a large sink full of lukewarm water. Submerge a single item and gently press up and down on it. Soak for a few minutes, then rinse to remove the soapy water.

Squeeze out the water very gently, pressing the item against the sink. Do not wring. Supporting the damp item, move it onto a large towel. Roll in the towel to remove more moisture.

Drying

Dry washed crochet flat on a fresh towel, turning over occasionally to speed up the process and avoid damage by mildew.

Large items, such as throws, can be dried on the floor: cover the floor first with a large plastic sheet, then lay towels on top of this before positioning the throw.

Mould damp crochet into its correct size and shape before leaving to dry, and never leave in direct sunlight or near a heating source. Once completely dry, you can block and steam the piece if necessary, see p.117.

Storing and moth control

Check regularly for telltale holes. If storing all summer, place an anti-moth product in the drawer or closet with your wool crochet and renew it as directed.

Before repairing a hole in a moth-infested item, place it in the freezer overnight to kill any eggs. Crochet too large for the freezer, such as throws and afghans, can be placed all day in the sun to achieve the same result.

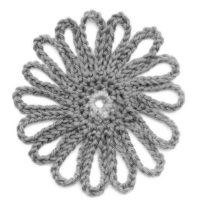
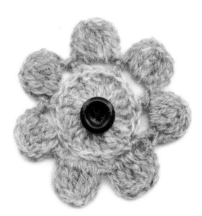

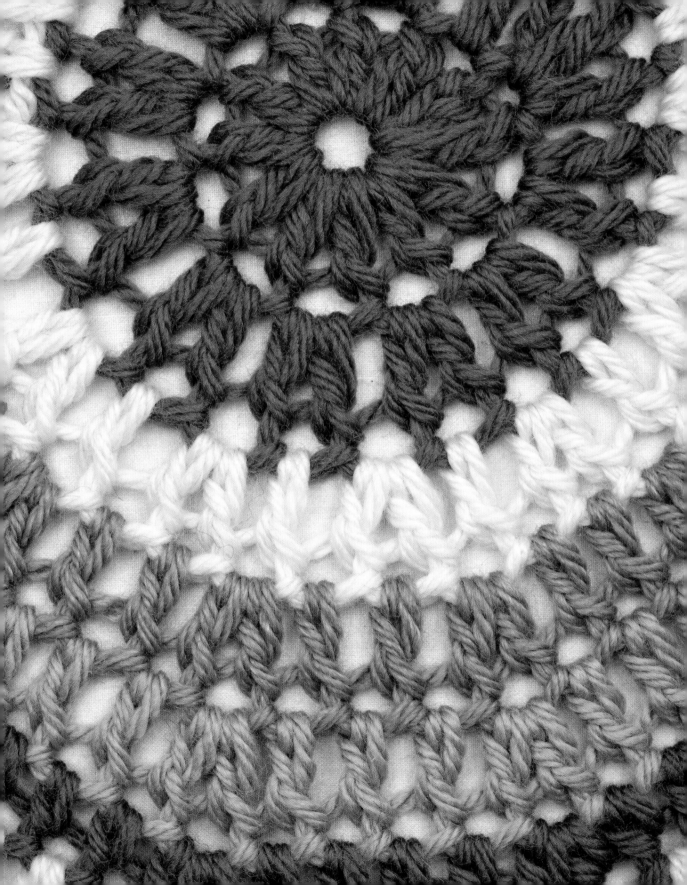

Projects

Slouchy hat

This slouchy hat is perfect for those chilly days of early spring and autumn. The hat is made in the round starting at the top. You can adjust slouchiness by adding or subtracting even rounds, and create a different look by using a different edging, or leaving it off altogether.

DIFFICULTY LEVEL
Moderate

SIZE
To fit an adult female

YARN
Sirdar Click DK 50g

x 1 ball

CROCHET HOOK
4.5mm hook

TENSION
Measure tension after completing Round 3. Circle should be approximately 9cm (3½in) in diameter.

SPECIAL ABBREVIATIONS
fphtr: front post half treble. Yrh and insert hook from front to back to front around the post of next st. Yrh and pull up a loop. Yrh and pull through all three loops on hook.
bphtr: back post half treble. Yrh and insert hook from back to front to back around post of next st. Yrh and pull up a loop. Yrh and pull through all three loops on hook.

PATTERN
HAT
Work 4 ch, ss in first ch to form loop.
Round 1 3 ch, work 13 tr in loop. Ss in top of first 3-ch to join. (14sts)
Round 2 3 ch, tr in same st as joining. 2 tr in each st to end, ss in top of first 3-ch to join. (28sts)
Round 3 3 ch, 2 tr in next st. *1 tr in next st, 2 tr in next st; rep from * to end, ss in top of first 3-ch to join. (42sts)

Round 4 3 ch, 1 tr in next st, 2 tr in next st. *1 tr in each of next 2 sts, 2 tr in next st; rep from * to end, ss in top of first 3-ch to join. (56sts)
Round 5 3 ch, 1 tr in each of next 2 sts, 2 tr in next st. *1 tr in each of next 3 sts, 2 tr in next st; rep from * to end, ss in top of first 3-ch to join. (70sts)
Round 6 3 ch, 1 tr in each of next 3 sts, 2 tr in next st. *1 tr in each of next 4 sts, 2 tr in next st; rep from * to end, ss in top of first 3-ch to join. (84sts)
Round 7 3 ch, 1 tr in each of next 4 sts, 2 tr in next st. *1 tr in each of next 5 sts, 2 tr in next st; rep from * to end, ss in top of first 3-ch to join. (98sts)
Round 8 3 ch, 1 tr in each of next 5 sts, 2 tr in next st. *1 tr in each of next 6 sts, 2 tr in next st; rep from * to end, ss in top of first 3-ch to join. (112sts)
Round 9 3 ch, 1 tr in each of next 6 sts, 2 tr in next st. *1 tr in each of next 7 sts, 2 tr in next st; rep from * to end, ss in top of first 3-ch to join. (126sts)
Round 10 3 ch, 1 tr in each of next 7 sts, 2 tr in next st. *1 tr in each of next 8 sts, 2 tr in next st; rep from * to end, ss in top of first 3-ch to join. (140sts)
Rounds 11–12 3 ch, work 1 tr in each st to end, ss in top of first 3-ch to join. (140sts)
More even rounds can be worked here to make hat more slouchy
Round 13 3 ch, 1 tr in next st, tr2tog. *1 tr in each of next 2 sts, tr2tog; rep from * to end, ss in top of first 3-ch to join. (105sts)
Round 14 3 ch, tr2tog. *1 tr in next st, tr2tog; rep from * to end, ss in top of first 3-ch to join. (70sts)

BRIM
Round 15 2 ch, 1 htr in each st to end, ss in top of first 2-ch to join.

Rounds 16–18 2 ch, *bphtr in next st, fphtr in next st; rep from * to end, ss in top of first 2-ch to join.

Round 19 Miss next 2 sts, 5 htr in next st. *Miss 2 sts, ss in next st, miss 2 sts, 5 tr in next st; rep from * to end, miss 2 sts, ss in first st of round to join.
Fasten off, weave in ends.

Be sure to measure tension after the first three rounds to ensure the finished hat is the correct size.

Shell edging is added to the edge for a feminine finish to the hat. Other edgings from the Techniques section could also be used.

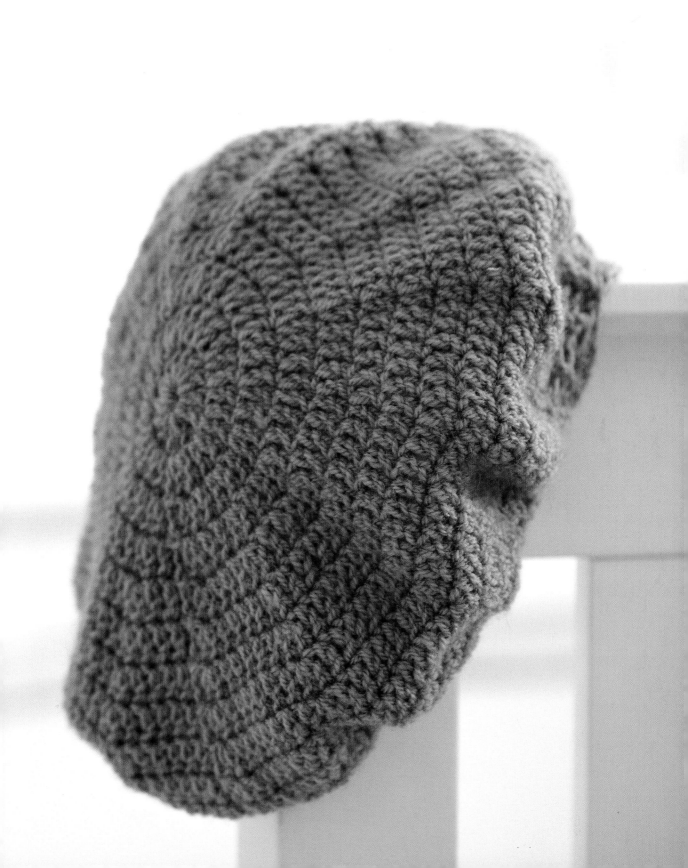

Beanie hat

This cosy hat is made in the round starting at the top and increasing to the circumference of the head to fit the recipient. This hat has been made with two contrasting stripes near the brim, but it could easily be customized with additional stripes and colours.

DIFFICULTY LEVEL
Easy

SIZE
To fit an adult male

YARN
A: Wendy Aran 400g
B: Debbie Bliss Cashmerino Aran 50g

A 1 B 1 ball

CROCHET HOOK
5mm hook

TENSION
11sts per 10cm (4in)

SPECIAL ABBREVIATIONS
fphtr: front post half treble. Yrh and insert hook from front to back to front around the post of next st. Yrh and pull up a loop. Yrh and pull through all three loops on hook.
bphtr: back post half treble. Yrh and insert hook from back to front to back around the post of next st. Yrh and pull up a loop. Yrh and pull through all three loops on hook.

PATTERN
With yarn A, work 4 ch, ss in first ch to form loop.
Round 1 2 ch, 11 htr in loop, ss in top of first 2-ch to join. (12sts)
Round 2 2 ch, 2 htr in next st. *1 htr in next st, 2 htr in next st; rep from * to end, ss in top of first 2-ch to join. (18sts)
Round 3 2 ch, 1 htr in next st, 2 htr in next st. *1 htr in each of next 2 sts, 2 htr in next st; rep from * to end, ss in top of first 2-ch to join. (24sts)

Round 4 2 ch, 1 htr in each of next 2 sts, 2 htr in next st. *1 htr in each of next 3 sts, 2 htr in next st; rep from * to end, ss in top of first 2-ch to join. (30sts)
Round 5 2 ch, 1 htr in each of next 3 sts, 2 htr in next st. *1 htr in each of next 4 sts, 2 htr in next st; rep from * to end, ss in top of first 2-ch to join. (36sts)
Round 6 2 ch, 1 htr in each of next 4 sts, 2 htr in next st. *1 htr in each of next 5 sts, 2 htr in next st; rep from * to end, ss in top of first 2-ch to join. (42sts)
Round 7 2 ch, 1 htr in each of next 5 sts, 2 htr in next st. *1 htr in each of next 6 sts, 2 htr in next st; rep from * to end, ss in top of first 2-ch to join. (48sts)
Round 8 2 ch, 1 htr in each of next 6 sts, 2 htr in next st. *1 htr in each of next 7 sts, 2 htr in next st; rep from * to end, ss in top of first 2-ch to join. (54sts)
Round 9 2 ch, 1 htr in each of next 7 sts, 2 htr in next st. *1 htr in each of next 8 sts, 2 htr in next st; rep from * to end, ss in top of first 2-ch to join. (60sts)
Increases can be stopped sooner or continued as set for a smaller or larger head size
Rounds 10–16 2 ch, work 1 htr in each st to end, ss in top of first 2-ch to join.
Even rounds can be added or subtracted to adjust length of hat
Round 17 With yarn B, 2 ch, work 1 htr in each st to end, ss in top of first 2-ch to join.
Rounds 18–19 With yarn A, 2 ch, work 1 htr in each st to end, ss in top of first 2-ch to join.
Round 20 With yarn B, 2 ch, work 1 htr in each st to end, ss in top of first 2-ch to join.
Round 21 With yarn B, 2 ch, *fphtr in next st, bphtr in next st; rep from * to end, ss in top of first 2-ch to join.
Fasten off, weave in ends.

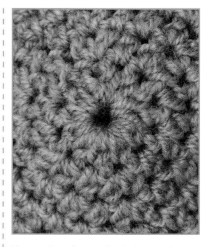

Ensure that the starting hole is nearly closed after the first round. If not, pull out and start again with a shorter chain.

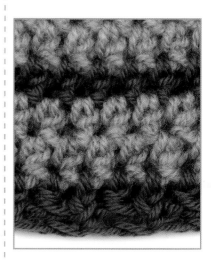

The decorative stripes are made as part of the stitch pattern. Be sure to stitch in loose ends when switching colours.

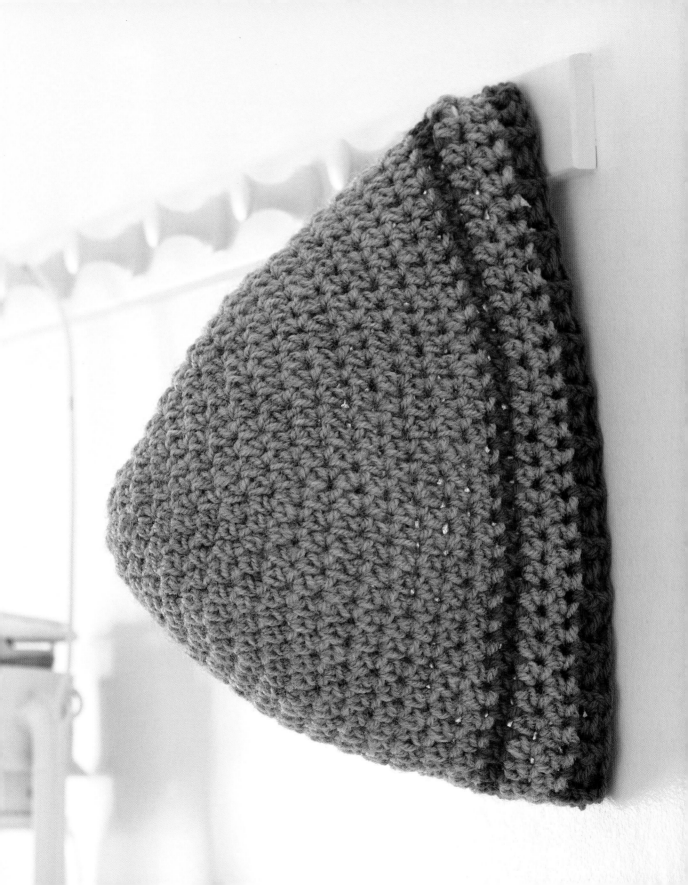

Baby's hat

This adorable hat would suit a baby girl or boy. Suitable for an intermediate crocheter, the hat is made in one piece: first the hat is made in the round, and the earflaps are then crocheted in rows. Only the ears are joined separately.

DIFFICULTY LEVEL
Moderate

SIZE
To fit a baby aged 9–12 months

YARN
Debbie Bliss Baby Cashmerino 50g

A 1 B 1 ball

CROCHET HOOK
A: 3.75mm hook
B: 3mm hook
Stitch marker

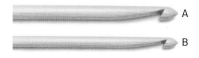

A

B

TENSION
17sts per 10cm (4in)

SPECIAL NOTES
Corded edge/rev dc: Work dc from left to right, instead of right to left. (Left-handed crocheters will work right to left.) After completing a round of double crochet, do not turn work. 1 ch, *insert hook into next stitch to the right, not in the stitch just completed, but the next one. Draw a loop through. Yrh and pull through both loops on the hook; rep from * around.

PATTERN
HAT CROWN
Using 3.75mm hook and yarn A, work 3 ch and work 8 htr into 3rd ch from hook, ss in first st to join. (8sts)
Round 1 2 ch, htr in same st, 2 htr in each htr around, ss in top of first 2-ch to join. (16sts)
Round 2 2 ch, htr in same st, *1 htr in next

st, 2 htr in next st; rep from * to end, ss in top of first 2-ch to join. (24sts)
Round 3 2 ch, htr in same st, 2 htr in next st. *1 htr in each of next 2 sts, 2 htr in next st; rep from * to end, ss in top of first 2-ch to join. (32sts)
Round 4 2 ch, htr in each of next 2 sts, 2 htr in next st. *1 htr in each of next 3 sts, 2 htr in next st; rep from * to end, ss in top of first 2-ch to join. (40sts)
Round 5 2 ch, htr in each of next 3 sts, 2 htr in next st. *1 htr in each of next 4 sts, 2 htr in next st; rep from * to end, ss in top of first 2-ch to join. (48sts)
Continue in this way, working 1 additional single htr between each increase per round, until there are 72sts.
Work one round straight.
Next round 2 ch, 1 htr in each of next 7 sts, 2 htr in next st. *1 htr in each of next 8 sts, 2 htr in next st; rep from * to end, ss in top of first 2-ch to join. (80sts)
Work straight without increasing for approximately 8cm (3in).

EARFLAPS
Rows 1–2 2 ch, 1 htr in each of next 14 sts, turn. (15sts)
Row 3 2 ch, htr2tog, 1 htr in each st to last 3 sts, htr2tog, 1 htr in last st. Turn. (13sts)
Rep last row until there are 5 sts.
Fasten off yarn.
Rejoin yarn to bottom round of hat crown, 20 sts to the left from first earflap.
Work second earflap to match the first.
Fasten off yarn A.

EDGING
Attach yarn B to any st along last round of hat crown. 1 ch, work evenly in dc around entire edge, including earflaps, join round with ss. Do not turn, but work back around in other direction using rev dc for a corded edge. (see Special Notes)
Fasten off yarn B and weave in ends.

EARS (make 2 in yarn A and 2 in yarn B)
Using 3mm hook, 2 ch, work 6 dc into 2nd ch from hook; ss in first st to join. (6sts)
Round 1 2 dc in each dc around, do not join. (12sts)
Round 2 (1 dc in next dc, 2 dc in next dc); rep around, do not join. (18sts)
Round 3 (1 dc in each of next 2 dc, 2 dc in next dc); rep around. Ss in top of first st to join. (24sts)
Round 3 (1 dc in each of next 3 dc, 2 dc in next dc); rep around. Ss in top of first st to join. (30sts)

FINISHING
Block hat pieces lightly (see p.117).
Sew each yarn B ear piece to a yarn A ear piece, with wrong sides facing each other and yarn B at front.
Sew one completed ear to either side of hat crown, above earflaps.

Two layers of spiral rounds are joined together to form each ear. The ears are attached directly to the hat crown.

Wrist warmers

Lacy and pretty yet surprisingly warm, this simple wrist warmer pattern works up quickly, and the softly variegated yarn provides visual appeal. This project is made using the arched mesh stitch (see p.86) and a variation of the picot scallop edging (see p.129), both from the Techniques section. Worked flat, the wrist warmers are then joined along the open edges, leaving a thumb hole open.

DIFFICULTY LEVEL
Moderate

SIZE
To fit an adult female

YARN
Rowan Creative Focus 100g

x 1 ball

CROCHET HOOK
5mm hook

TENSION
3.5 pattern repeats per 10cm (4in)

PATTERN
WRIST WARMERS (Make 2)
Work 28 ch (loosely).
Row 1 Dc in 2nd ch from hook, 3 ch, miss next ch, 1 tr in next ch, *2 ch, miss next ch, 1 dc in next ch, 2 ch, miss next ch, 1 tr in next ch; rep from * to end, turn.
Row 2 1 ch, 1 dc in first tr, 2 ch, 1 tr in next dc, *2 ch, 1 dc in next tr, 2 ch, 1 tr in next dc; rep from * to end, turn.
Rep row 2 until piece measures 17cm (7in). Do not fasten off.

TOP EDGING
1 ch, dc in first tr. Work [2 dc, 3 ch, 2 dc] in each 2-ch sp to end, dc in last dc. Do not fasten off.

JOINING, BOTTOM EDGING
Slip stitch join down open sides (see p.146), leaving 4cm (1½in), or length desired, open

for thumb hole. When sides are joined, 2 ch and work htr around entire lower edge of piece.
Fasten off, weave in ends. Wrist warmer can be left as is or turned inside out to hide seam, as desired.

The thumb hole is formed by leaving a gap of around 4cm (1½in) between the two seams when the two sides of the crocheted square are joined together.

Picot edging along the top of each wrist warmer adds a pretty finishing touch.

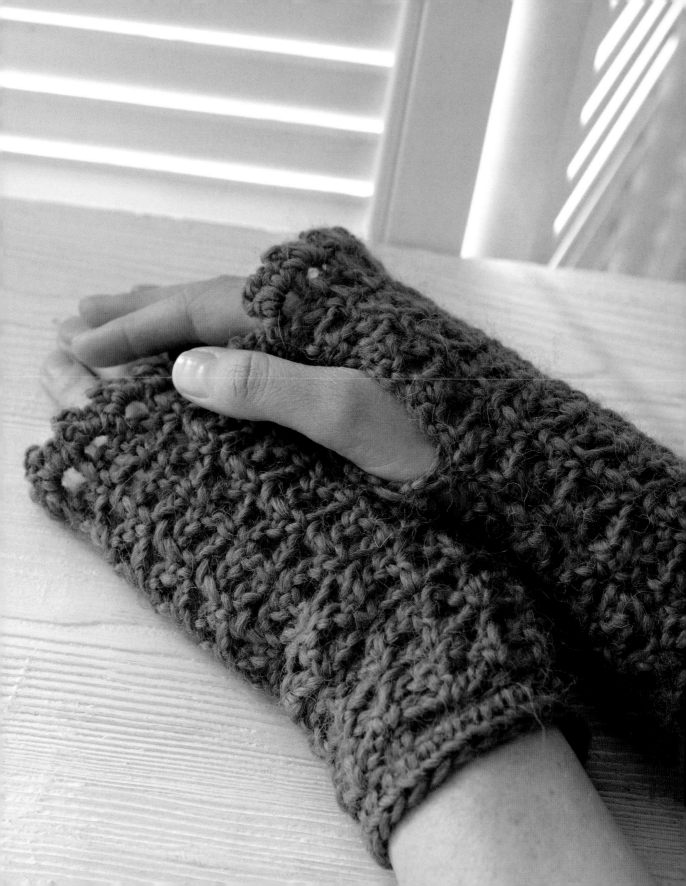

Lacy scarf

This lacy, openwork scarf is made using the fans stitch (see p.88) from the Techniques section. The openwork pattern is created using alternating chain loops and treble crochet stitches. It is an easy first project as it's very forgiving!

DIFFICULTY LEVEL
Moderate

SIZE
18cm x 180cm (7in x 71in) or desired length

YARN
Sirdar Country Style DK 100g

x 1 ball

CROCHET HOOK
4mm hook

PATTERN
Work 33 ch.

Row 1 1 tr in 5th ch from hook, *2 ch, miss 5 chs, 3 tr in next ch, 2 ch, tr in next ch; rep from * 3 times more.

Row 2 4 ch, turn. 1 tr in first 2-ch sp, *2 ch, work (4 tr, 2 ch, 1 tr) in next 2-ch sp; rep from * twice more, 2 ch, work 3 tr in last sp and 1 tr in 3rd of 4 chs of turning ch from row below.

Rep row 2 until piece is 180cm (71in) or desired length.

Fasten off, weave in ends.

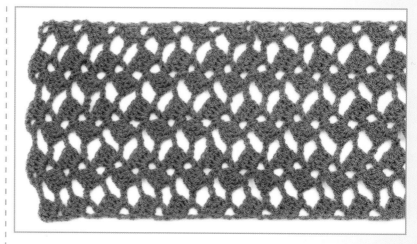

There is no need to add edging to either the long sides or the ends of this scarf as the stitch pattern forms its own.

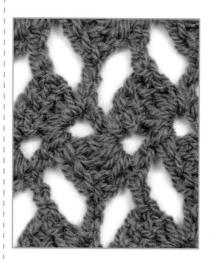

The alternating pattern forms rows of asymmetrical stitches and spaces, giving the scarf a light, lacy appearance.

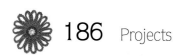

Cold-weather scarf

Suitably masculine, this warm scarf has a chunky textured appearance. It is made by working back and forth in rows using the crochet rib stitch from the Techniques section (see p.70) and is a great introduction to the technique of crocheting around the post of a stitch.

DIFFICULTY LEVEL
Easy

SIZE
18cm x 130cm (7in x 51in) or desired length

YARN
Rowan Colourspun 50g

x 4 balls

CROCHET HOOK
5mm hook

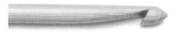

SPECIAL NOTES
fptr: front post treble. Yrh and insert hook around the post of next st, taking hook from front to back to front, yrh and pull up a loop, yrh and pull through two loops, yrh and pull through last two loops.

bptr: back post treble. Yrh and insert hook around the post of next st, taking hook from back to front to back, yrh and pull up a loop, yrh and pull through two loops, yrh and pull through last two loops.

PATTERN
Work 34 ch.
Row 1 1 tr in 4th ch from hook, 1 tr in each ch to end, turn.
Row 2 2 ch, miss first tr, fptr around next st, bptr around next st; rep from * to end, tr in top of turning ch at end, turn.
Rep row 2 until piece measures 130cm (51in), or desired length (additional balls of yarn will be required to make scarf longer). Fasten off, weave in ends.

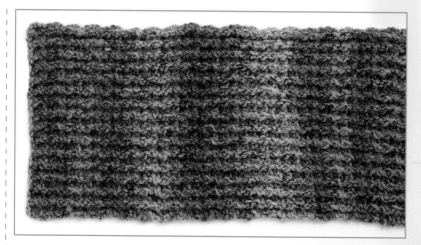

The gently variagated yarn used for this project forms subtle stripes when worked back and forth in rows.

The crochet rib stitch forms deep, textured ridges that help trap heat, making the scarf warm and cosy.

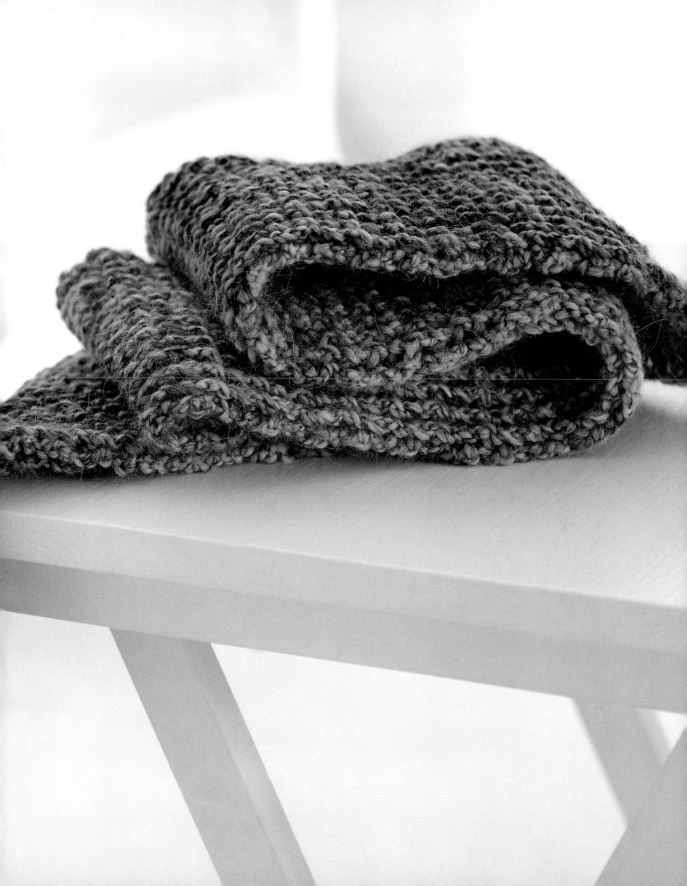

Shawl

This lacy, feminine shawl uses a variation of the chain loop mesh stitch (see p.77) from the Techniques section, as well as the picot and shell edgings (see pp.129 and 131). The shawl is made in rows, starting from the top and decreasing naturally down to a point at the bottom.

DIFFICULTY LEVEL
Easy

SIZE
135cm x 105cm (53in x 41in)

YARN
Sirdar Balmoral DK 50g

x 5 balls

CROCHET HOOK
4.5mm hook

PATTERN
Work 181 ch (or any multiple of 3+1).
Row 1 Miss first ch, dc in each ch to end, turn. (180sts)
Row 2 *6 ch, miss 2 sts, dc in next st; rep from * to end, turn.
Row 3 and all following rows Ss in first 3 chs, *6 ch, dc in next 6-ch loop; rep from * to end, turn.
Rep last row until left with one 6-ch loop.
Fasten off, weave in ends.

TOP PICOT EDGING
Working along top of shawl, attach yarn at one end, 1 ch, dc in same st, *4 ch, ss in 4th ch from hook, dc in each of next 2 sts; rep from * across top edge, ending (4 ch, ss in 4th ch from hook, dc) all in last st. Leave yarn attached.

SIDE SHELL EDGING
Working around two remaining sides, *ss in next 6-ch loop, 5 tr in same sp, ss in same sp; rep from * around two un-edged sides, working (ss, 10 tr, ss) in loop at bottom point.
Fasten off, weave in ends.

Picot edging is used to finish the top of the shawl. The edging can be made larger by adding chains.

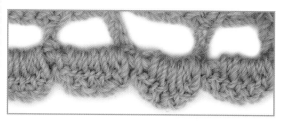

Shell edging finishes the long sides of the shawl. Each shell in the edging matches up with a single space in the lace pattern

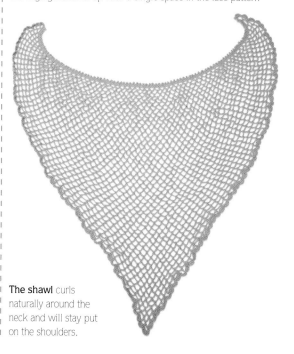

The shawl curls naturally around the neck and will stay put on the shoulders.

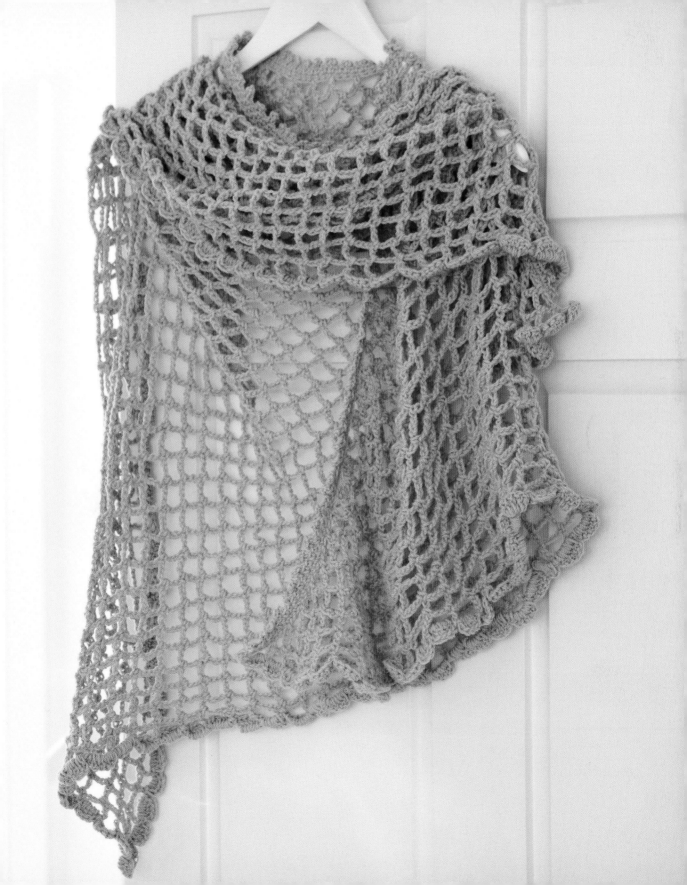

Waistcoat

A stunning addition to any wardrobe, this beautifully textured waistcoat would look great in any colour. The project is most suitable for an intermediate or advanced crocheter; special care should be taken to join the pieces neatly and professionally.

DIFFICULTY LEVEL
Moderate

SIZE
To fit an adult female (approximately 85cm/34in bust)

YARN
Natura Just Cotton 50g

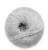

x 4 balls

CROCHET HOOK
4mm hook

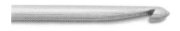

NOTIONS
1 button, approx 2cm (¾in) in diameter

TENSION
3.5 pattern repeats per 10cm (4in)

SPECIAL STITCHES USED
SHELL PATTERN
Row 1 1 dc in 2nd ch from hook, *miss next 2 ch, 5 tr in next ch, miss next 2 ch, 1 dc in next ch; rep from * to end, turn.
Row 2 3 ch (counts as first tr), 2 tr in first dc, *miss next 2 tr, 1 dc in next tr, 5 tr in next dc (between shells); rep from *, ending last rep with 3 tr in last dc (instead of 5 tr), turn.
Row 3 1 ch (does NOT count as a st), 1 dc in first tr, 5 tr in next dc (between shells), miss next 2 tr, 1 dc in next tr; rep from *, working last dc in top of 3-ch at end, turn. Rep rows 2 and 3 to form patt.

CHAIN SHELL PATTERN
Row 1 1 dc in 2nd ch from hook, *miss next 2 ch, work [1 tr, 1 ch, 1 tr, 1 ch, 1 tr]

all in next ch, miss next 2 ch, 1 dc in next ch; rep from * to end, turn.
Row 2 4 ch (counts as 1 tr and a 1-ch sp), 1 tr in first dc, miss next tr, 1 dc in next tr (centre tr of shell), *work [1 tr, 1 ch, 1 tr, 1 ch, 1 tr] all in next dc (between shells), miss next tr, 1 dc in next tr (centre tr of shell); rep from *, ending with [1 tr, 1 ch, 1 tr] in last dc, turn.
Row 3 1 ch (does NOT count as st), 1 dc in first tr, *work [1 tr, 1 ch, 1 tr, 1 ch, 1 tr] all in next dc, miss next tr, 1 dc in next tr (centre tr of shell); rep from *, working last dc of last rep in 3rd of 4-ch made at beg of previous row, turn.
Rep rows 2 and 3 to form patt.
Using 4mm hook, 170 ch.
Row 1 1 dc in 2nd ch from hook, *miss next 2 ch, 5 tr in next ch, miss next 2 ch, 1 dc in next ch; rep from * to end, turn.

PATTERN
Using 4mm hook, ch 170.
Work in shell pattern for 26cm (10in), ending with a row 2.
Change to chain shell pattern.
Work across 5 pattern repeats, then turn and work straight on these stitches until work measures approximately 17cm (7in) from armhole, ending at armhole edge.
Shape neckline as follows: Work across 3.5 patt reps, turn leaving rem sts unworked and work to end. Work across 2.5 patt reps, turn leaving rem sts unworked and work to end. Work on these sts until front measures 21cm (8in) from beg of armhole shaping. Rejoin yarn to rem front edge, work as previous side, reversing all shaping.
Rejoin yarn to 4 patt reps along from one of the front pieces, work across 10 patt reps, turn and work on these stitches until piece measures same as front to one row below shoulder. Work across 2.5 patt reps, fasten off yarn, leaving rem sts unworked. Rejoin to opposite shoulder and complete to match first.

FINISHING
Block piece lightly to shape (see p.117). Sew together shoulder seams. Rejoin yarn to neck at right front edge and work 1 row of dc all round neck to shape. Make a chain of approximately 8 ch, or length to go round your chosen button, then sew into a loop and attach to left front at same height as beginning of armhole. Attach button to opposite side to correspond with button loop.

The button loop is formed by making a short chain, which is made into a loop and attached to the left front of the waistcoat.

The stitch pattern is looser at the top and denser toward the bottom, creating a subtle difference in texture between the two.

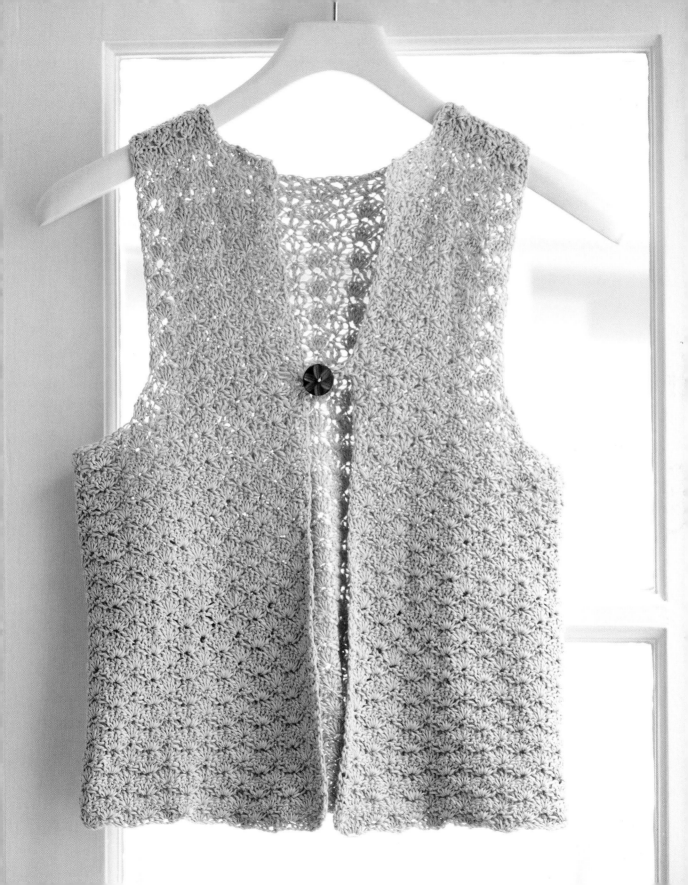

Baby's booties

These adorable booties are made in the softest yarn for delicate skin, and in a style that is sure to stay on small feet. The booties are made in the round, starting with the sole. Be sure to use a stitch marker throughout to mark the first stitch of the round.

DIFFICULTY LEVEL
Moderate

SIZE
To fit a newborn baby

YARN
Sublime Cashmere Merino Silk DK 50g

x 1 ball

CROCHET HOOK
4mm hook

TENSION
Measure tension after completing the sole of each bootie. The length of the sole should be a minimum of 8.5cm (3¼in).

NOTIONS
4 small buttons

PATTERN
BOOTIES (Make 2)
Work 9 ch.

Round 1 Miss 1 ch, dc in each ch to end, 4 dc in last ch. Working down other side of ch, dc in each ch to end, work 4 dc in last ch. (22sts)

Round 2 *Dc in next 7 sts, work (1 dc in next st, 2 dc in next st) twice; rep from * once more. (26sts)

Round 3 *Dc in next 7 sts, work (1 dc in each of next 2 sts, 2 dc in next st) twice; rep from * once more. (30sts)

Round 4 *Dc in next 7 sts, work (1 dc in each of next 3 sts, 2 dc in next st) twice; rep from * once more. (34sts)

Round 5 Working into back loops only, dc in each dc to end. (34sts)

Round 6 Dc in next 7 sts, work (1 dc in each of next 3 sts, dc2tog) twice, dc in next 17 sts. (32sts)

Round 7 Dc in next 7 sts, tr2tog 4 times, dc in next 7 sts, htr in next 10 sts. (28sts)

Round 8 Dc in next 7 sts, tr2tog twice, dc in next 7 sts, htr in next 10 sts, ss in first st to close. (26sts)

Do not fasten off yarn.

First strap: 9 ch, dc in 4th ch from hook and in each of next 5 chs, ss in beg st. Fasten off.

Second strap: Rejoin yarn on other side of bootie at corresponding st (the last dc before the htr sts) and rep instructions for first strap. Fasten off, weave in ends.

Attach buttons securely, as shown in picture.

The button loop at the end of each strap needs to fit snugly around the button. Adjust the size by adding or subtracting chains.

The sole of the bootie is worked in rounds without joining. Be sure to check the measurement of each sole for tension.

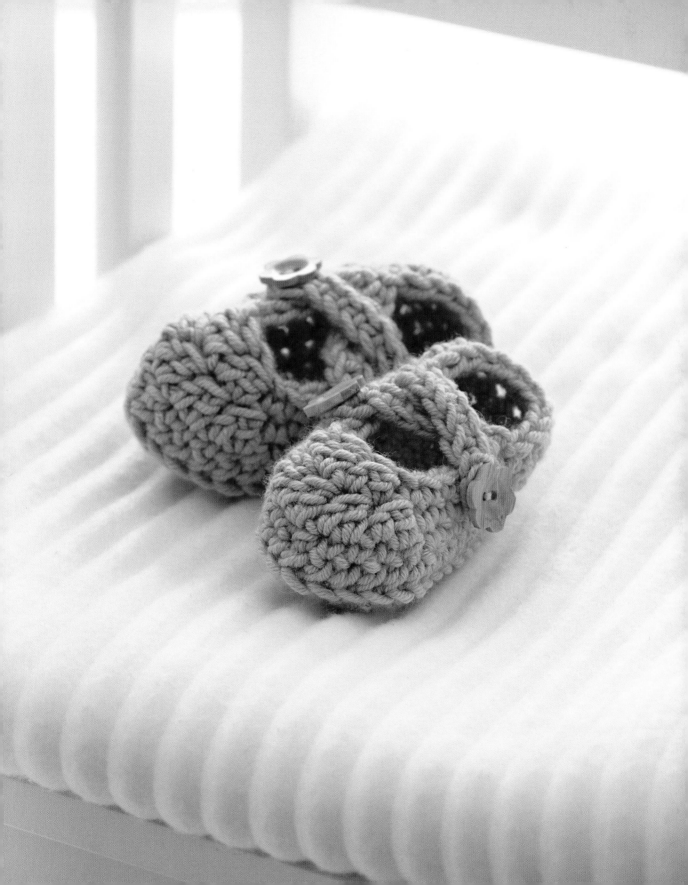

Baby's cardigan

A beautiful cardigan for a very special baby, this project is sure to keep your favourite little one warm and cosy. The clever, simple construction incorporates the sleeves into the body of the cardigan so no seaming is needed, making this a great introductory garment project.

DIFFICULTY LEVEL
Moderate

SIZE
To fit a baby aged 0–6 (6–12) months

YARN
Jarol Heritage DK 100g

A 2 B 1 ball

CROCHET HOOK
4mm hook

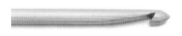

NOTIONS
3 buttons, approx 1cm (½in) in diameter

TENSION
17 htr per 10cm (4in)

PATTERN
FRONT (Make 2)
Using yarn B and 4mm hook, work 22 (25) ch.
Row 1 1 htr into 3rd ch from hook, 1 htr into each ch to end. Turn. 20 (23) sts.
Row 2 2 ch, 1 htr into each st across row. Turn. Change to yarn A and work straight in htr until piece measures 15 (16)cm/6 (6½)in.
Next row: 27(32) ch, 1 htr into 3rd ch from hook, then one htr into each ch to end of ch. 25 (30) sts increased for arm. Work across body stitches. 45 (53) htr
Work straight on these sts until piece measures approx 20 (21)cm/8 (8½)in from hem, ending at arm edge.
Next row: Work across in htr to last 6 (8) sts, 1 dc into next st, turn leaving rem sts unworked for neck opening.

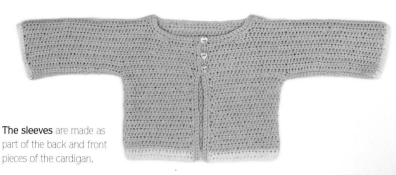

The sleeves are made as part of the back and front pieces of the cardigan.

Next row: Sl st across 5 sts, htr to end of row. Work straight until piece measures 24 (25)cm/9½ (10)in to shoulder. Fasten off yarn.

BACK
Using yarn B and 4mm hook, work 43 (47) ch.
Row 1 1 htr into 3rd ch from hook, then 1htr into each ch to end. Turn. 41(45) htr
Row 2 2 ch, work 1htr into each st across row. Turn. Change to yarn A and work straight in htr until piece measures the same as front to one row below armhole. Fasten off yarn.
Using yarn A, work 25 (30) ch, then work across body stitches in htr, work 27 (32) ch.
Next row: Work 1htr into 3rd ch from hook, then one htr into each ch to end of ch. 25 (30) sts increased for arm. Work in htr across body stitches, then 1 htr into each ch to end for opposite arm. 50 (60) sts in total increased for arms. 91 (105) htr
Work straight on these sts until piece measures same as front to one row below shoulder.
Next row: Work across 35 (40) sts. Fasten off yarn, leaving rem sts unworked. Fasten yarn to opposite arm edge, work across 35 (40) sts, fasten off yarn, leaving rem 21 (25) sts unworked for neck.

FINISHING
Block all pieces lightly to shape. Sew

shoulder seams, then sew up each underarm and side seam.

NECK EDGE
Rejoin yarn A to bottom of right front edge and work evenly in dc up edge, then round neck. At top of left edge, work 5 ch for button loop, then work 4 dc down edge, 5 ch, 4 dc, 5 ch, dc to bottom of left front. Sew buttons to right front, corresponding to the button loops.

CUFFS
Using yarn B, rejoin yarn to cuff and work 2 rows of dc evenly round. Weave in all ends.

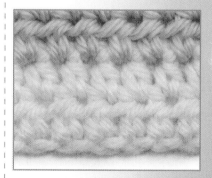

Rows of double crochet in a contrasting colour add a neat finishing touch to the cuffs and cardigan hem.

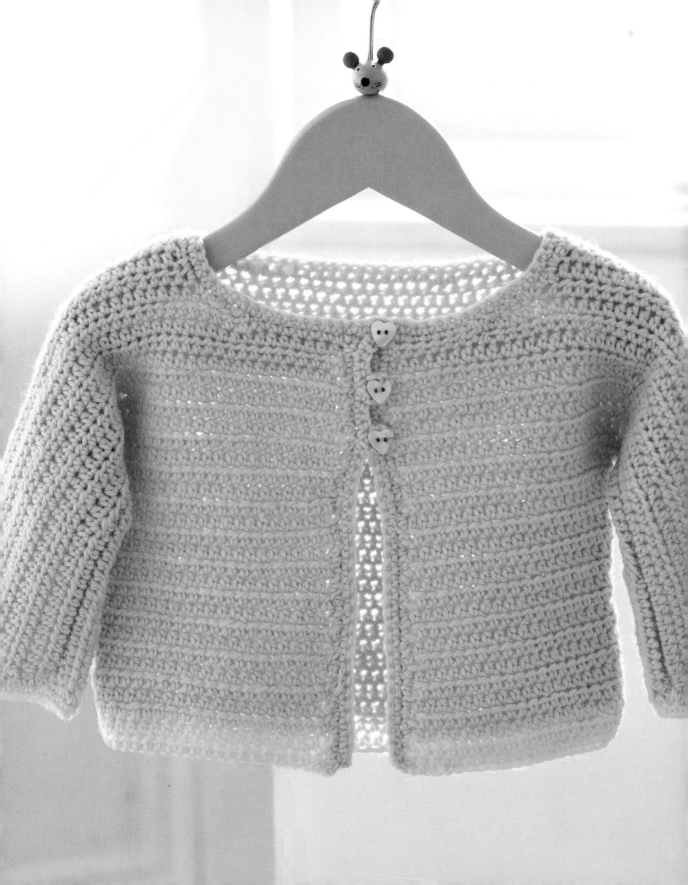

Toy balls

These colourful little balls are made with small amounts of 4-ply mercerized cotton, and are a great way to use up leftover yarn. This project uses an especially small hook to achieve a tight tension, essential for making a solid fabric that will hold in the filling.

DIFFICULTY LEVEL
Easy

SIZE
5cm (2in) diameter

YARN
Rowan Siena 4-ply 50g

A 1 B 1 C 1 ball

CROCHET HOOK
2mm hook

NOTIONS
Toy stuffing

PATTERN
CENTRE STRIPED BALL
With yarn C, make 6 dc in magic loop (see p.143). Pull tail to close.
Round 1 2 dc in each dc to end. (12sts)
Round 2 *1 dc in next dc, 2 dc in next dc; rep from * to end. (18sts)
Round 3 *1 dc in each of next 2 dc, 2 dc in next dc; rep from * to end. (24sts)
Round 4 *1 dc in each of next 3 dc, 2 dc in next dc; rep from * to end. (30sts)
Round 5 *1 dc in each of next 4 dc, 2 dc in next dc; rep from * to end. (36sts)
Round 6 *1 dc in each of next 5 dc, 2 dc in next dc; rep from * to end. (42sts)
Round 7 *1 dc in each of next 6 dc, 2 dc in next dc; rep from * to end. (48sts)
Rounds 8–9 1 dc in each dc to end, finish last dc with yarn A.
Round 10 With yarn A, work 1 dc in each dc to end, finish last dc with yarn B.
Rounds 11–12 With yarn B, work 1 dc in each dc to end, finish last dc of round 12 with yarn A.

Round 13 With yarn A, work 1 dc in each dc to end, finish last dc with yarn C.
Rounds 14–15 With yarn C, work 1 dc in each dc to end.
Round 16 *1 dc in each of next 6 dc, dc2tog; rep from * to end. (42sts)
Round 17 *1 dc in each of next 5 dc, dc2tog; rep from * to end. (36sts)
Round 18 *1 dc in each of next 4 dc, dc2tog; rep from * to end. (30sts)
Round 19 *1 dc in each of next 3 dc, dc2tog; rep from * to end. (24sts)
Round 20 *1 dc in each of next 2 dc, dc2tog; rep from * to end. (18sts)
Round 21 *1 dc in next dc, dc2tog; rep from * to end. (12sts)
Stuff very firmly.
Round 22 dc2tog to end. (6sts)
Fasten off, leaving a long tail. Use tail to close hole, weave in ends.

ALL-OVER STRIPED BALL
Follow above pattern, but change the yarn colour in each round, finishing the last st of prev round with new colour.

TRICOLOURED BLOCK BALL
With yarn B, make 6 dc in magic loop (see p.143). Pull tail to close.
Round 1 2 dc in each dc to end. (12sts)
Round 2 *1 dc in next dc, 2 dc in next dc; rep from * to end. (18sts)
Round 3 *1 dc in each of next 2 dc, 2 dc in next dc; rep from * to end. (24sts)
Round 4 *1 dc in each of next 3 dc, 2 dc in next dc; rep from * to end. (30sts)
Round 5 *1 dc in each of next 4 dc, 2 dc in next dc; rep from * to end. (36sts)
Round 6 *1 dc in each of next 5 dc, 2 dc in next dc; rep from * to end. (42sts)
Round 7 *1 dc in each of next 6 dc, 2 dc in next dc; rep from * to end, finish last st with yarn A. (48sts)
Rounds 8–15 With yarn A, work 1 dc in each dc to end, finish last st of round 15 with yarn C.

Round 16 With yarn C, *1 dc in each of next 6 dc, dc2tog; rep from * to end. (42sts)
Round 17 *1 dc in each of next 5 dc, dc2tog; rep from * to end. (36sts)
Round 18 *1 dc in each of next 4 dc, dc2tog; rep from * to end. (30sts)
Round 19 *1 dc in each of next 3 dc, dc2tog; rep from * to end. (24sts)
Round 20 *1 dc in each of next 2 dc, dc2tog; rep from * to end. (18sts)
Round 21 *1 dc in next dc, dc2tog; rep from * to end. (12sts)
Stuff very firmly.
Round 22 dc2tog to end. (6sts)
Fasten off, leaving a long tail. Use tail to close hole, weave in ends.

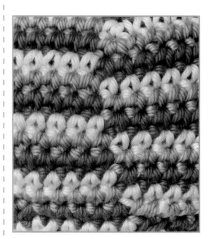

The starting and end points of the different coloured rounds form an off-set seam down the back of the ball.

Teddy bear

This adorable teddy is made in continuous rounds. The head is started from the top and the body from the bottom; both are decreased to the same number of stitches and then stuffed and joined. Arms, legs, and ears are added separately, as is a contrasting scarf.

DIFFICULTY LEVEL
Moderate

SIZE
15cm (6in)

YARN
A (for teddy): Stylecraft Special DK 100g
B (for scarf): Rowan Purelife DK 50g

A 1 B 1 ball

CROCHET HOOK
A: 3mm hook (for teddy)
B: 4mm hook (for scarf)

A

B

NOTIONS
Toy stuffing
Light brown and black embroidery thread

PATTERN
HEAD
Make 6 dc in magic loop (see p.143), pull tail to close.
Round 1 2 dc in each dc to end. (12sts)
Round 2 *1 dc in next dc, 2 dc in next dc; rep from * to end. (18sts)
Round 3 *1 dc in each of next 2 dc, 2 dc in next dc; rep from * to end. (24sts)
Round 4 *1 dc in each of next 3 dc, 2 dc in next dc; rep from * to end. (30sts)
Round 5 *1 dc in each of next 4 dc, 2 dc in next dc; rep from * to end. (36sts)
Round 6 *1 dc in each of next 5 dc, 2 dc in next dc; rep from * to end. (42sts)
Rounds 7–14 1 dc in each dc to end. (42sts)
Round 15 *1 dc in each of next 5 dc, dc2tog; rep from * to end. (36sts)
Round 16 *1 dc in each of next 4 dc, dc2tog; rep from * to end. (30sts)

Round 17 *1 dc in each of next 3 dc, dc2tog; rep from * to end. (24sts)
Fasten off, leaving a long tail. Embroider eyes, nose, and mouth. Stuff firmly.

EARS (Make 2)
Make 5 dc in magic loop, pull tail to close.
Round 1 2 dc in each dc to end. (10sts)
Rounds 2–3 1 dc in each dc to end. (10sts)
Fasten off, leaving a long tail. Use tail to sew open ends of ears to head.

BODY
Make 6 dc in magic loop, pull tail to close.
Round 1 2 dc in each dc to end. (12sts)
Round 2 *1 dc in next dc, 2 dc in next dc; rep from * to end. (18sts)
Round 3 *1 dc in each of next 2 dc, 2 dc in next dc; rep from * to end. (24sts)
Round 4 *1 dc in each of next 3 dc, 2 dc in next dc; rep from * to end. (30sts)
Round 5 *1 dc in each of next 4 dc, 2 dc in next dc; rep from * to end. (36sts)
Round 6 *1 dc in each of next 5 dc, 2 dc in next dc; rep from * to end. (42sts)
Rounds 7–14 1 dc in each dc to end. (42sts)
Round 15 *1 dc in each of next 5 dc, dc2tog; rep from * to end. (36sts)
Rounds 16–17 1 dc in each dc to end. (36sts)
Round 18 *1 dc in each of next 4 dc, dc2tog; rep from * to end. (30sts)
Rounds 19–20 1 dc in each dc to end. (30sts)
Round 21 *1 dc in each of next 3 dc, dc2tog; rep from * to end. (24sts)
Rounds 22–23 1 dc in each dc to end. (24sts)
Fasten off, leaving a long tail. Stuff firmly. Sew body to head.

LEGS (Make 2)
Make 6 dc in magic loop, pull tail to close.
Round 1 2 dc in each dc to end. (12sts)
Round 2 *1 dc in next dc, 2 dc in next dc; rep from * to end. (18sts)
Round 3 *1 dc in each of next 2 dc, 2 dc in next dc; rep from * to end. (24sts)

Round 4 *1 dc in each of next 3 dc, 2 dc in next dc; rep from * to end. (30sts)
Round 5 dc2tog to end. (15sts)
Rounds 6–9 1 dc in each dc to end. (15sts)
Fasten off, leaving a long tail. Stuff firmly, use tail to sew legs to body.

ARMS (Make 2)
Make 6 dc in magic loop, pull tail to close.
Round 1 2 dc in each dc to end. (12sts)
Rounds 2–8 1 dc in each dc to end. (12sts)
Fasten off, leaving a long tail. Stuff firmly, use tail to sew arms to body.

SCARF
Work 31 ch.
Row 1 Miss 1 dc, dc in rem 30 chs. (30sts)
Row 2 1 ch, dc in each dc to end.
Fasten off, weave in ends.

The head and neck are both worked to the same number of stitches, and attached to each other with matching yarn.

The teddy's eyes, nose, and mouth are embroidered on the finished head with black and light brown embroidery thread.

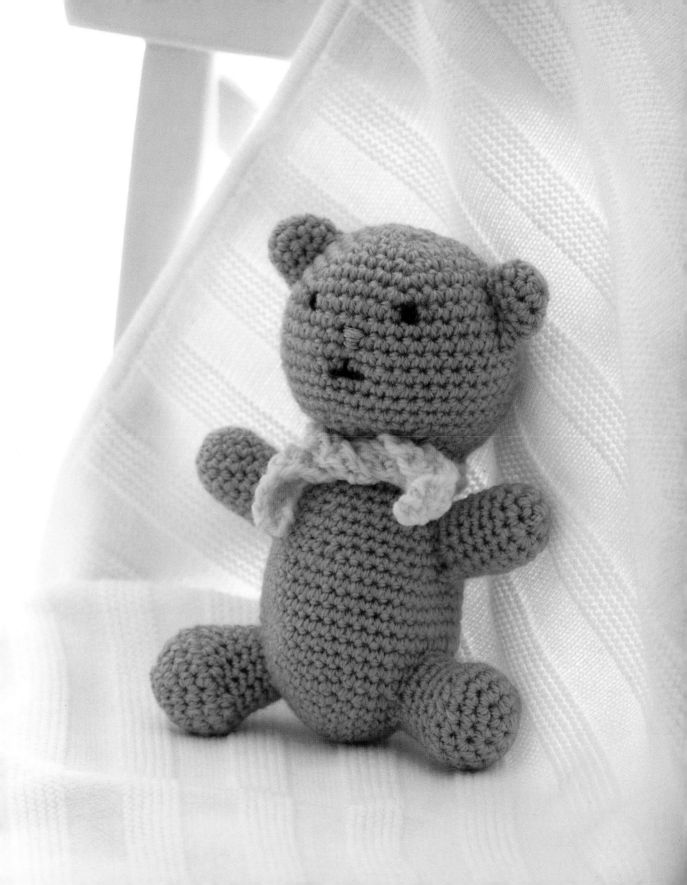

Bookmark

Worked in fine crochet cotton, this small project makes a lovely and quick gift. If you have never used crochet cotton and a small hook before, a bit of care and patience is required but the results are stunning. Press the bookmark lightly once finished to flatten it.

DIFFICULTY LEVEL
Moderate

SIZE
2cm x 18cm (¾in x 7in)

YARN
DMC Petra 100g

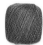

x 1 ball

CROCHET HOOK
1.5mm hook

PATTERN
Work 51 ch.
Row 1 Miss 1 ch, dc in each rem ch to end. (50sts)
Rows 2–3 1 ch, turn. Dc in each dc to end. (50sts)
Row 4 1 ch, turn. Dc in first st, *miss 1 st, 5 tr in next st, miss 1 st, ss in next st; rep from * around entire piece including other side of foundation chain, ending dc in last st, leaving last short side unworked. Fasten off, weave in ends.

TASSEL
Cut 8 lengths of cotton twice the length of desired tassel (sample used lengths of 40cm/16in). Insert hook into centre of unworked short side, fold cotton lengths over hook at centre of lengths, pull loop through, fold all tails over hook and pull tails through. Trim neatly. Also see Making a tassel, p.174.

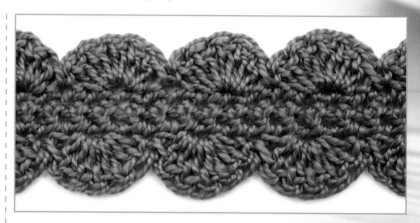

Shell edging runs along both sides of the bookmark, giving the appearance of a symmetrical pattern.

A tassel is surprisingly easy to make. It provides a neat finishing touch and makes it easy to find your place in the book.

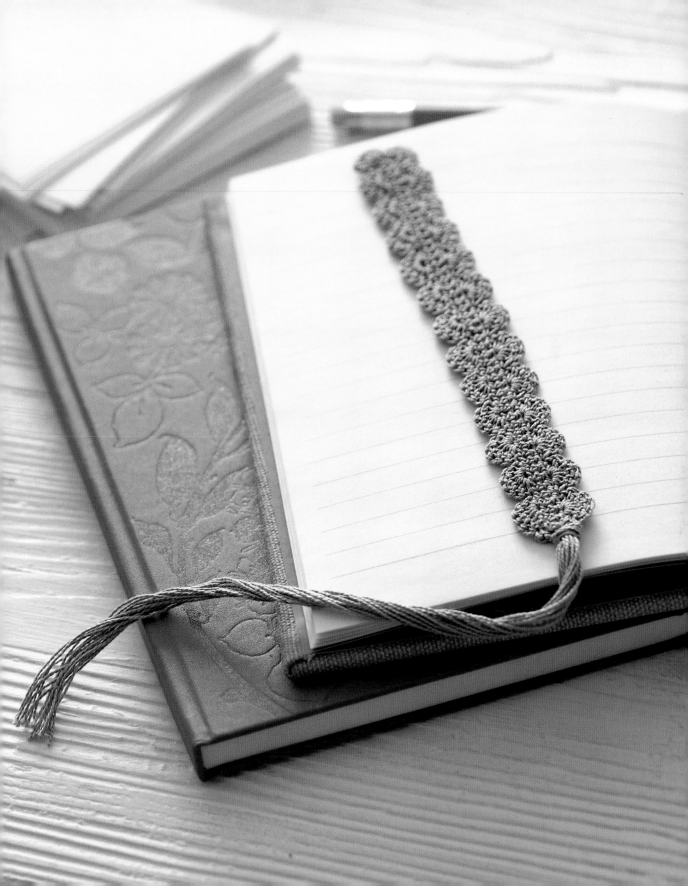

String bag

Do your part for the environment by making up this surprisingly roomy string bag. It holds more than a typical plastic carrier bag and can be re-used over and over. The bag is made in the round, and has a solid bottom to prevent smaller objects from falling out.

DIFFICULTY LEVEL
Easy

SIZE
38cm x 28cm (15in x 11in)

YARN
Rowan Handknit Cotton 50g

x 2 balls

CROCHET HOOK
4.5mm hook

PATTERN
Work 9 ch.
Join with ss in last ch from hook to form loop.
Round 1 3 ch, 11 tr in loop, ss in top of first 3-ch. (12sts)
Round 2 3 ch, 1 tr in same st, 2 tr in each st to end, ss in top of first 3-ch. (24sts)
Round 3 3 ch, 2 tr in next st. *1 tr in next st, 2 tr in next st; rep from * to end, ss in top of first 3-ch. (36sts)
Round 4 3 ch, 1 tr in next st, 2 tr in next st. *1 tr in each of next 2 sts, 2 tr in next st; rep from * to end, ss in top of first 3-ch. (48sts)
Round 5 3 ch, 1 tr in each of next 2 sts, 2 tr in next st. *1 tr in each of next 3 sts, 2 tr in next st; rep from * to end, ss in top of first 3-ch. (60sts)
Round 6 3 ch, 1 tr in each of next 3 sts, 2 tr in next st. *1 tr in each of next 4 sts, 2 tr in next st; rep from * to end, ss in top of first 3-ch. (72sts)
Round 7 3 ch, 1 tr in each of next 4 sts, 2 tr in next st. *1 tr in each of next 5 sts, 2 tr in next st; rep from * to end, ss in top of first 3-ch. (84sts)

Round 8 *4 ch, miss 2 sts, dc in next st; rep from * to end, omit last dc, end with a ss at base of first 4-ch. (28 4-ch loops)
Round 9 Ss in next 2 chs, *4 ch, dc in next 4-ch loop; rep from * to end, ending ss in first ss from beg of round.
Rounds 10–14 Rep round 9.
Round 15 Ss in next 2 chs, *6 ch, dc in next 4-ch loop; rep from * to end, ending ss in first ss from beg of round.
Round 16 Ss in next 3 chs, *6 ch, dc in next 6-ch loop; rep from * to end, ending ss in first ss from beg of round.
Rounds 17–21 Rep round 16.
Round 22 Ss in next 3 chs, *4 ch, dc in next 6-ch loop; rep from * to end, ending ss in first ss from beg of round.
Rounds 23–27 Rep round 9.
Round 28 *2 ch, dc in next 4-ch loop; rep from * to end, ss at base of first 2-ch loop.

TOP
Round 29 1 ch. *2 dc in next 2-ch loop, dc in next dc; rep from * to end, ss in first 1-ch to join. (82sts)

CREATE HANDLES
Round 30 1 ch, dc in next 8 sts, 24 ch (handle can be lengthened by adding more chs here, as desired), miss 23 sts, dc in 24th st and next 17 sts, 24 ch (handle can be lengthened by adding more chs here, as desired), miss 23 sts, dc in 24th st and rem 10 sts, ss in first st to join.
Round 31 1 ch, dc in same st and in each st to handle, dc in each ch across handle, dc in each st to next handle, dc in each ch across handle, dc to end of round, ss in first st to close.
Round 32 1 ch, dc in same st and in each st all around bag, ss in first st to close. Fasten off, weave in ends.

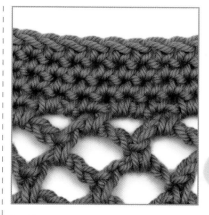

Double crochet stitches across the top of the bag give it structure and prevent it from stretching too much when carried.

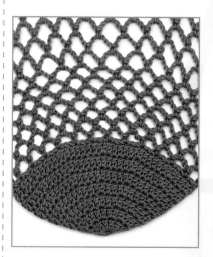

A closed bottom and smaller chain loops in the lower half of the bag ensure that smaller items won't fall out easily.

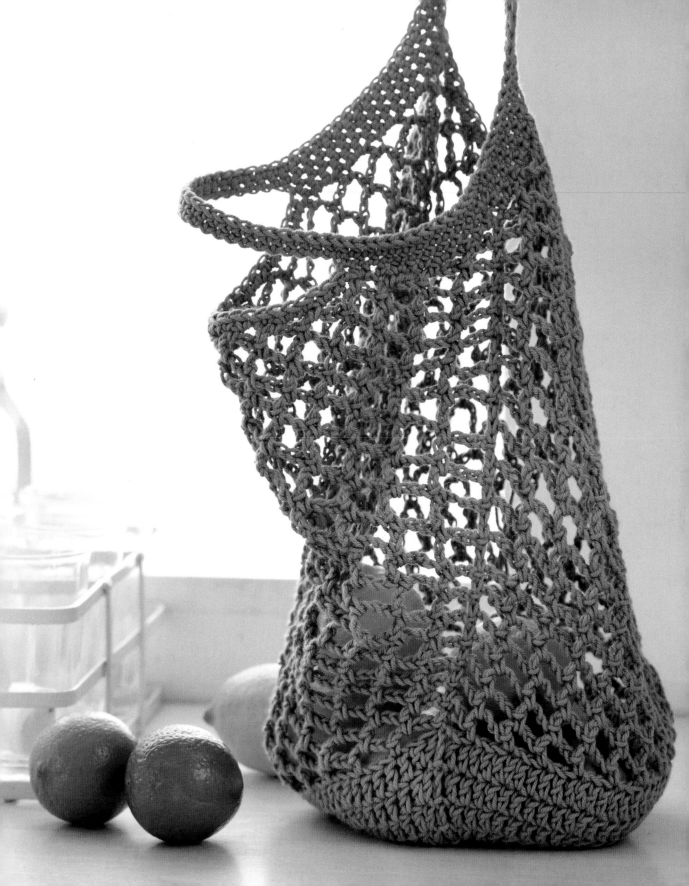

Clutch bag

This elegant clutch is crocheted in a softly shimmering mercerized cotton and is just big enough to hold all your essentials for an evening out. It is made in rows using the cluster and shell stitch (see p.72) from the Techniques section, and forms its own edging and buttonholes. This is a quick and easy project – why not crochet one for tonight?

DIFFICULTY LEVEL
Easy

SIZE
20cm x 10cm (8in x 4in)

YARN
Rico Essentials Cotton DK 50g

x 1 ball

CROCHET HOOK
3.5mm hook

NOTIONS
Shell button, approximately 2cm (¾in)

SPECIAL NOTES
Cluster: over next 5 sts, (which include 2 tr, 1 dc, 2 tr), work [yrh and insert hook in next st, yrh and draw a loop through, yrh and draw through first two loops on hook] 5 times (6 loops on hook), yrh and draw through all 6 loops on hook.

PATTERN
Work 46 ch.
Row 1 2 tr in 4th ch from hook, miss next 2 chs, 1 dc in next ch. *miss next 2 chs, 5 tr in next ch, miss next 2 chs, 1 dc in next ch; rep from * to last 3 chs, miss next 2 chs, 3 tr in last ch, turn.
Row 2 1 ch, 1 dc in first tr, *2 ch, 1 cluster over next 5 sts, 2 ch, 1 dc in centre tr of 5-tr group; rep from * to end, working last dc of last rep in top of 3-ch at end, turn.
Row 3 3 ch, 2 tr in first dc, miss next 2 chs, 1 dc in next st (top of first cluster), miss next 2 chs, *5 tr in next dc, miss next 2 chs, 1 dc

in next st (top of next cluster); rep from *, ending with 3 tr in last dc, turn.
Rep rows 2 and 3 until piece measures 25cm (10in), ending on a row 3. Fold at 10cm (4in) and sew (or use slip stitch join, see p.121) 2 sides to form pocket. Fold top flap over and attach button.

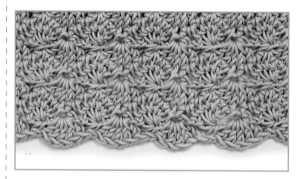

The cluster and shell stitch pattern forms its own decorative edge so there is no need to add edging.

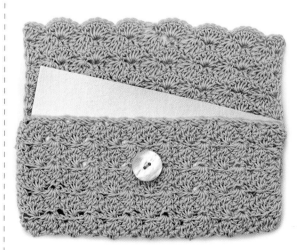

You may choose to line your clutch with fabric, or place a piece of card inside to help it keep its shape.

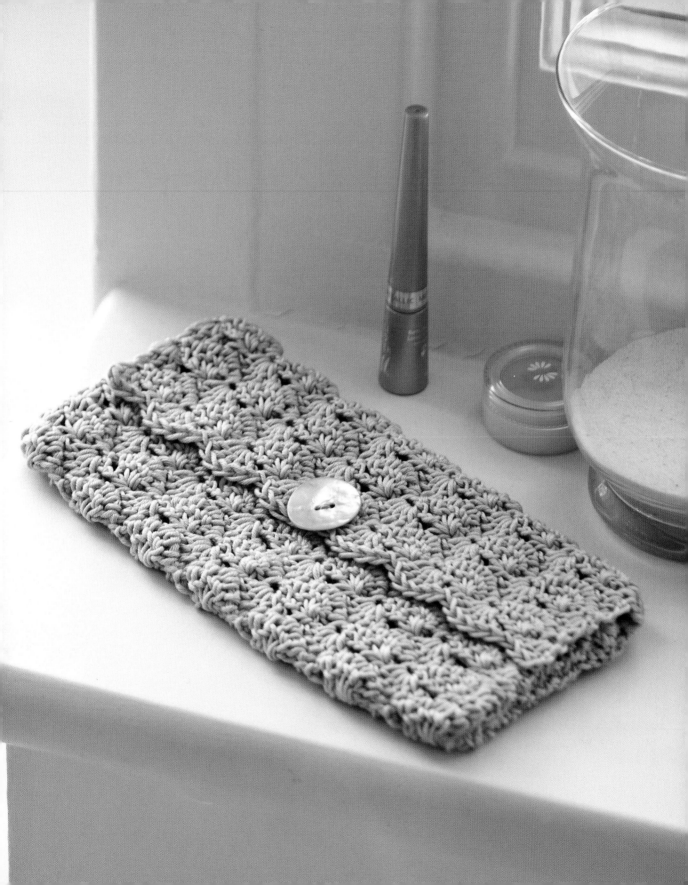

Project basket

This handy, versatile basket is made in the round, starting at the centre bottom. The bottom edge and brim fold are cleverly made by crocheting only into the back loop of the stitch for one round. Size can be adjusted by adding or subtracting increase and even rounds.

DIFFICULTY LEVEL
Easy

SIZE
13cm x 16cm (5in x 6in)

YARN
Stylecraft Special DK 100g

A 1 B 1 ball

CROCHET HOOK
4mm hook

PATTERN
BASKET
With yarn A, work 2 ch, 6 dc in 2nd ch from hook.

Round 1 2 dc in each dc to end. (12sts)

Round 2 *1 dc in next dc, 2 dc in next dc; rep from * to end. (18sts)

Round 3 *1 dc in each of next 2 dc, 2 dc in next dc; rep from * to end. (24sts)

Round 4 *1 dc in each of next 3 dc, 2 dc in next dc; rep from * to end. (30sts)

Round 5 *1 dc in each of next 4 dc, 2 dc in next dc; rep from * to end. (36sts)

Round 6 *1 dc in each of next 5 dc, 2 dc in next dc; rep from * to end. (42sts)

Round 7 *1 dc in each of next 6 dc, 2 dc in next dc; rep from * to end. (48sts)

Round 8 *1 dc in each of next 7 dc, 2 dc in next dc; rep from * to end. (54sts)

Round 9 *1 dc in each of next 8 dc, 2 dc in next dc; rep from * to end. (60sts)

Round 10 *1 dc in each of next 9 dc, 2 dc in next dc; rep from * to end. (66sts)

Round 11 *1 dc in each of next 10 dc, 2 dc in next dc; rep from * to end. (72sts)

Round 12 *1 dc in each of next 11 dc, 2 dc in next dc; rep from * to end. (78sts)

Round 13 *1 dc in each of next 12 dc, 2 dc in next dc; rep from * to end. (84sts)

Round 14 *1 dc in each of next 13 dc, 2 dc in next dc; rep from * to end. (90sts)

Round 15 *1 dc in each of next 14 dc, 2 dc in next dc; rep from * to end. (96sts)

Round 16 *1 dc in each of next 15 dc, 2 dc in next dc; rep from * to end. (102sts)

Increase can be stopped earlier for a smaller basket or continued as set for a larger basket

Round 17 Working into back loops only, dc in each dc to end. (102sts)

Continue working even rounds through both loops (1 dc in each dc to end) until piece measures 13cm (5in) from Round 17, or desired height.

FOLDOVER
Round 1 Working in the front loops only, with yarn B, 1 dc in each dc to end. (102sts)

Round 2 With yarn A, 1 dc in each dc through both loops to end. (102sts)

Round 3 With yarn B, 1 dc in each dc through both loops to end. (102sts)

Rep last 2 rounds once more.
Fasten off, weave in ends.

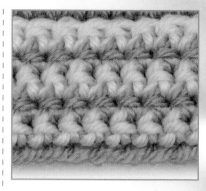

The **decorative brim** with three contrasting stripes is crocheted as part of the basket and then folded down.

As **rounds increase** on the bottom of the basket, it begins to look more and more like a hexagon.

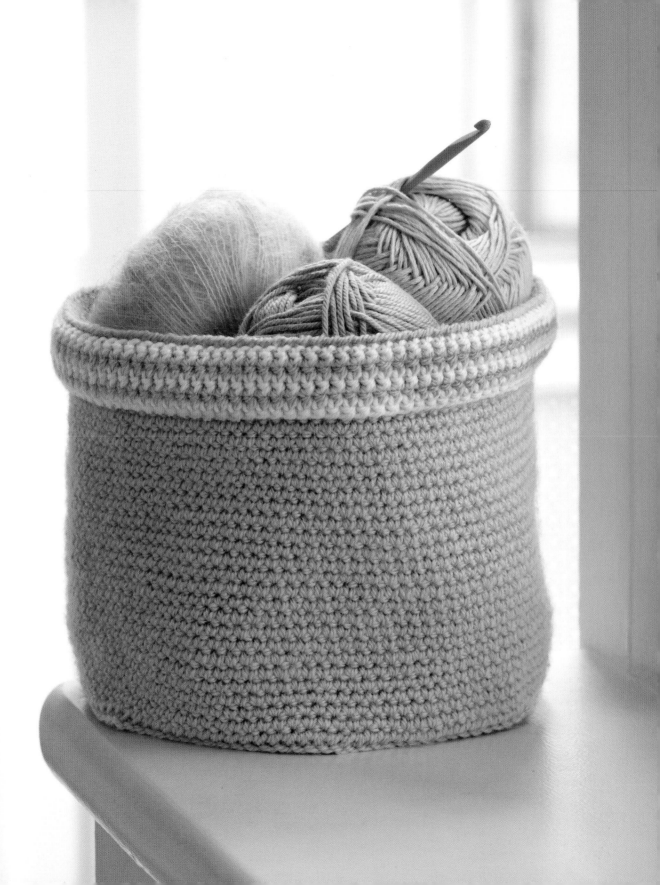

Round cushion

Concentric stripes in harmonious shades feature on this pretty cushion. Two flat circles are worked in the round and then sewn together at the edges. This is a quick project that works up easily, and is great for using up leftover lengths of yarn!

DIFFICULTY LEVEL
Easy

SIZE
35cm (14in) diameter

YARN
Debbie Bliss Cashmerino Aran 50g

A 2 B 1 C 1 D 1 ball

CROCHET HOOK
5mm hook

NOTIONS
Round cushion pad, 35cm (14in) diameter

PATTERN
CUSHION FRONT
With yarn A, work 4 ch, 12 tr in 4th ch from hook, ss in first st to join. (12sts)

Round 1 3 ch, tr in same st. *2 tr in next st; rep from * around, ss in top of first 3-ch to join. (24sts)

Round 2 3 ch, 2 tr in next st. *1 tr in next st, 2 tr in next st; rep from * around, ss in top of first 3-ch to join. (36sts)
Change to yarn B.

Round 3 3 ch, 1 tr in next st, 2 tr in next st. *1 tr in each of next 2 sts, 2 tr in next st; rep from * around, ss in top of first 3-ch to join. (48sts)
Change to yarn C.

Round 4 3 ch, 1 tr in each of next 2 sts, 2 tr in next st. *1 tr in each of next 3 sts, 2 tr in next st; rep from * around, ss in top of first 3-ch to join. (60sts)
Change to yarn D.

Round 5 3 ch, 1 tr in each of next 3 sts, 2 tr in next st. *1 tr in each of next 4 sts, 2 tr in next st; rep from * around, ss in top of first 3-ch to join. (72sts)

Change to yarn A.
Round 6 3 ch, 1 tr in each of next 4 sts, 2 tr in next st. *1 tr in each of next 5 sts, 2 tr in next st; rep from * around, ss in top of first 3-ch to join. (84sts)
Change to yarn B.
Continue in this way, working one additional single tr between increases per round and changing colour in this order every round, to 132 sts, ending with yarn B.
Work one further round in pattern in yarn B. (144sts)
Fasten off yarn.

CUSHION BACK
Work one more cushion side in the same way, but worked entirely in yarn A.

FINISHING
Block pieces lightly (see p.117).
Sew together two pieces around circumference, trapping cushion pad inside.

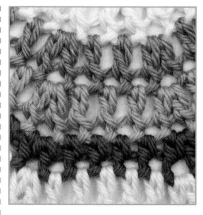

The treble crochet stitch used for the cover forms a pretty, lacy pattern, showing a glimpse of the cushion underneath.

The back of the cushion is worked using the same pattern as on the front, but in a single colour.

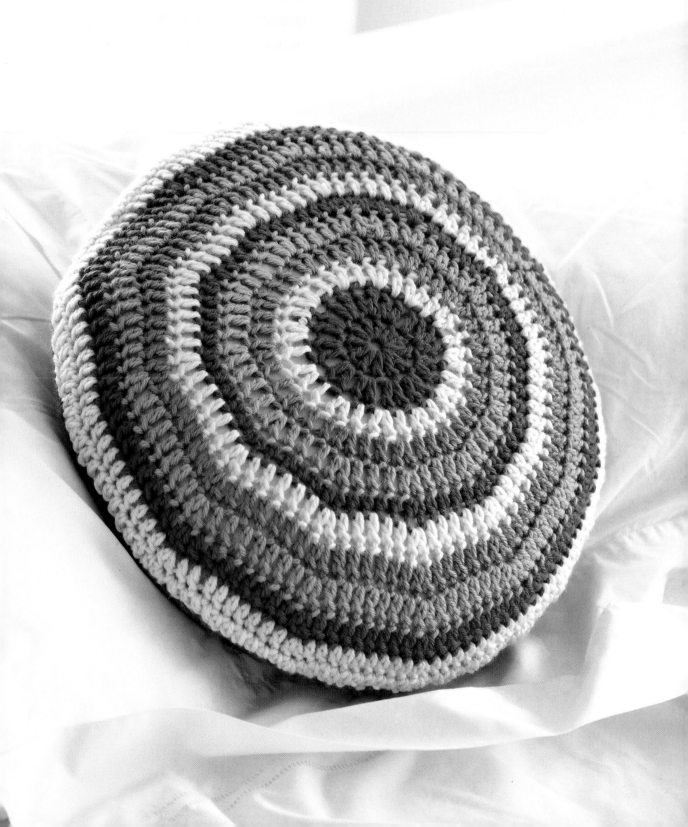

Chevron cushion

A great introduction to colourwork, this project uses the zigzag stitch from the Techniques section (see p.94). The entire cushion cover is made in one piece and then stitched up the sides. The buttonholes are created as part of the pattern.

DIFFICULTY LEVEL
Moderate

SIZE
40cm x 30cm (16in x 12in)

YARN
A: Sirdar Click DK 50g
B: Sirdar Country Style DK 50g

A 2 B 1 ball

CROCHET HOOK
4mm hook

NOTIONS
Cushion pad 40cm x 30cm/16in x 12in (or size required for your cushion cover)
5 buttons, approx 1.5cm (½in) in diameter

PATTERN

CUSHION
With yarn B, work 81 ch.
Row 1 1 dc in 2nd ch from hook, 1 dc in each ch to end, turn. (80sts)
Rows 2–3 1 ch, 2 dc in next st, 1 dc in each of next 7 sts, miss next 2 dc, 1 dc in each of next 7 sts, *2 dc in each of next 2 sts, 1 dc in each of next 7 sts, miss next 2 dc, 1 dc in each of next 7 sts; rep from * to last st, 2 dc in last st. Turn.
Change to yarn A.
Rows 4–6 2 ch, 2 htr in next st, 1 htr in each of next 7 sts, miss next 2 sts, 1 htr in each of next 7 sts, *2 htr in each of next 2 sts, 1 htr in each of next 7 sts, miss next 2 dc, 1 htr in each of next 7sts; rep from * to last st, 2 htr in last st. Turn.
Change to yarn B.
Row 7 1 ch, 2 dc in next st, 1 dc in each of next 7 sts, miss next 2 dc, 1 dc in each

of next 7 sts, *2 dc in each of next 2 sts, 1 dc in each of next 7 sts, miss next 2 dc, 1 dc in each of next 7 sts; rep from * to last st, 2 dc in last st. Turn.
Change to yarn A.
Rep last 4 rows until work measures approximately 70cm (28in), or desired length – long enough to fit comfortably around a cushion with an overlap.
End with a row 7, then rep row 7 twice more in yarn B.
Fasten off.

FINISHING
Block piece lightly to shape (see p.117). Wrap piece around cushion pad, with an overlap halfway down back of pad. Ensure top edge of piece, with 5 complete points, is on top, overlapping bottom of piece. Sew up bottom two side seams of cushion, then sew down top two side seams, overlapping bottom seam. Fasten middle flap of cushion by sewing buttons on bottom edge of piece, corresponding to first decrease hole in yarn A htr row next to end of each point. Fasten buttons and weave in all ends.

The stitch pattern forms a neat zigzag edge to the cushion cover. The buttons are simply pushed through holes in the pattern.

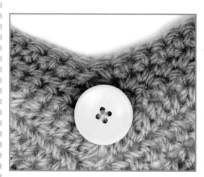

Buttons are fixed to the bottom layer of the cushion cover at the bottom of each "V" in the zigzag pattern.

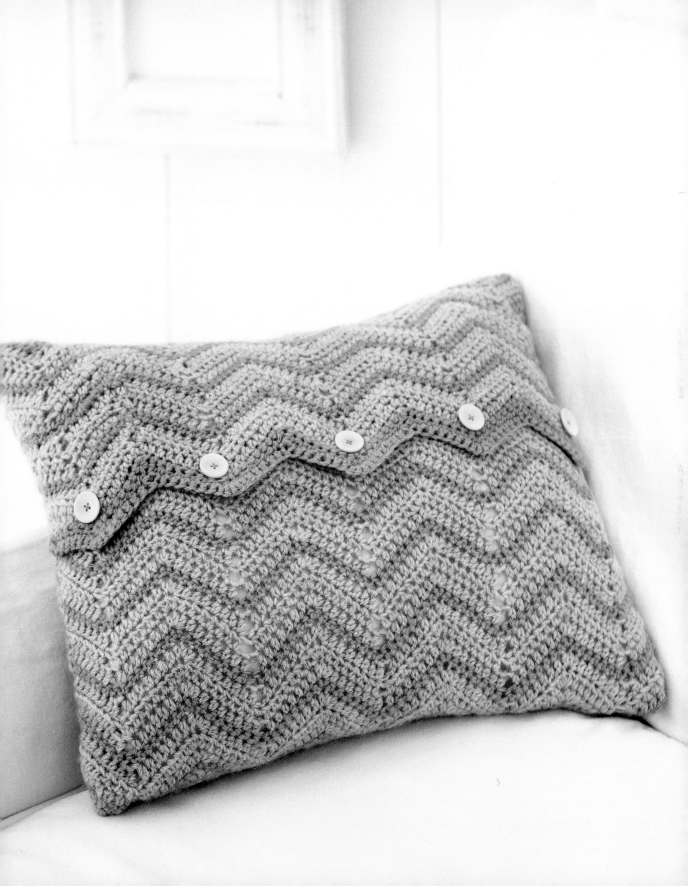

Baby's blanket

This adorable baby blanket is made as a large Afghan (or Granny) square with a centre of mini squares and finished with a shell edging. Each new colour is joined directly to the previous square or round, so no seaming is required – just weave in the ends to finish.

DIFFICULTY LEVEL
Easy

SIZE
84cm x 84cm (33in x 33in)

YARN
Sirdar Wash 'n' Wear DK Double Crepe 100g

A 2 **B** 3 balls

CROCHET HOOK
4mm hook

PATTERN
STARTING MINI SQUARE
With yarn A, work 4 ch, ss to first ch to form loop.

Round 1 3 ch, 2 tr in loop. *2 ch, 3 tr in loop; rep from * twice more, 2 ch, ss in top of beg 3-ch to join. Fasten off.

For next mini square, use the join-as-you-go-method.

With yarn B, work 4 ch, ss to first ch to form loop.

Round 1 3 ch, 2 tr in loop. *dc in any 2-ch corner sp of starting mini square, 3 tr in loop of current square; rep from * once more. 2 ch, 3 tr in loop, 2 ch, ss in top of beg 3-ch to join.
Fasten off.

Continue making and joining the mini squares as you go, alternating colours, until centre large square is desired size. Sample blanket uses 6 x 6 mini squares.

BEGIN GRANNY SQUARE ROUNDS
Join yarn A in next ch sp after any corner.
Round 1 3 ch, 2 tr into same space. *1 ch, 3 tr into next ch sp; rep from * to corner, work (3 tr, 2 ch, 3 tr) in corner space.

Rep around piece. Fasten off yarn A.
Rounds 2–3 Attach yarn B and rep round 1. At the end of round 2, ss in top of beg 3-ch, ss in each st to next ch sp from prev round, then begin as round 1. Fasten off yarn B.
Round 4 Attach yarn A and rep round 1. Rep rounds 1–3 to form pattern, one round of yarn A and two rounds of yarn B. Continue with Granny rounds until blanket is desired size. Sample blanket uses 24 rounds, ending on a round 3.

EDGING
Round 1 Attach yarn B in any st. Dc in each st and ch around blanket, working 3 dc in each corner sp. Ss in first dc to join. Fasten off yarn B.
Round 2 Attach yarn A. 2 ch, *5 tr in next dc, dc into next dc. Rep from * around blanket. Fasten off.

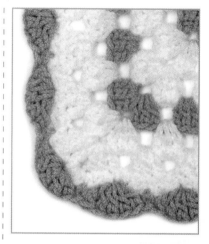

The outermost stripe in this design is actually shell edging. It finishes the blanket without breaking up the pattern of stripes.

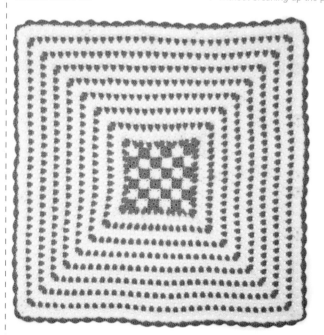

A central block of mini squares is surrounded by rounds of traditional Afghan (or Granny) square stitch.

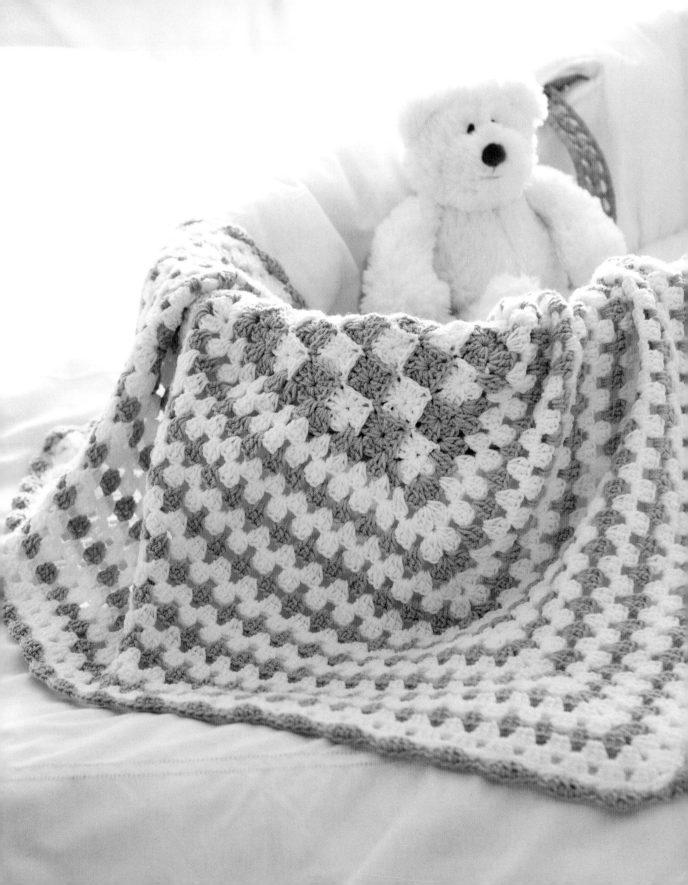

Patchwork blanket

This beautiful blanket is made up of individual squares – a variation of the plain square from the Techniques section (see p.148) – which are then joined together and finished with a border. The squares can be crocheted all at once or over time, and the size of the blanket can easily be varied by increasing or decreasing the number of squares in each row or column.

DIFFICULTY LEVEL
Easy

SIZE
110cm x 94cm (43in x 37in)

YARN
Stylecraft Special DK 100g

A 3 B 2 C 2 balls

CROCHET HOOK
4mm hook

PATTERN
SQUARE
With yarn A, work 4 ch, ss in first ch to form loop.
Round 1 3 ch, 2 tr in loop, *2 ch, 3 tr in loop, rep from * twice more, 2 ch, ss in top of beg 3-ch to join.
Fasten off yarn A.
Round 2 Join yarn B in any centre tr from 3-tr set from prev round. 3 ch, *1 tr in each tr to corner sp. Work (2 tr, 4 ch, 2 tr) in next 2-ch corner sp; rep from * to end, work 1 tr in each rem tr, ss in top of beg 3-ch to join. (7 tr per side of square)
Round 3 3 ch, *1 tr in each tr to corner. Work (2 tr, 4 ch, 2 tr) in 4-ch corner sp. Rep from * to end, work 1 tr in each rem tr, ss in top of beg 3-ch to join. (11 tr per side of square)
Fasten off yarn B.
Round 4 Join yarn A in any tr st. Rep round 3 with yarn A. (15 tr per side of square)
Fasten off yarn A.
Make 27 more squares using yarn B in rounds 2 and 3 (28 B squares total), and 28 squares using yarn C in rounds 2 and 3.

JOIN SQUARES
Lay two squares right sides facing. Work dc join in back loops only of each st. Join squares into strips of 8 squares. Lay two strips of 8 right sides facing. Work dc join in back loops only of each st. Continue until all squares are joined. Sample blanket uses 7 x 8 squares.

EDGING
Round 1 Join yarn A in any tr. 3 ch, *1 tr in each tr to corner sp. Work (2 tr, 4 ch, 2 tr) into each 4-ch corner sp. Rep from * around entire blanket, work 1 tr in each rem tr, ss in top of beg 3-ch to join.
Round 2 Rep round 1.
Fasten off. Weave in all ends.

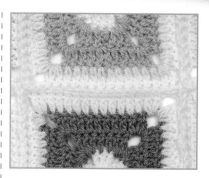

The **squares** of the blanket are joined by working through only the back loops of each stitch. This helps the blanket lie flat.

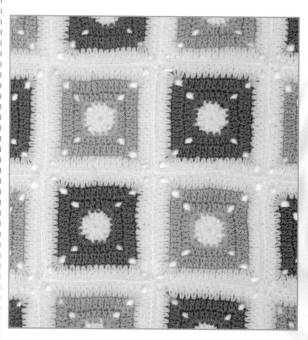

Alternate block colours as shown, or add others to create your own colour combinations.

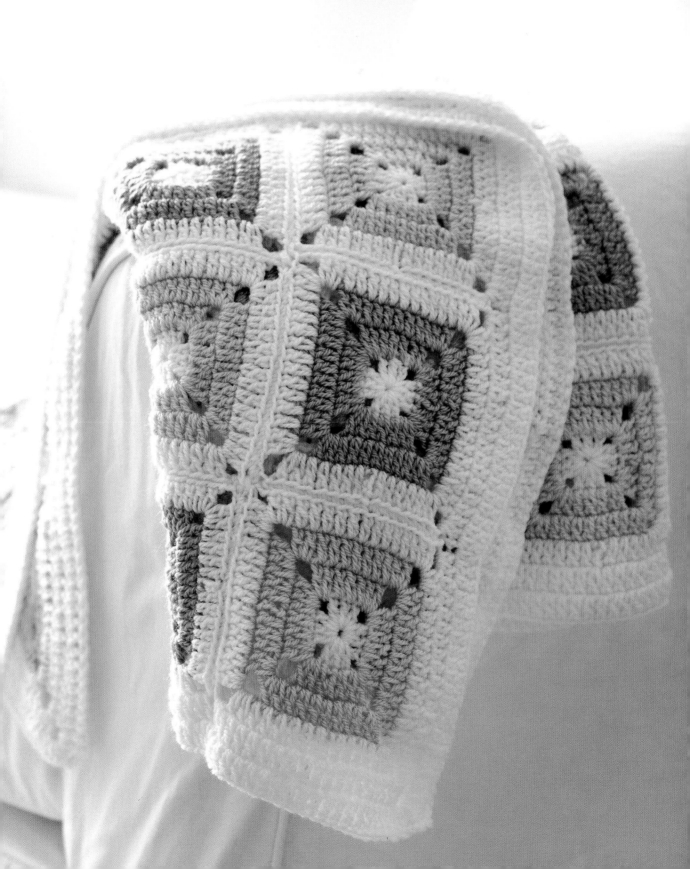

Glossary

Acrylic
Man-made fibres spun into yarn resembling wool.

Aran yarn
Also called medium, 12-ply, worsted, or Afghan (yarn symbol 4). A medium yarn suitable for jumpers, menswear, blankets, hats, scarves, and mittens.

Ballband
The wrapper around a ball of yarn, which usually details fibre content, weight, length, hook size, tension, and cleaning instructions.

Ball-winder
A device for winding hanks of yarn into balls; also used to wind two or more strands together to make a double-stranded yarn. Often used in conjunction with a swift.

Blocking
Manipulating a finished piece into the correct shape by wetting and pinning it out, or pinning it out and steam pressing it.

Bulky or chunky yarn
Also called 14-ply, craft, or rug (yarn symbol 5). A chunky yarn suitable for rugs, jackets, blankets, hats, legwarmers, and winter accessories.

Cashmere
From Kashmir goats; the most luxurious of all wools.

Chain loop, chain space
A length of chain stitches worked between basic stitches to create a space in the fabric.

Colourwork
Any method of incorporating colour into your crochet. This includes stripes, jacquard, and intarsia.

Darning in ends
The process of completing a piece of crochet by weaving yarn ends into the crochet to disguise them.

Decrease
Removing a stitch or stitches in order to reduce the number of working stitches and shape the fabric.

Double-knit yarn (DK)
A medium-weight yarn. Also called DK, 5–6-ply, or light worsted (yarn symbol 3). A light yarn suitable for jumpers, lightweight scarves, blankets, and toys.

Fibres
Yarn is made up of fibres, such as the hair from an animal, man-made (synthetic) fibres, or fibres derived from a plant. The fibres are processed and spun into a yarn.

Filet crochet
A form of openwork crochet created by working a combination of squares or rectangles of open mesh and solid blocks.

Fine yarn
Also called 4-ply, sport, or baby (yarn symbol 2). A fine yarn is suitable for lightweight jumpers, babywear, socks, and accessories.

Foundation chain
A length of chain stitches that forms the base of the piece of crochet.

Hank
A twisted ring of yarn, which needs to be wound into one or more balls before it can be used.

Hook and eye fastening
Two-part metal fastening used to fasten overlapping edges of fabric where a neat join is required. Available in a wide variety of styles.

Increase
Adding a stitch or stitches to increase the number of working stitches and shape the fabric.

Intarsia
A term used to refer to a technique in which a colour appears only in a section of a row and is not needed across the whole row. Unlike jacquard crochet, more than two colours may be used in a row. A separate ball or length of yarn is used for each area of colour and carried vertically up to the next row when it is needed again.

Jacquard crochet
A type of colourwork crochet worked in double crochet stitch, with no more than two colours in each row, in which the colour not in use is carried across the top of the row below and covered with the stitches of the other colour so that it is hidden from view. This results in a thicker-than-normal fabric, so it is best worked in a fine yarn.

Lace yarn
Also called 2-ply or fingering (yarn symbol 0). A very fine yarn for crocheting lace.

Lanolin
An oily substance contained in sheeps' wool.

Medallion
A flat shape worked from the centre outwards.

Mercerized cotton
Cotton thread, fabric, or yarn that has been treated in order to strengthen it and add a sheen. The yarn is a good choice for items that need to be strong and hold a shape, such as a bag.

Mohair
Fluffy wool yarn spun from the hair of Angora goats.

Notion
An item of haberdashery, other than fabric, needed to complete a project, such as a button, zip, or elastic. Notions are normally listed in the pattern.

Nylon
Hard-wearing, man-made fabric.

Openwork crochet
A lacelike effect created by working chain spaces and/or loops between the basic stitches.

Plied yarn
A yarn made from more than one strand of spun fibre, so 4-ply is four strands plied together. Most yarns are plied, as plying prevents the yarn from twisting and the resulting fabric from slanting diagonally.

Right side
The front of a piece of fabric, the side that will normally be in view when the piece is made up.

Round
A row worked in a circle, with the last stitch of the row being joined to the first to complete the foundation circle.

Seam
The join formed when two pieces of fabric are sewn together.

Silk
Threads spun by the silkworm and used to create cool, luxurious fabrics.

Slip knot
A knot that you form when you place the first loop on the hook.

Slip stitch
The shortest of all the crochet stitches. Although slip stitches can be worked in rows, the resulting fabric is very dense and suitable only for bag handles. Slip stitches are frequently used in crochet projects, for example to join on new yarn, to work invisibly along the top of a row to move to a new position, and to join rounds in circular crochet.

Skein
Yarn wound into a long oblong shape, which is ready to crochet.

Snaps
Also known as press studs, these fasteners are used as lightweight hidden fasteners.

Super bulky or super chunky yarn
Also called 16-ply (and upwards), bulky, or roving (yarn symbol 6). A chunky yarn suitable for heavy blankets, rugs, and thick scarves.

Superfine yarn
Also called 3-ply, fingering, or baby (yarn symbol 1). A very fine yarn suitable for fine-knit socks, shawls, and babywear.

Tape measure
Flexible form of ruler made from plastic or fabric.

Tape yarn
A wide, flat, or tubular yarn, flattened when wound into a ball. Can be crocheted to produce a nubbly or smooth result.

Tension
The number of stitches and rows over a given area, usually 10cm (4in) square. Also, the relative tightness used by the crocheter.

Turning chain
A length of chain stitches worked at the start of a row in order to bring the hook up to the necessary height to work the first stitch of that row.

Velcro™
Two-part fabric fastening consisting of two layers, a "hook" side and a "loop" side; when pressed together the two pieces cling together.

Wool
A natural animal fibre, available in a range of weights, weaves, and textures. It is warm, comfortable to wear, and crease-resistant.

Wrong side
The reverse of a piece of fabric, the side that will normally be hidden from view when the piece is made up.

Yarn
Fibres that have been spun into a long strand. Yarns may be made of natural fibres, man-made fibres, a blend of the two, or even non-standard materials.

Yarn bobbins
Small plastic shapes for holding yarn when doing intarsia work, where there are many yarns in different colours.

Zip
Fastening widely used on garments consisting of two strips of fabric tape, carrying specially shaped metal or plastic teeth that lock together by means of a pull or slider. Zips are available in different colours and weights.

Index

A

abbreviations 56–57, 68–69
acrylic yarns 12
Afghan (Granny) square 147
 baby's blanket 214–215
apple 82
arched mesh stitch 86
 wrist warmers 184–185

B

baby's blanket 214–215
baby's booties 194–195
baby's cardigan 196–197
baby's hat 182–183
back post treble 63
backstitch seam 118
bags
 clutch bag 206
 plarn make-up bag 163
 rag-strip bag 160–161
 string market bag 204–205
ballbands 19
banded net stitch 86
basic skills
 counting stitches 35, 53
 darning in yarn 54
 double crochet 36–38
 double treble crochet 48–49
 fastening off 52
 foundation chain 34–35
 foundation rings 52, 136
 half treble crochet 39–41
 holding the hook 30
 holding the yarn 31
 joining on new yarn 54, 146
 making a slip knot 32
 slip stitch 51–52
 tensioning the yarn 33
 triple treble crochet 50
basket 208–209
beaded crochet 124–125
beaded wire bangle 158–159
beanie hat 180–181
bird 82
blanket stitch 126
blankets
 baby's blanket 214–215
 patchwork blanket 216–217
blocking 117

steam blocking 117
wet blocking 117
blocks lace 87
bloom 81
bobbles 64, 68
 bobble stripe 100
 simple bobble stitch 72
bookmark 202–203
bouclé yarn 14
button bangle 159
button flower 150
button loops 116, 192, 194
buttons 166, 168–170
 crochet buttons 115–116
 oversized and layered buttons 170
 sewing on a 2-hole button 168
 sewing on a 4-hole button 169
 sewing on a reinforced button 170
 sewing on a shanked button 169

C

care labels 19, 175
care of crochet 175
 moth control 175
 storing 175
 washing and drying 175
cashmere yarns 11
chain fringe 134
chain loop mesh 77, 84
 shawl 190–191
chains
 chain loops 59
 chain spaces 59, 61
 chain stitch necklace 35
 counting stitches 35
 embroidery 126
 fastening off 52
 foundation chains 34–35, 55, 68
 shells and chains 73
 turning chains 55, 68
 working into a chain space 61
chevron cushion 212
circles edging 133
circular crochet 136–153
 baby's booties 194–195
 baby's hat 182–183
 basket 208–209
 beanie hat 180–181
 flat circles 142–143

flowers 150–153
medallions 144–149
round cushion 210–211
slouchy hat 178–179
string market bag 204–205
teddy bear 200–201
toy balls 198–199
tubes 136–139
close shells stitch 71
 coloured close shells 100
cluster and shell stitch 72
 clutch bag 206–207
 coloured cluster and shell 99
clusters 64–65, 68
 cluster and shell edging 135
 cluster and shell stitch 72, 99, 206–207
 cluster scallop edging 131
clutch bag 206
colours
 black and white 23
 colour choices 20–21
 colour temperature 21–23
 colour wheel 20
 complementary colours 20
 monochromatic designs 20
colourwork 89–101
 carrying colours up side edge 90
 changing colours 89, 92, 93
 colour combinations 94
 intarsia crochet 91, 93
 jacquard 91, 92
 stitch patterns 94–95, 98–101
 stripes 89, 90
cotton yarns 10
 fine-weight 10
 matt cotton 10
 mercerized cotton 10
 variegated 13
 wool and cotton mixes 13
counting stitches 35, 53
 row counter 27
crochet patterns, following 109–119
 accessory patterns 102
 finishing 114–116
 garment patterns 103
 measuring tension 104
 shaping 104–111
 see also stitch patterns
cross stitch (embroidery) 126

crossed stitch 71
crosses border 81
cushions 102
 chevron cushion 212
 round cushion 210–211

D

darning in yarn 54
decreasing 108–111
 step decreases 111
diamond edging 128
diamonds border 80
dog 83
double crochet 36–38
 beaded double crochet 124–125
 counting stitches 53
 decreases 108–109
 double-crochet seam 146
 edging 114
 increases 104–105
 parts of stitches 58
 spiral tube 137
 stitch height 55
 stitch pattern instructions 56
 working into back loop of 59
 working into front loop of 60
double loop edging 130
double scallop edging 132
double treble crochet 48–49
 stitch height 55
 stitch pattern instructions 57
double zigzag 98

E

edge-to-edge seam 119
edgings 127–135
 circles edging 133
 cluster and shell edging 135
 cluster scallop edging 131
 crocheting on an edging 114–115
 diamond edging 128
 double crochet 114
 double loop edging 130
 double scallop edging 132
 grand eyelet edging 127
 long loop edging 132
 multiple-stitch edging 135
 petal edging 133
 picot scallop edging 129

pillar edging 129
scallop edging 128
sewing on an edging 127
shell edging 131
step edging 134
triple picot edging 129
 see also fringes
embellishments 124–135, 173
 beaded crochet 124–125
 edgings see edgings
 embroidery 126
embroidery stitches 126
equipment 24–27

F

fans stitch 88
 lacy scarf 186–187
fastening off 52, 68
 chain stitch 52
 slip stitch 52
fastenings 166–171
 buttons see buttons
 hooks and eyes 167, 171
 snap tape 167
 snaps 167, 172
 Velcro™ 167
 zips 167
filet crochet 78–83
 filet blocks 79
 filet charts 79
 filet mesh 78
 stitch patterns 80–83
finishing 114–116, 168–174
 see also buttons; edgings; fastenings
flat circles 142–143
flowers 150–153
 button flower 150
 flower hexagon 148
 flowers and circles 80
 leaf 153
 long loop flower 151
 pentagon flower 152
 short loop flower 151
 square petal flower 152
foundation chains 34–35, 55, 68
foundation rings 52, 136
foundation rows 68
fringes 173
 chain fringe 134

twirl fringe 130
front post treble 62

G

garment patterns 103
 beginners 103
 garment sizes 103
 modifying 103
gem stitch 95
grand eyelet edging 127

H

half treble crochet 39–41
 stitch height 55
 stitch pattern instructions 56
hats
 baby's hat 182–183
 beanie hat 180–181
 slouchy hat 178–179
heart 83
hemp yarns 12
hexagons 149
 flower hexagon 148
hook, holding 30
 knife position 30
 pencil position 30
hooks
 handles 24
 jumbo hooks 25
 lace hook 24
 metal hooks 24
 plastic hooks 25
 sizes 25
 wooden hooks 25
hooks and eyes 167, 171

I

increasing 104–107
 step increases 106–107
intarsia crochet 91, 93

J

jacquard 91, 92
joining on new yarn 54, 146
jumbo hooks 25

L

lace hook 24
lace techniques 77–78

leaf 153
left-handed crocheters 55, 79
long loop edging 132
long loop flower 151

M

mattress stitch *see* edge-to-edge seam
medallions 144–149
 Afghan (Granny) square 147, 214–215
 flower hexagon 148
 joining 146
 joining on a new colour 146
 plain square 148
 round circle medallion 144
 simple hexagon 149
 simple loop ring 145
merino wool 11
metallic yarns 14
microfibre yarns 12
mohair yarns 14, 84
moth control 175
multicoloured yarns 13
multiple-stitch edging 135

N

necklace, chain stitch 35
novelty yarns 14
nylon yarns 12

O

open shell stitch 67, 85
openwork 77–87
 filet crochet 78–83
 lace techniques 77–78
 lacy scarf 186–187
 shawl 190–191
 stitch patterns 84–88
overcast stitch seam 118

P

pastel colours 22
patchwork blanket 216–217
pentagon flower 152
petal edging 133
picot net stitch 78, 85
picot scallop edging 129
 shawl 190–191
 wrist warmers 184–185
pillar edging 129
pincushion 27
pineapples 68

pins 26
plastic-strip crochet (plarn) 15, 162–163
 plarn make-up bag 163
 preparing plarn strips 162
pompoms 173
popcorns 65, 68, 73
projects
 baby's blanket 214–215
 baby's booties 194–195
 baby's hat 182–183
 basket 208–209
 beaded wire bangle 158–159
 beanie hat 180–181
 bookmark 202–203
 button bangle 159
 chevron cushion 212–213
 clutch bag 206–207
 cold-weather scarf 188–189
 lacy scarf 186–187
 patchwork blanket 216–217
 plarn make-up bag 163
 rag-strip bag 160–161
 round cushion 210–211
 round string container 156–157
 shawl 190–191
 slouchy hat 178–179
 string market bag 204–205
 teddy bear 200–201
 toy balls 198–199
 waistcoat 192–193
 wrist warmers 184–185
puff stitch 68, 76

R

rag-strip crochet 15, 160–161
 preparing fabric strips 160
 rag-strip bag 160–161
ramie yarns 12
rib stitch 70
 cold-weather scarf 188–189
round circle medallion 144
round cushion 210–211
row counter 27

S

scallop edging
 bold scallop edging 128
 cluster scallop edging 131
 double scallop edging 132
 picot scallop edging 129
scarves 84

cold-weather scarf 188–189
 lacy scarf 186–187
scissors 26
seams 117, 118–121
 backstitch seam 118
 double-crochet seam 146
 edge-to-edge seam 119–120
 overcast stitch seam 118
 slip stitch seam 121, 146
seasonal colours 23
shaping 104–111
 decreases 108–111
 increases 104–107
shawl 84, 190–191
shell edging 131
 baby's blanket 214–215
 bookmark 202–203
 cluster and shell edging 135
 shawl 190–191
shells 63, 68
 close shells stitch 71, 100
 cluster and shell stitch 72, 99, 206
 coloured close shells 100
 open shell stitch 67, 85
 shell mesh stitch 77, 87
 shells and chains 73
short loop flower 151
silk yarns 11
simple bobble stitch 72
simple loop ring 145
simple texture stitch 76
slip knot 32
slip stitch 51–52
 as a fabric 51
 fastening off 52
 forming a foundation ring 52
 slip stitch seam 121
slouchy hat 178–179
snap tape 167
snaps 167, 172
spike stitch stripes 99
square petal flower 152
square, plain 148
 patchwork blanket 216–217
steam blocking 117
step decreases 111
 beginning of row 111
 end of row 111
step edging 134
step increases 106–107
 beginning of row 106

end of row 106–107
stitch markers 27
stitch patterns
 abbreviations 56–57, 68–69
 colourwork charts 91
 diagrams 66, 67
 filet charts 79
 openwork diagrams 84
 reading 55–57, 66–69, 79, 91
 sample pattern 67
 stitch symbols 55, 56–57, 66, 69
 terminology 68
 written instructions 66, 67
stitch techniques
 back post treble 63
 bobbles 64, 72
 chain loops 59
 chain spaces 59, 61
 close shells stitch 71, 100
 cluster and shell stitch 72, 99
 clusters 64–65
 crossed stitch 71
 front post treble 62
 popcorns 65, 73
 rib stitch 70
 sculptural textures 62–65
 shells 63
 shells and chains 73
 simple puff stitch 76
 simple texture stitch 76
 simple textures 58–61, 70–73
 working into a chain space 61
 working into back loops of stitches 59, 60
 working into front loops of stitches 60
 working into spaces between stitches 61
stitches
 counting 35, 53
 embroidery stitches 126
 stitch heights 55
 see also basic skills; stitch techniques, and
 individual index entries
storing crochet 175
string container 156–157
string crochet 15, 156–157
string market bag 204–205
stripes 89, 90
 bobble stripe 100
 changing colours 89
 combinations 90
 spike stitch stripes 99
symbols

stitch diagrams 66, 67, 84
 yarns 19
synthetic yarns 12
 natural and synthetic mixes 13

T
tape measure 26
tape yarn 14
tassels 173, 174, 202
teddy bear 200–201
tension
 measuring 104
 tensioning the yarn 33
terminology 68
 see also abbreviations
test swatches 70, 104
textures
 sculptural textures 62–65, 70
 simple textures 58–61, 70–73
 see also stitch techniques
tiara lace 88
tools and equipment 24–27
toy balls 198–199
treble crochet 42–45
 back post treble 63
 counting stitches 53
 decreases 109–111
 front post treble 62
 increases 105
 parts of stitches 58
 stitch height 55
 stitch pattern instructions 57
 tube with turns 139
 tube without turns 138
 working into back loop of 60
triangles spike stitch 101
triple picot edging 129
triple treble crochet 50
 stitch height 55
tubes 136–139
 double crochet spiral tube 137
 starting a tube 136
 treble crochet tube with turns 139
 treble crochet tube without turns 138
turning chains 55, 68
tweed stitch 61, 95
twirl fringe 130

V
Velcro™ 167

W
waistcoat 192–193
warm/cool colours 21
washing and drying crochet 19, 175
wet blocking 117
whip stitch see overcast stitch seam
wire crochet 15, 158–159
wool yarns 11
 merino wool 11
 organic wool 11
 variegated 13
 wool and cotton mixes 13
wrist warmers 184–185

Y
yarn bobbins 27
yarn embellishments 173
 see also fringes; tassels
yarn needles 26
yarn(s) 10–23
 balls/cones/hanks/skeins 18
 blends 13
 buying 18–19
 colours 20–23
 darning in yarn 54
 fibres 10–13
 holding 31
 joining on new yarn 54, 146
 labels 19, 175
 luxury yarns 11
 multicoloured 13
 novelty yarns 14
 synthetic fibres 12
 tensioning 33
 textures 14–15
 unusual 15, 156–163
 weights 18–19

Z
zigzag border 81
zigzag stitch 94
 chevron cushion 212–213
 double zigzag 98
zips 167

Acknowledgments

ABOUT THE AUTHORS

SALLY HARDING, author of the Tools and Materials and Techniques sections, is a needlecraft technician, author, designer, and editor. Born in the United States, she now lives in London. She was the Technical Knitting Editor for *Vogue Knitting* from 1982, and has for many years edited needlecraft books by acclaimed textile designer Kaffe Fassett. Her books include *Crochet Style* (1987), *Fast Knits Fat Needles* (2005), and *Quick Crochet Huge Hooks* (2005).

CATHERINE HIRST, Technical Consultant for this book, also designed and created the following projects in the Projects section: Slouchy hat, Beanie hat, Wrist warmers, Lacy scarf, Cold-weather scarf, Shawl, Baby booties, Toy balls, Teddy bear, Bookmark, String bag, Clutch bag, and Project basket. Catherine is a professional textiles and crafts instructor at colleges and independent studios across London, the UK, and abroad. She teaches knitting, crochet, and hand embroidery to groups and individuals at all levels. Her work has been featured in top craft publications, including *Mollie Makes*, *Let's Knit*, *Inside Crochet*, *Handmade Living*, *Simply Crochet*, and *Crafts Beautiful*. Catherine is the author of *Teeny Tiny Crochet* (2012) and *Granny Square Crochet* (2012). Visit her at www.catherinehirst.com.

CLAIRE MONTGOMERIE designed and created the Baby's hat, Waistcoat, Baby's cardigan, Round cushion, and Chevron cushion, all in the Projects section. Claire is a textiles designer who specializes in knitting and crochet, constructing fabrics, garments, creatures, and accessories that are fun, quirky and modern. Her main aim is to reinvent the products of ancient and traditional needlecraft processes, while retaining all their intricacies and comforting charm. Claire has written many knitting and crochet books and also edits the UK craft magazine, *Inside Crochet*.
Find out more at www.montyknits.blogspot.com.

ERIN McCARTHY designed and created the Baby blanket and Patchwork blanket in the Projects section. Erin learned to crochet three years ago after longing to make beautiful crocheted blankets like those she had spied all over blogland. Crochet acts as a relaxing hobby that balances out a busy day job as a special needs teacher. Erin would like to thank Catherine Hirst for teaching her everything she knows about crochet!

ACKNOWLEDGMENTS

DORLING KINDERSLEY WOULD LIKE TO THANK: Julie Stewart and Jennifer Pattison for their assistance on the photoshoot. Irene Lyford for proofreading this book and Marie Lorimer for creating the index.